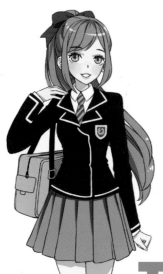

THE MANGA
FASHION BIBLE

The Go-To Guide for Drawing
Stylish Outfits and Characters

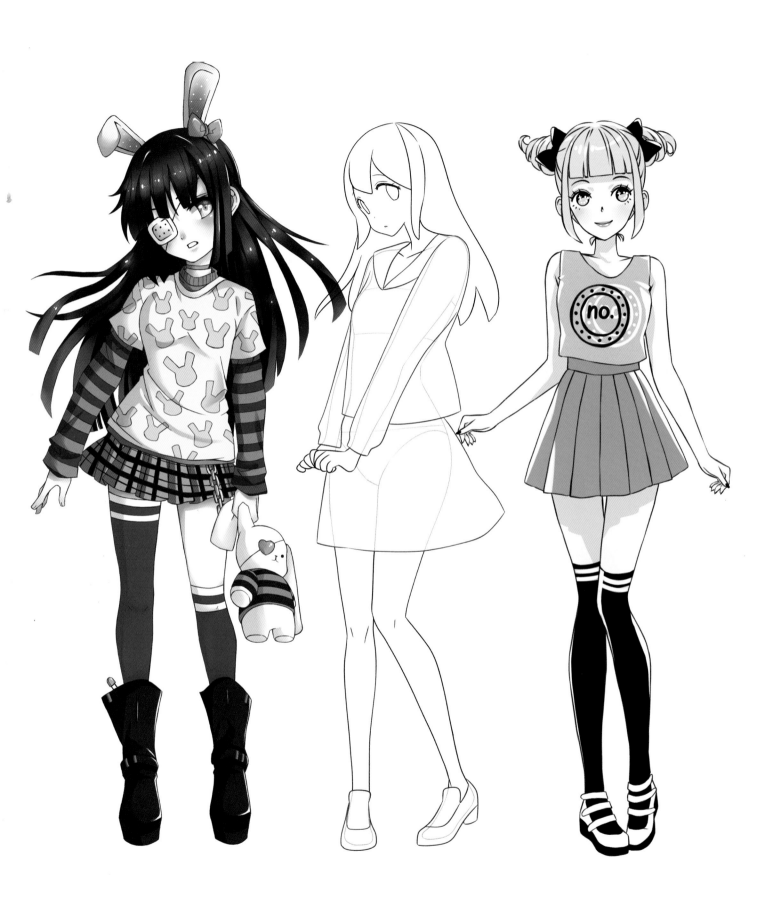

DRAWING WITH Christopher Hart

THE MANGA FASHION BIBLE

The Go-To Guide for Drawing Stylish Outfits and Characters

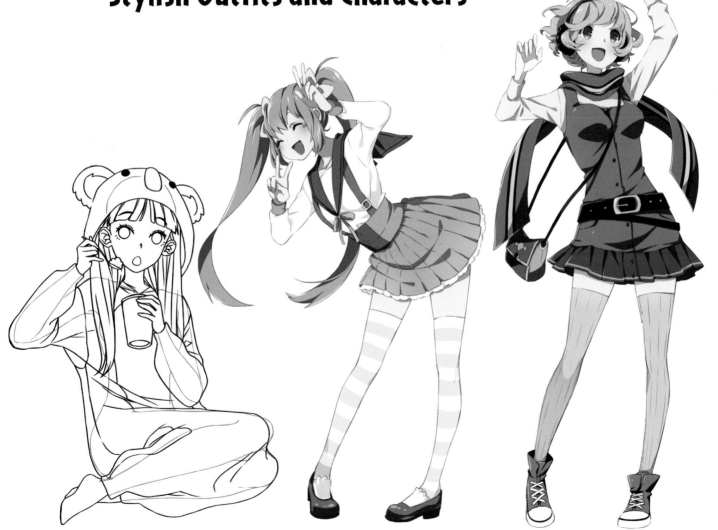

sixth&spring books

DRAWING WITH *Christopher Hart*

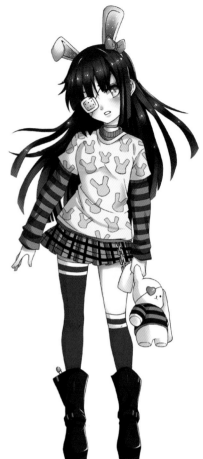

An imprint of Sixth&Spring Books
104 West 27th Street, New York, NY 10001
sixthandspringbooks.com

Editorial Director
JOAN KRELLENSTEIN

Managing Editor
LAURA COOKE

Art Director
IRENE LEDWITH

Editorial Assistant
JACOB SEIFERT

Design
MICHELLE HENNING

Production
J. ARTHUR MEDIA

Contributing Artists:
AKANE
AYAME
ERO-PINKU
TABBY KINK
INMA R.

Vice President
TRISHA MALCOLM

Publisher
CAROLINE KILMER

Production Manager
DAVID JOINNIDES

President
ART JOINNIDES

Chairman
JAY STEIN

Library of Congress Cataloging-in-Publication Data
The manga fashion bible : the go-to guide for
drawing stylish outfits and characters / by
Christopher Hart.
 ISBN 978-1-942021-62-9
 1. ART/Techniques/Comic strip characters.
 2. ART/Fashion drawing—Technique.
 3. ART/Cartooning—Technique.
 NC1764 .H3766 2016
 741.5/6028—dc23
LC record available at
http://lccn.loc.gov/2016004667
 2016004667

Manufactured in China

9 10

First Edition

Visit Christopher Hart on Facebook at
www.FACEBOOK.com/CARTOONS.MANGA.

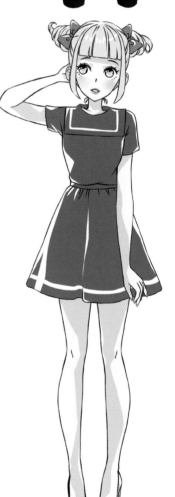

I'd like to thank my publishers, editors, book designer, and, of course, you, my reader!

—Christopher Hart

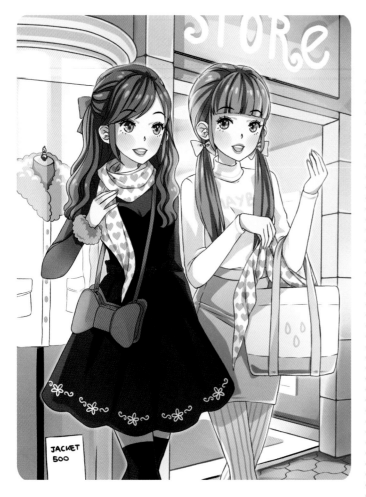

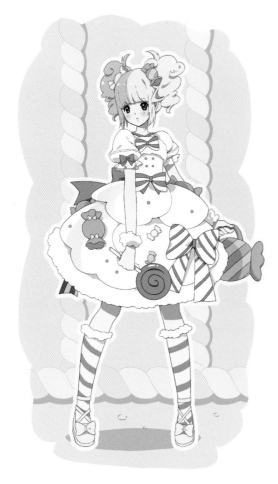

CONTENTS

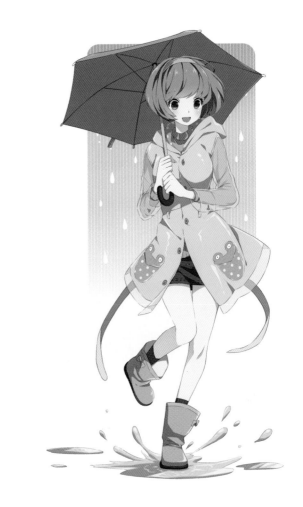

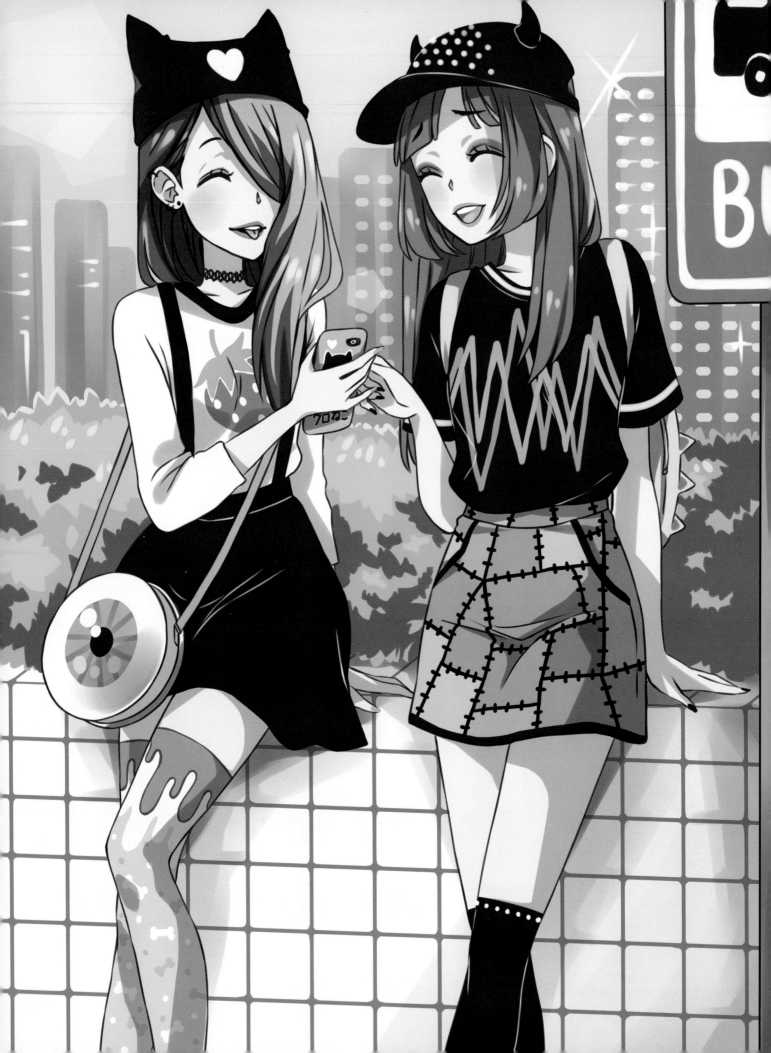

INTRODUCTION......

Through fashion, ordinary characters are transformed into extraordinary characters. But fashion means more than drawing cool clothes. It also means learning which style goes with which character type. It means drawing popular hairstyles, attractive poses, current and emerging trends, accessories, and of course, learning to mix and match pieces to create eye-catching outfits.

This book is the ultimate how-to-draw collection of tops, jackets, sweaters, skirts, dresses, pants, hats, and footwear. The tutorials will take you step-by-step through fashionable poses to finished outfits. The drawing instruction is clear, easy to follow, and fun.

And it gets even better! This book features four emerging fashion trends from Japan: Mori, J-Pop, Lolita, and Punk and Gothic. These are visually stunning styles that manga fans won't want to miss.

Fashion is a game changer for your characters—and for you as an artist. If you want to draw great looking manga, then this book is your go-to-guide. I'm delighted to have you with me as we discover all of the coolest styles manga has to offer.

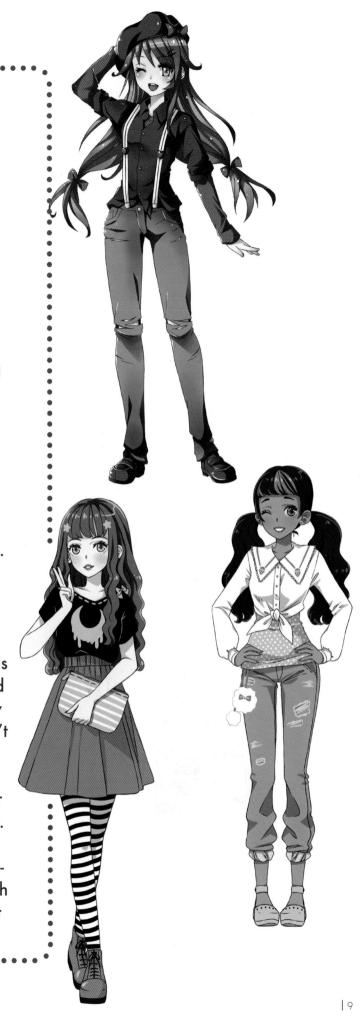

Getting Started

You can get all the art supplies you'll need without spending a fortune. Use this section to make a checklist for yourself, and bring it with you to your local art store. You should also bring a few pieces of blank paper to test out the art pencils and other drawing tools. It's one thing to view art supplies in a catalog or online. It's quite another to see how they feel in your hand. Ask the store manager if you can try a few drawing utensils. In my experience, they're very accommodating.

PENCILS AND PENS

Pencils have different grades of darkness, while pens have thicker or finer points. Many artists like to work with a variety of thicknesses.

ERASERS

There are red ones, brown ones, and gray ones. The gray ones are primarily used for life drawing on oversized paper. Red erasers are inexpensive and work quite well. Everyone has a favorite.

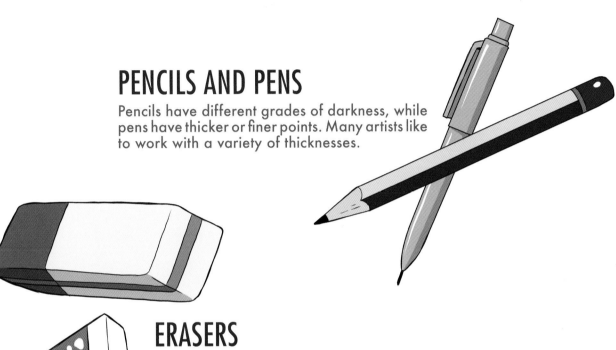

CORRECTION PAINT

Have you ever tried to erase a pencil line that stubbornly remains? By applying white paint over it, the pencil lines appear to be gone. Remember, erase first, then apply the paint.

SETTING UP YOUR WORK SPACE

You don't need a fancy studio to produce great manga art. You need a comfortable chair, a desk that's the right height, and lots of shelves or cabinet space for your drawings. Here are the basics:

- Simple drafting desk
- Desk lamp with moveable stem
- Trash basket • Light pad • Comfortable chair
- A cabinet or file for your drawings (A *tabouret* is a rolling filing cabinet that many artists use.)
- How-to-draw books by a certain popular author...

Now you're ready to start!

SHARPENERS

This sharpener works, but spurts pencil shavings everywhere. For a few dollars more, you can get one with a chamber that holds the shavings.

COLOR

Whatever tools you choose for coloring, be sure to get several shades of each color. For example: light blue, medium blue, and dark blue.

RULERS AND TRIANGLES

Rulers are for measuring, while triangles are for drawing.

PAPER

Pads of quality paper are great for sketching. Manga is usually drawn on smooth paper, rather than the bumpy paper used for watercolor. If you're planning to scan your work, printer paper has an advantage of being the exact dimensions of your printer.

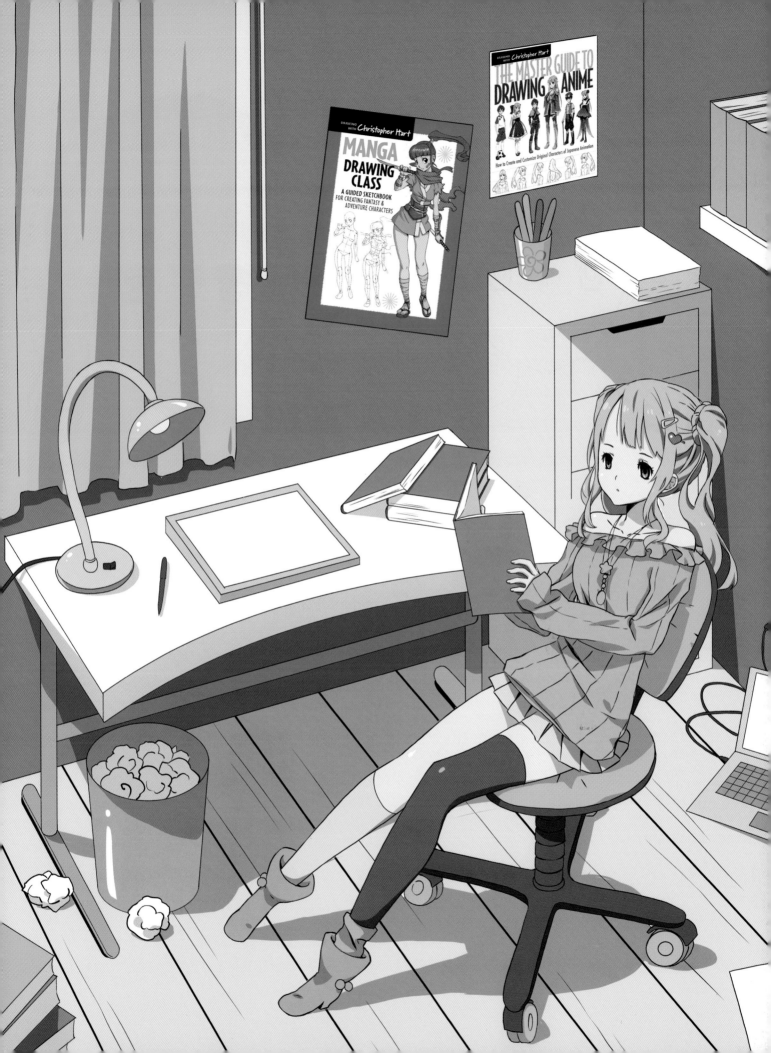

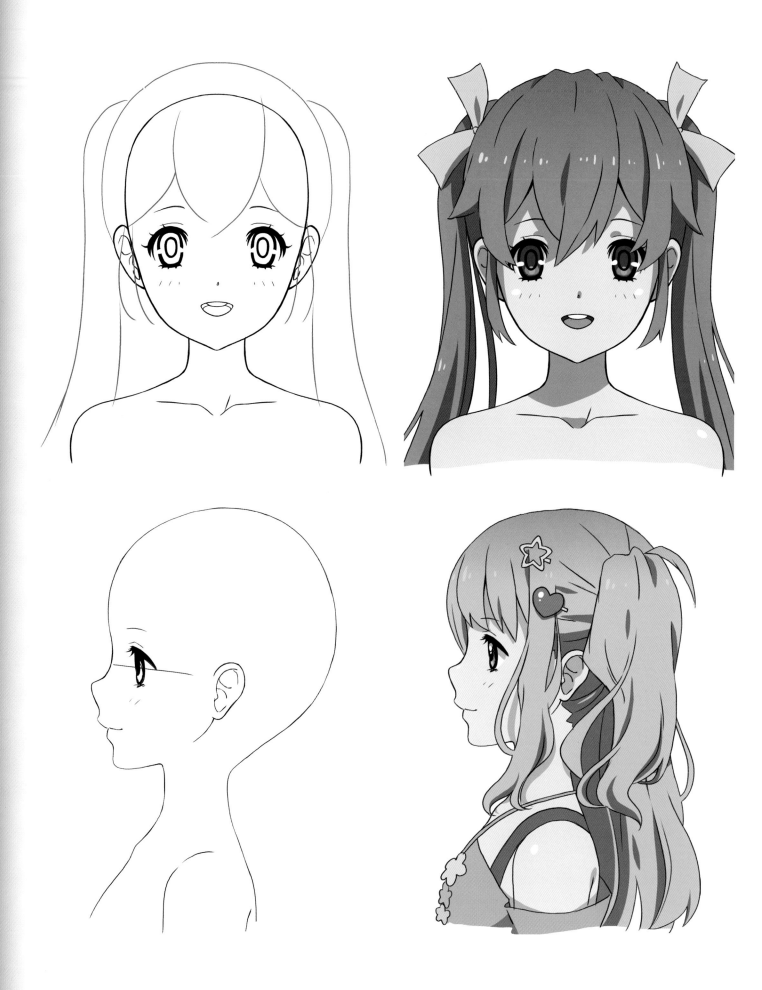

The Attractive Head

We'll begin with the basic shape of the manga head. The classic manga girl is based on a simple shape. This simplicity gives it charm. A large forehead, covered in bangs, dominates the upper half of the head. A profusion of stylish hair is always a major factor in manga characters. As to the features, the eyes dominate while the nose and lips are understated.

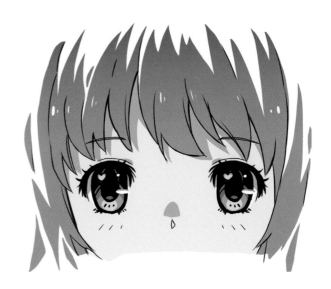

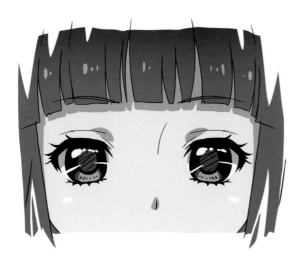

THE BASICS

The basic angles of the head are: front, side, and three-quarter. Fashion poses are drawn in many different positions. Therefore, we need to be able to draw the head at different angles, too.

Front Angle

Notice that the eyes, nose, and mouth are drawn within the bottom half of the face.

An extra large forehead serves as a canvas for a great hairstyle.

The *eye line* is drawn at the level of the ears.

Be sure to center the neck directly below the chin.

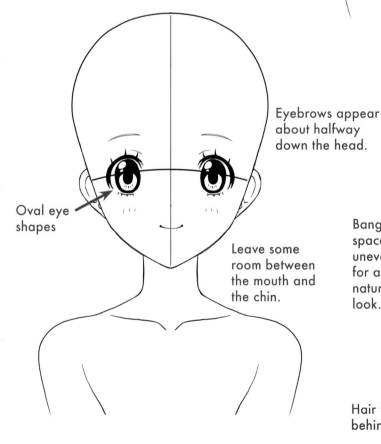

Eyebrows appear about halfway down the head.

Oval eye shapes

Leave some room between the mouth and the chin.

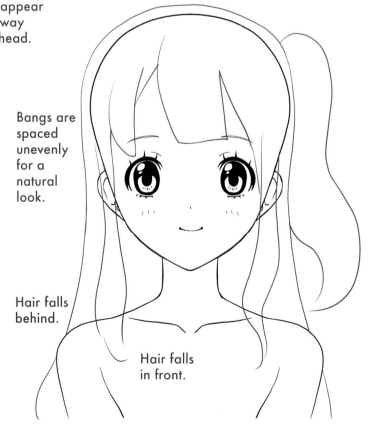

Bangs are spaced unevenly for a natural look.

Hair falls behind.

Hair falls in front.

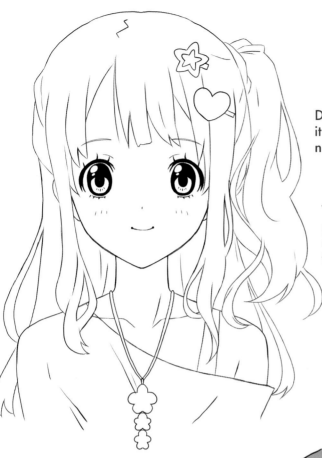

Draw the hair so that it looks relaxed and natural.

The wavy strands of hair are paced so that they appear to come apart and then merge together again.

Hair accessories and a charm necklace complete the look.

Draw a ponytail off to the side.

HELPFUL HINT
The underside of the hair, shown in the back, is slightly darker to create the look of depth.

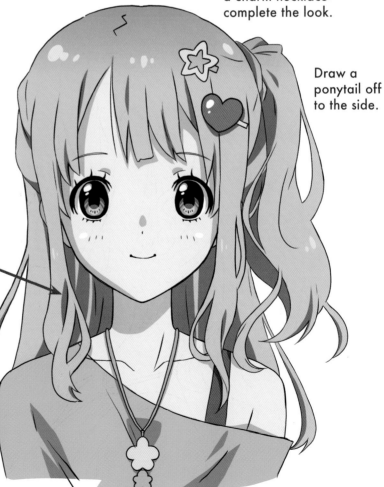

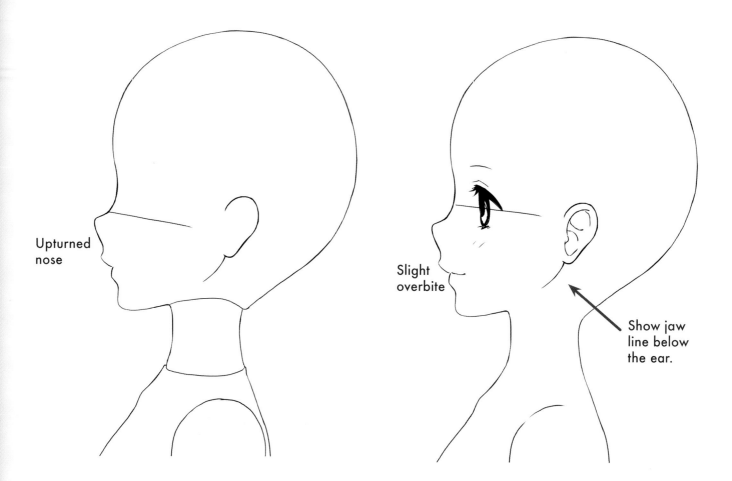

Upturned nose

Slight overbite

Show jaw line below the ear.

Profile Angle

The profile, or side view, is an opportunity to create a really cute look for your character. To do this, use gently curved lines rather than angular ones. The profile has two major curves:

- Forehead curves out.
- Bridge of nose curves in.

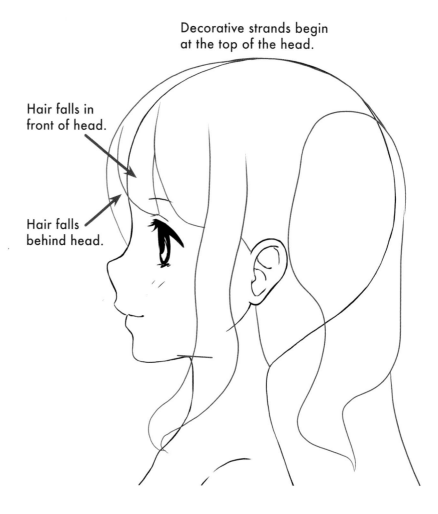

Decorative strands begin at the top of the head.

Hair falls in front of head.

Hair falls behind head.

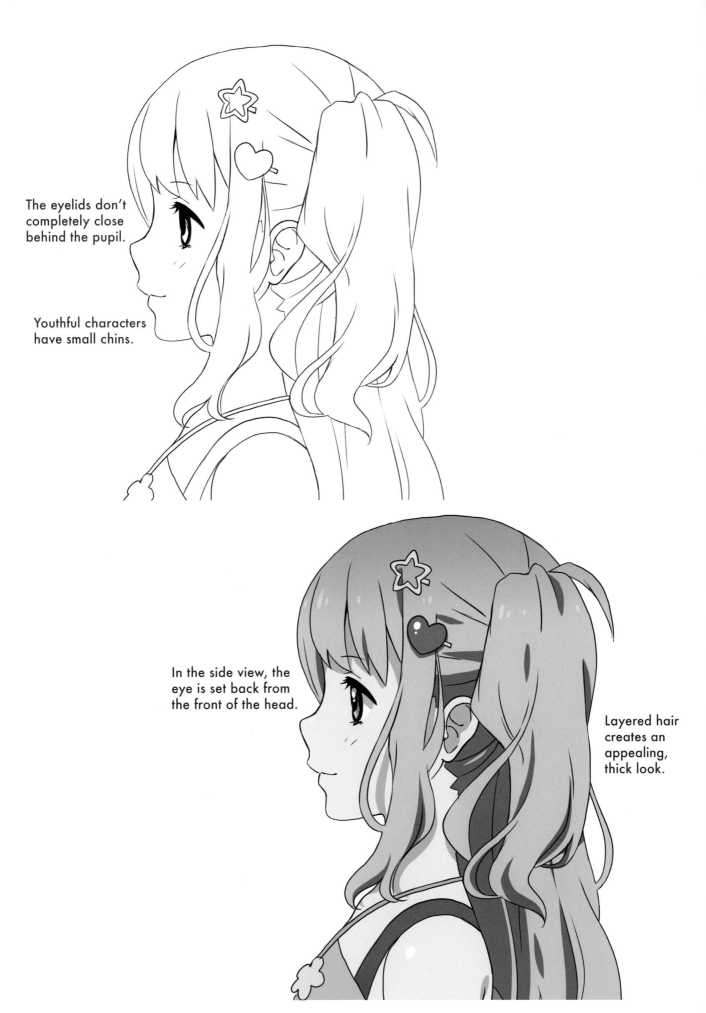

The eyelids don't completely close behind the pupil.

Youthful characters have small chins.

In the side view, the eye is set back from the front of the head.

Layered hair creates an appealing, thick look.

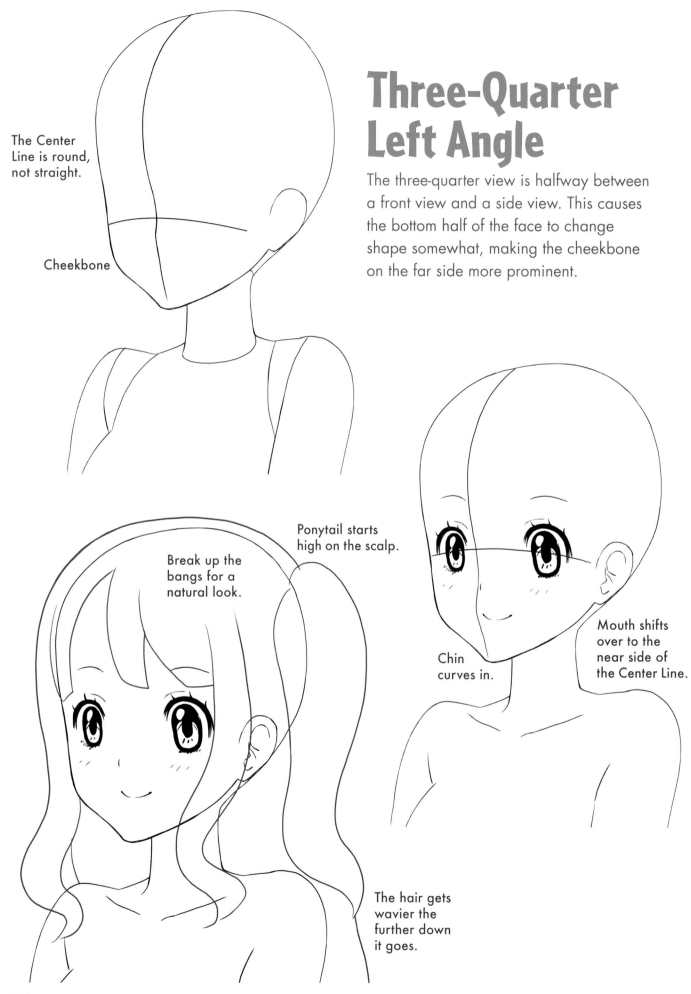

The Center Line is round, not straight.

Cheekbone

Three-Quarter Left Angle

The three-quarter view is halfway between a front view and a side view. This causes the bottom half of the face to change shape somewhat, making the cheekbone on the far side more prominent.

Break up the bangs for a natural look.

Ponytail starts high on the scalp.

Chin curves in.

Mouth shifts over to the near side of the Center Line.

The hair gets wavier the further down it goes.

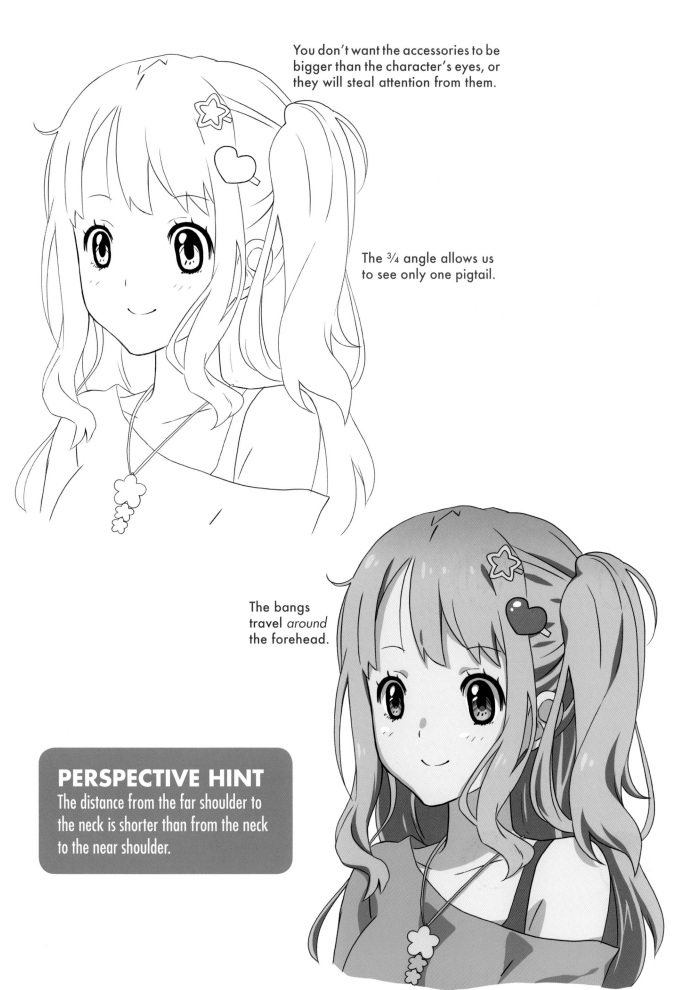

You don't want the accessories to be bigger than the character's eyes, or they will steal attention from them.

The ¾ angle allows us to see only one pigtail.

The bangs travel *around* the forehead.

PERSPECTIVE HINT
The distance from the far shoulder to the neck is shorter than from the neck to the near shoulder.

DRAWING BEAUTIFUL EYES

How do you draw amazing manga eyes? One step at a time! Try this easy-to-follow tutorial, and your eyes will look amazing.

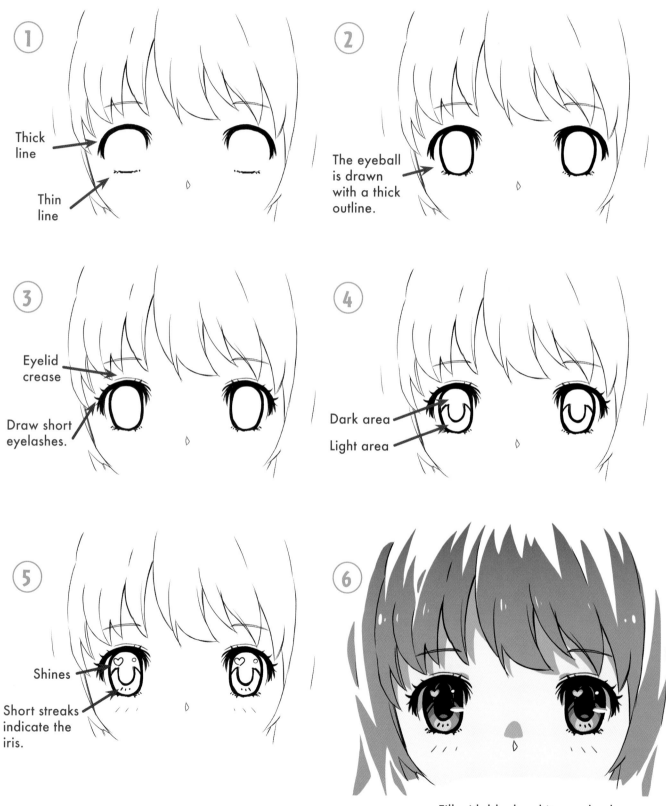

① Thick line / Thin line

② The eyeball is drawn with a thick outline.

③ Eyelid crease / Draw short eyelashes.

④ Dark area / Light area

⑤ Shines / Short streaks indicate the iris.

⑥ Fill with black, white, and color. Darkest on top; lightest on bottom.

Try these popular eye styles. You can increase the glamour and intensity by lengthening the eyelashes and adding color to the eyelids.

ATTRACTIVE VARIATIONS

MOODY

Moody eyes are pretty. Draw the eyelids so that they appear to be weighing down on the eyes below them.

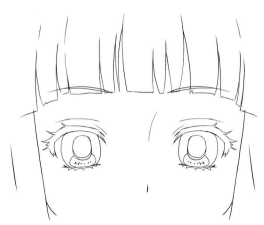

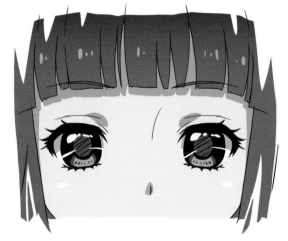

LIVELY

Cheerful expressions are created with wide-opened eyes. Start with tall ovals for the eyeballs and add plenty of scattered shines.

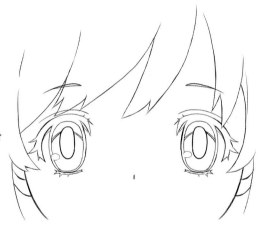

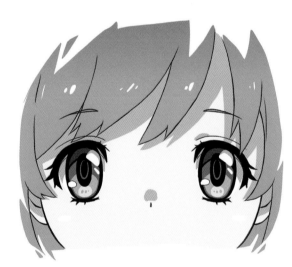

SUPER-GLAMOROUS

You can draw eye shines in the shape of stars. Square-shaped shines also add a glittery look.

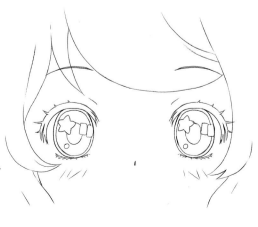

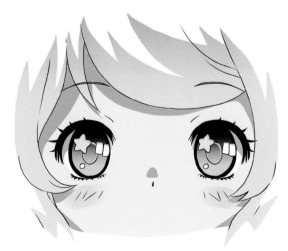

CHIC HAIRSTYLES

Although new styles emerge each season, the basic manga cuts never go out of style. Let's learn how to draw them.

Exaggerate the size of the forehead to give more surface area for your hairstyle.

Waves begin halfway down the head.

Inner strands overlap the face.

Draw streaks—they show the direction the hair is combed.

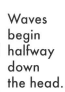

A shadow under the bangs adds the look of depth.

Super-Wavy

A hairstyle full of soft curls creates a captivating look for pretty characters.

Natural

This popular style is cool, casual, and somewhat mysterious!

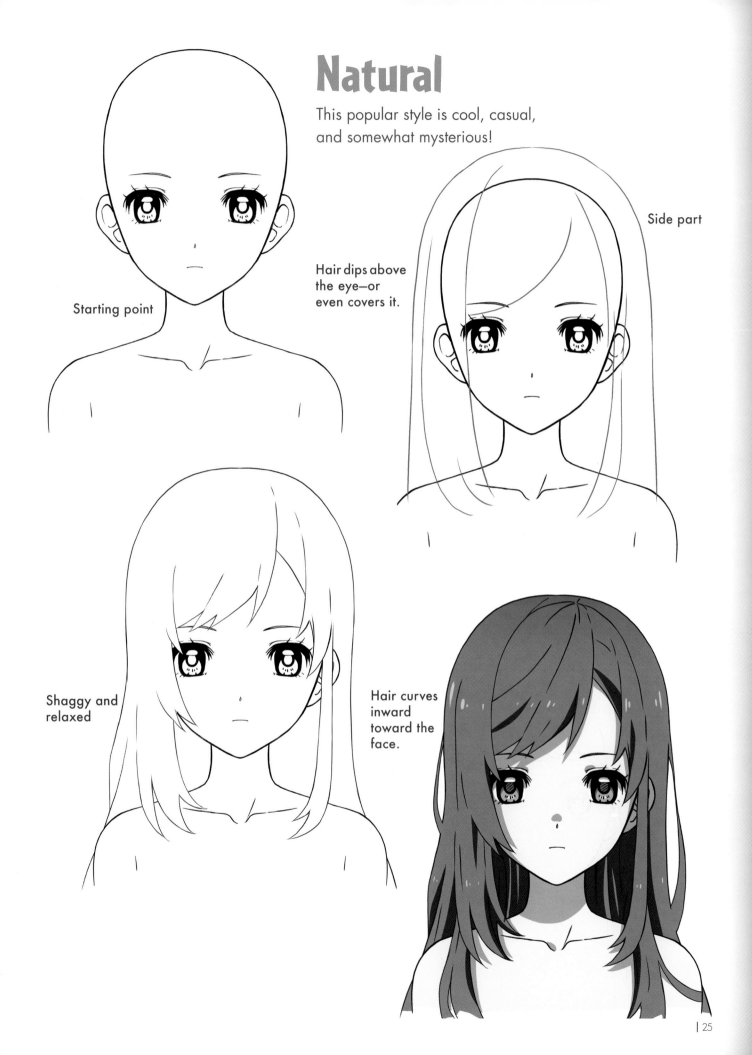

Starting point

Hair dips above the eye—or even covers it.

Side part

Shaggy and relaxed

Hair curves inward toward the face.

High Pigtails

This style works well with high school girls and older teens.

Starting point

Bangs separate into thirds.

Hair falls behind shoulders.

Hair flairs out.

Shortened strands

Pigtails flow, rather than hang straight.

Low Pigtails

This approach works well when drawing younger teens.

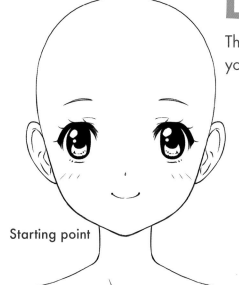

Starting point

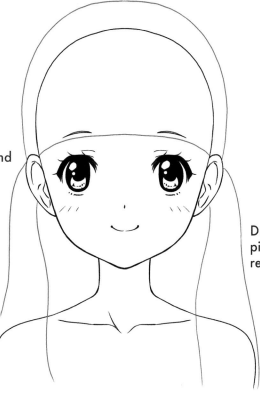

Pigtails begin behind the ears.

Draw the pigtails relaxed.

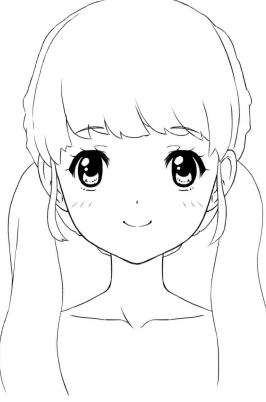

Draw the eyebrows, even though the bangs cover them.

Draw the bangs slightly uneven for a lifelike look.

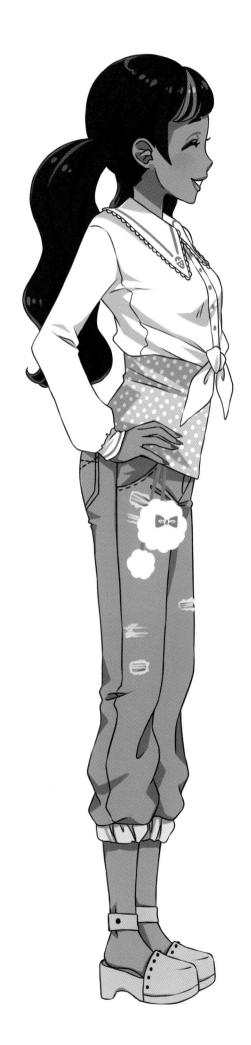
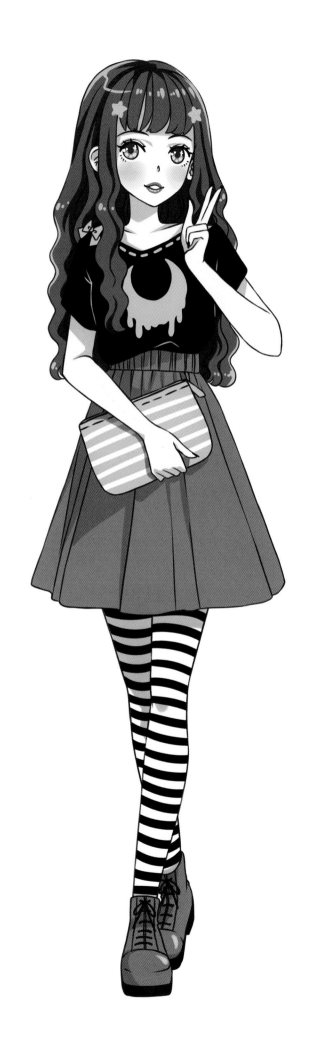

The Basics: Bodies and Fashions

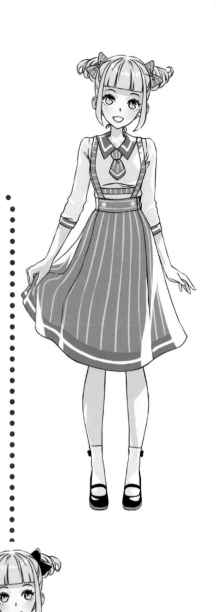

This chapter gives you the tools to create a great variety of popular outfits. We'll start each lesson by drawing the figure—because that's where it all starts. Then we'll create the classic outfits that your favorite character types wear most often. And importantly, we'll also establish standard lengths for sleeves, skirts, and dresses.

SLEEVE AND SKIRT LENGTHS

The standard lengths for sleeves and skirts give your drawings a pleasing look. It's no coincidence that the standard lengths are where they are. That's where they look best on the figure. And drawing them at their proper lengths tells the reader that you understand the style.

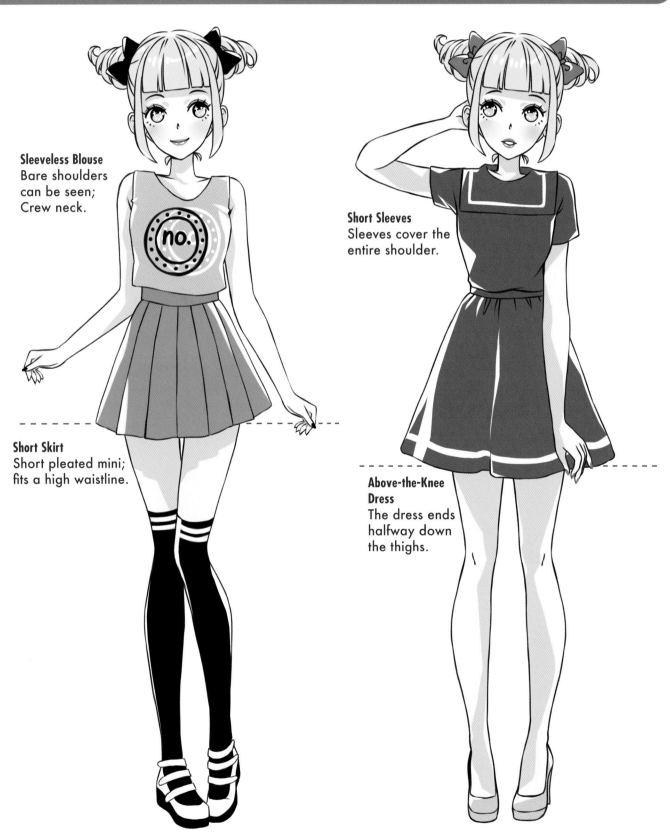

Sleeveless Blouse
Bare shoulders can be seen; Crew neck.

Short Skirt
Short pleated mini; fits a high waistline.

Short Sleeves
Sleeves cover the entire shoulder.

Above-the-Knee Dress
The dress ends halfway down the thighs.

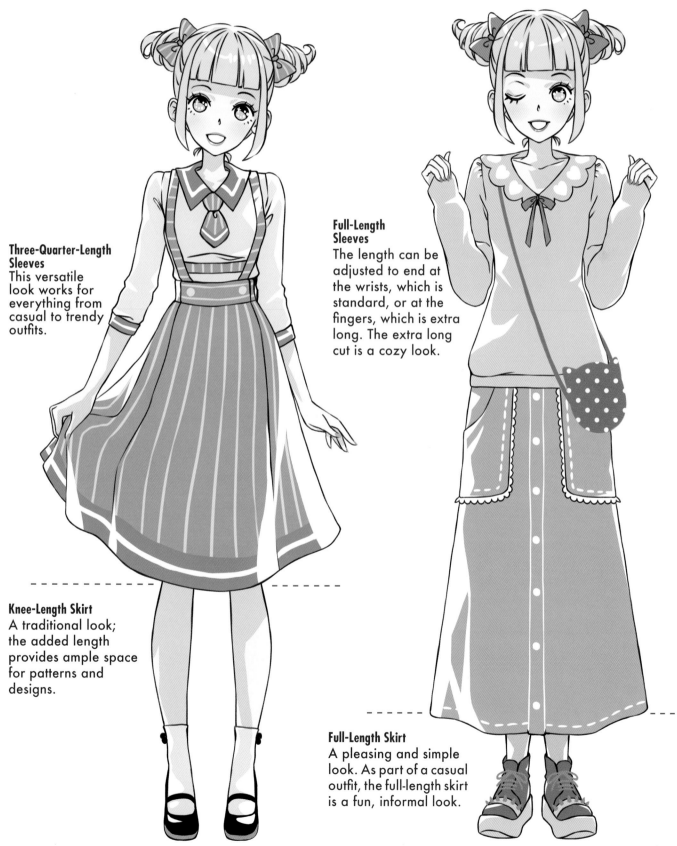

Three-Quarter-Length Sleeves
This versatile look works for everything from casual to trendy outfits.

Full-Length Sleeves
The length can be adjusted to end at the wrists, which is standard, or at the fingers, which is extra long. The extra long cut is a cozy look.

Knee-Length Skirt
A traditional look; the added length provides ample space for patterns and designs.

Full-Length Skirt
A pleasing and simple look. As part of a casual outfit, the full-length skirt is a fun, informal look.

FROM BASIC BODIES TO COMPLETE OUTFITS

There are three basic outfits that every manga artist needs to be able to draw. They are: a skirt outfit, a pants outfit, and a uniform. There are many more outfits and styles covered in this book, but this is where it all starts. Let's go step by step and take it from the figure all the way through to the clothed character.

Blouse and Skirt: Front View

This outfit combines a number of popular elements.

- Top with splashy design
- Simple skirt
- Bold leggings
- Trendy shoes
- Vibrant colors.

The rounding off of the hips continues down the thighs.

Wavy hair falls in back and in front of shoulders.

The waist is created with gentle curves.

Legs cross at the knees.

Draw a straight line from the shin to the big toe. (This gives the legs a sleek look.)

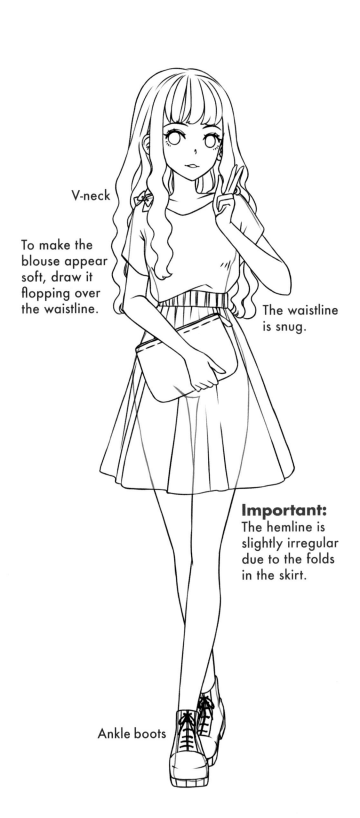

V-neck

To make the blouse appear soft, draw it flopping over the waistline.

The waistline is snug.

Important:
The hemline is slightly irregular due to the folds in the skirt.

Ankle boots

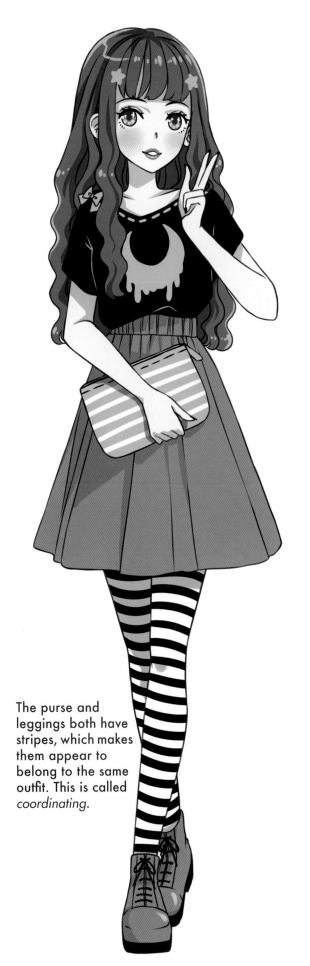

The purse and leggings both have stripes, which makes them appear to belong to the same outfit. This is called *coordinating*.

Side View

Here's a trick to creating variety in an outfit. Combine pieces that fit the body differently. In this example, the blouse is relaxed, the skirt is wide, and the leggings are snug.

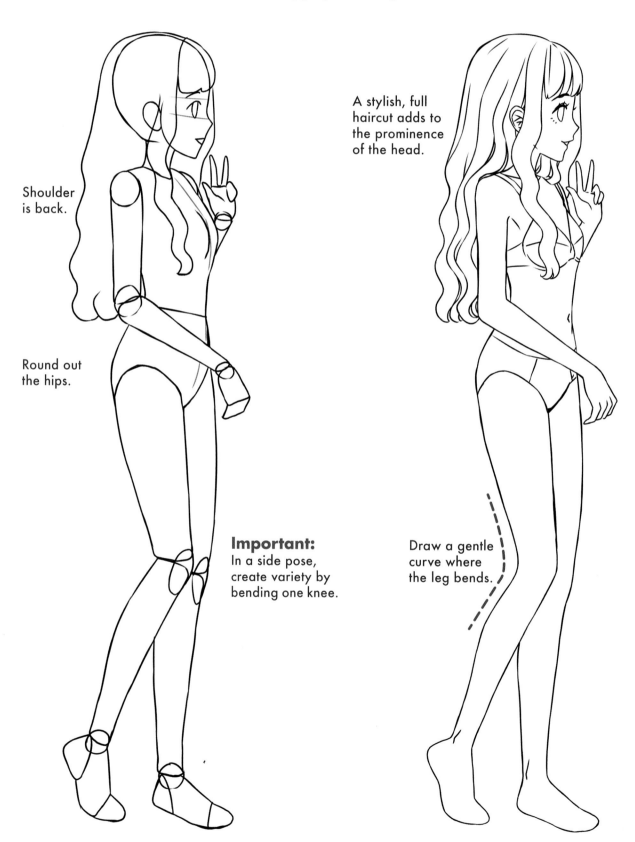

Shoulder is back.

Round out the hips.

Important: In a side pose, create variety by bending one knee.

A stylish, full haircut adds to the prominence of the head.

Draw a gentle curve where the leg bends.

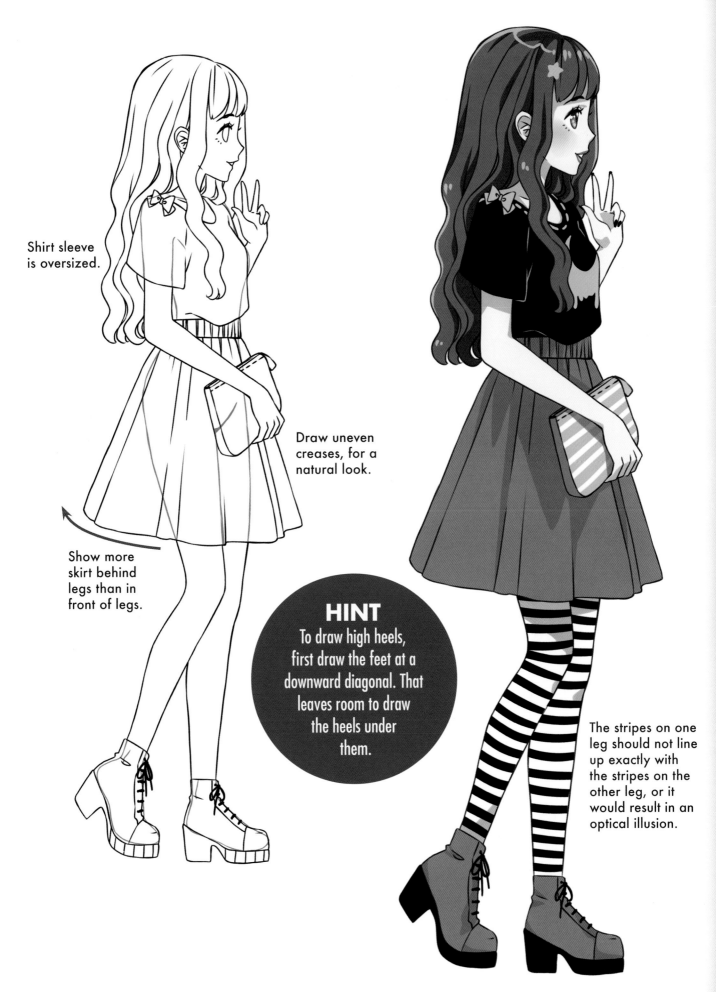

Shirt sleeve is oversized.

Draw uneven creases, for a natural look.

Show more skirt behind legs than in front of legs.

HINT
To draw high heels, first draw the feet at a downward diagonal. That leaves room to draw the heels under them.

The stripes on one leg should not line up exactly with the stripes on the other leg, or it would result in an optical illusion.

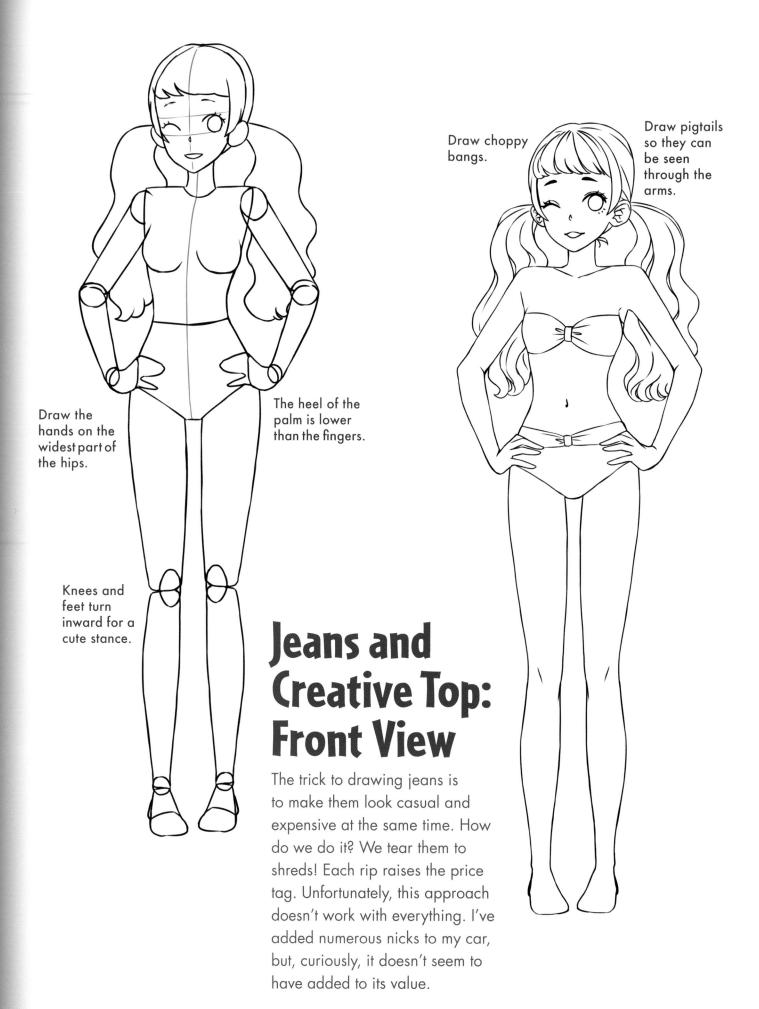

Draw choppy bangs.

Draw pigtails so they can be seen through the arms.

Draw the hands on the widest part of the hips.

The heel of the palm is lower than the fingers.

Knees and feet turn inward for a cute stance.

Jeans and Creative Top: Front View

The trick to drawing jeans is to make them look casual and expensive at the same time. How do we do it? We tear them to shreds! Each rip raises the price tag. Unfortunately, this approach doesn't work with everything. I've added numerous nicks to my car, but, curiously, it doesn't seem to have added to its value.

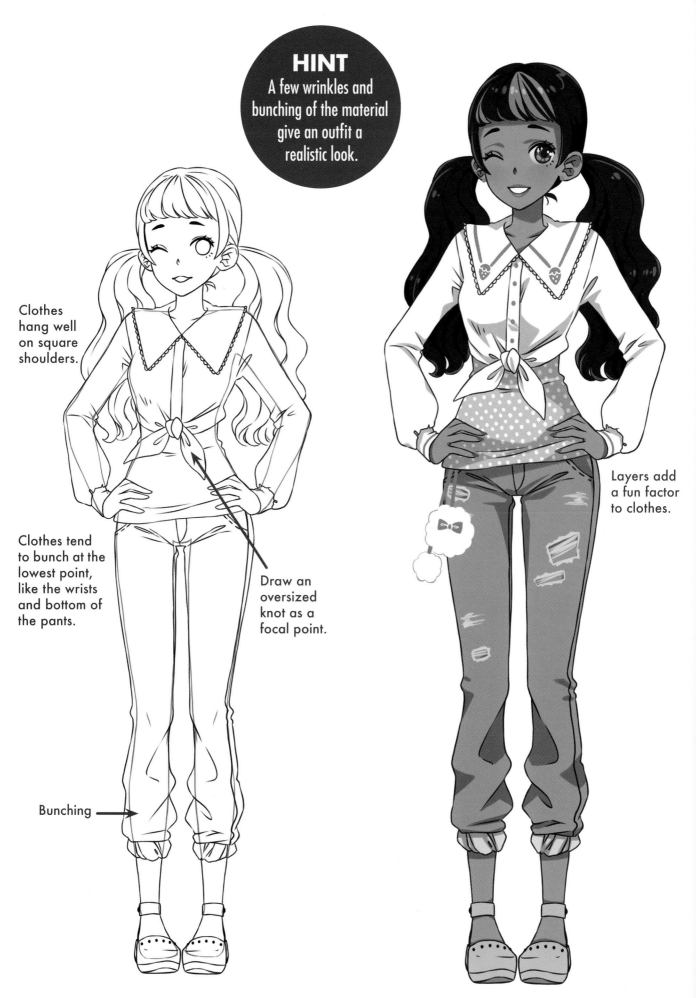

HINT
A few wrinkles and bunching of the material give an outfit a realistic look.

Clothes hang well on square shoulders.

Clothes tend to bunch at the lowest point, like the wrists and bottom of the pants.

Bunching

Draw an oversized knot as a focal point.

Layers add a fun factor to clothes.

Side View

This standing side pose highlights three sections of the torso: chest, midsection, and hips. Youthful bodies are curvy, which makes these segments appear to flow together.

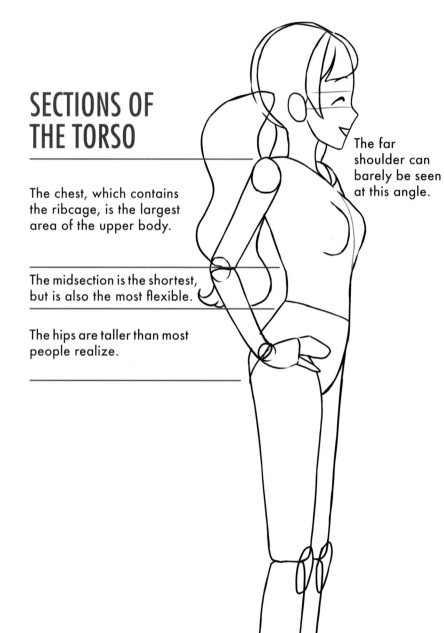

SECTIONS OF THE TORSO

The chest, which contains the ribcage, is the largest area of the upper body.

The midsection is the shortest, but is also the most flexible.

The hips are taller than most people realize.

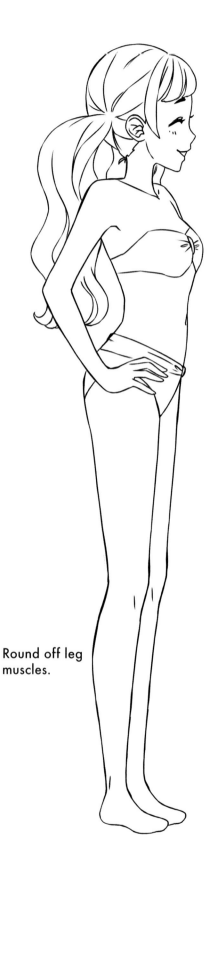

The far shoulder can barely be seen at this angle.

Round off leg muscles.

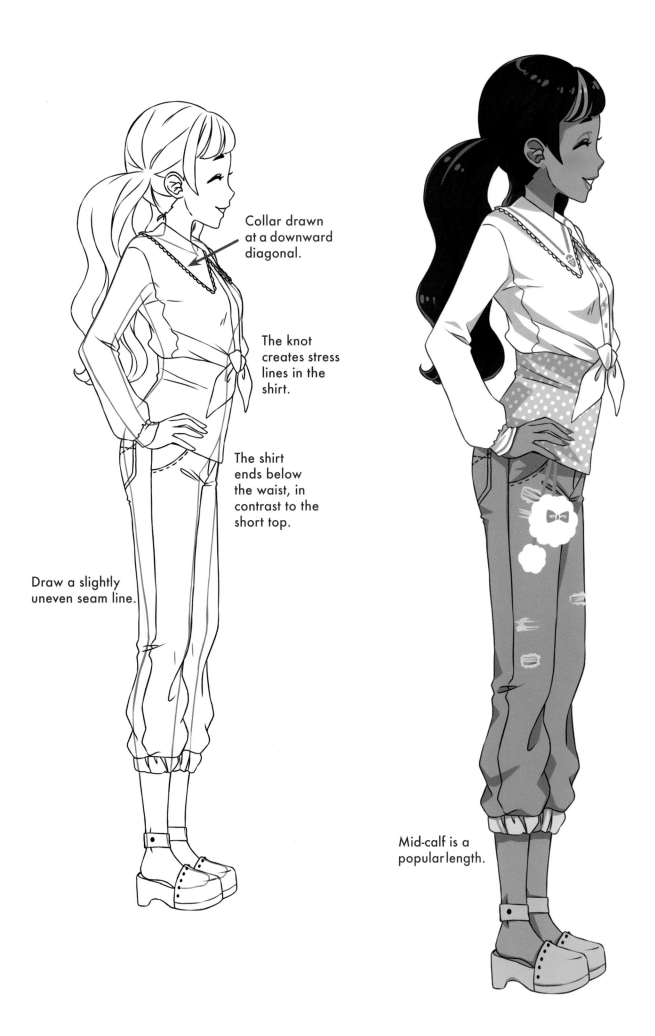

Collar drawn at a downward diagonal.

The knot creates stress lines in the shirt.

The shirt ends below the waist, in contrast to the short top.

Draw a slightly uneven seam line.

Mid-calf is a popular length.

Schoolgirl Uniform: Front View

The schoolgirl uniform is the most popular outfit in all of manga—and a must-know for drawing manga fashions. It's a simple outfit: a jacket, a skirt, and tall socks. Ever wonder why?
It's because within the framework of a uniform, there are many different components to choose from. By combining them in specific ways, you can keep the overall appearance of a uniform while infusing it with individuality, as we'll see in the next chapter!

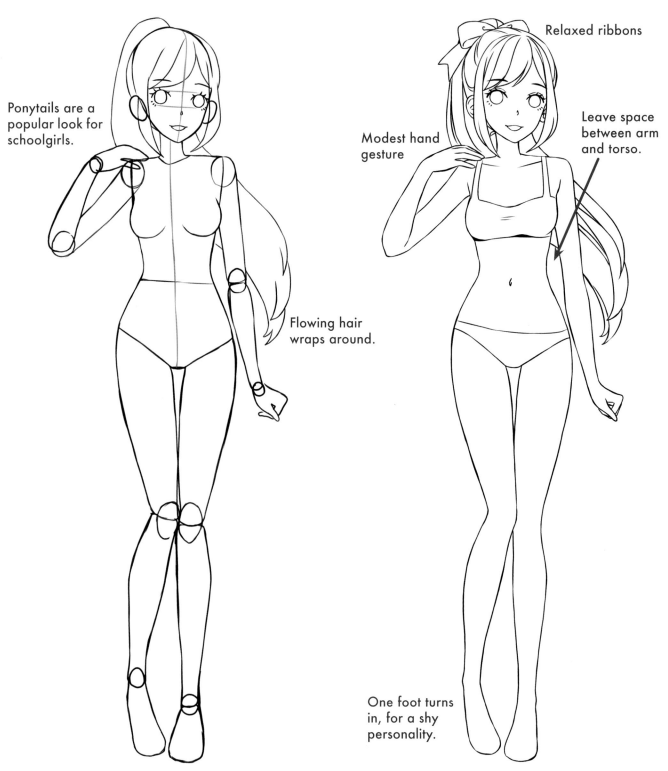

Ponytails are a popular look for schoolgirls.

Flowing hair wraps around.

Relaxed ribbons

Modest hand gesture

Leave space between arm and torso.

One foot turns in, for a shy personality.

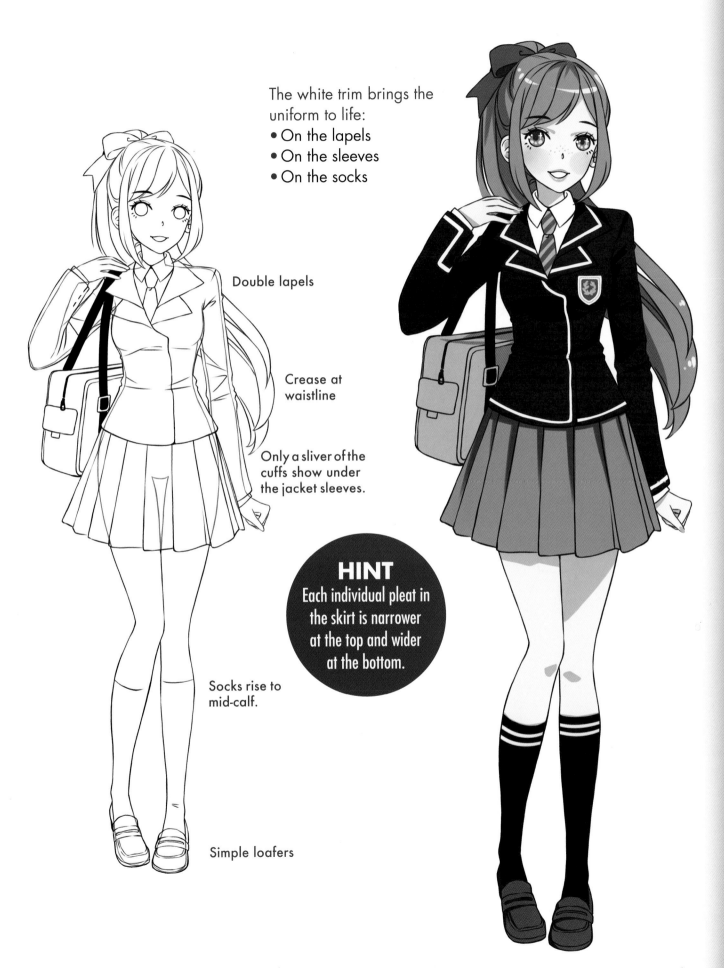

The white trim brings the uniform to life:

- On the lapels
- On the sleeves
- On the socks

Double lapels

Crease at waistline

Only a sliver of the cuffs show under the jacket sleeves.

HINT
Each individual pleat in the skirt is narrower at the top and wider at the bottom.

Socks rise to mid-calf.

Simple loafers

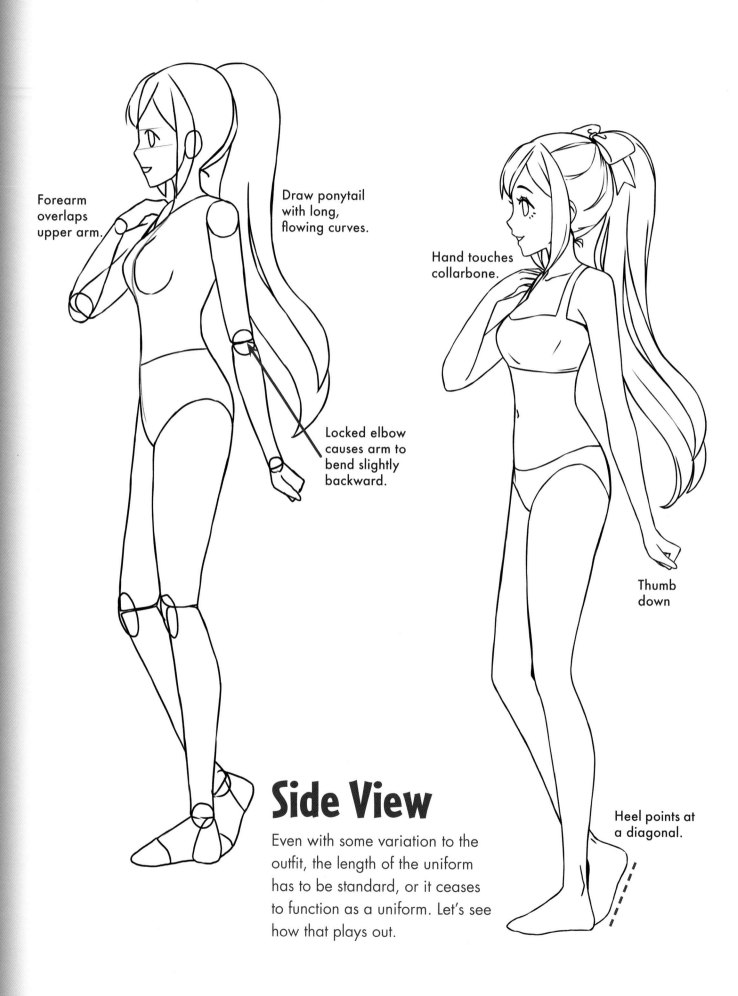

Forearm overlaps upper arm.

Draw ponytail with long, flowing curves.

Locked elbow causes arm to bend slightly backward.

Hand touches collarbone.

Thumb down

Heel points at a diagonal.

Side View

Even with some variation to the outfit, the length of the uniform has to be standard, or it ceases to function as a uniform. Let's see how that plays out.

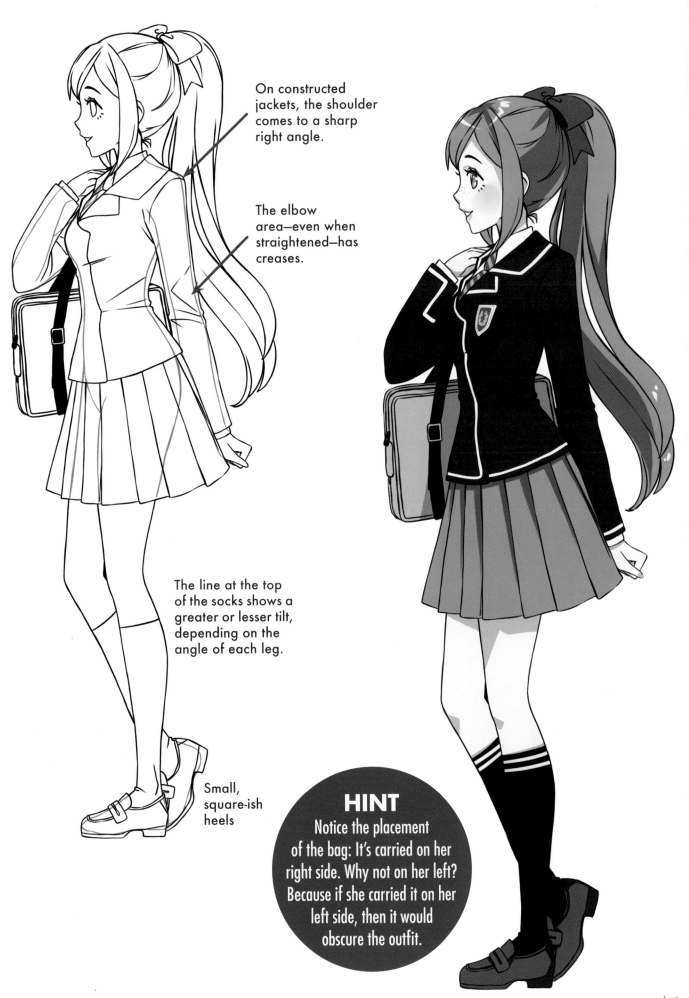

On constructed jackets, the shoulder comes to a sharp right angle.

The elbow area—even when straightened—has creases.

The line at the top of the socks shows a greater or lesser tilt, depending on the angle of each leg.

Small, square-ish heels

HINT
Notice the placement of the bag: It's carried on her right side. Why not on her left? Because if she carried it on her left side, then it would obscure the outfit.

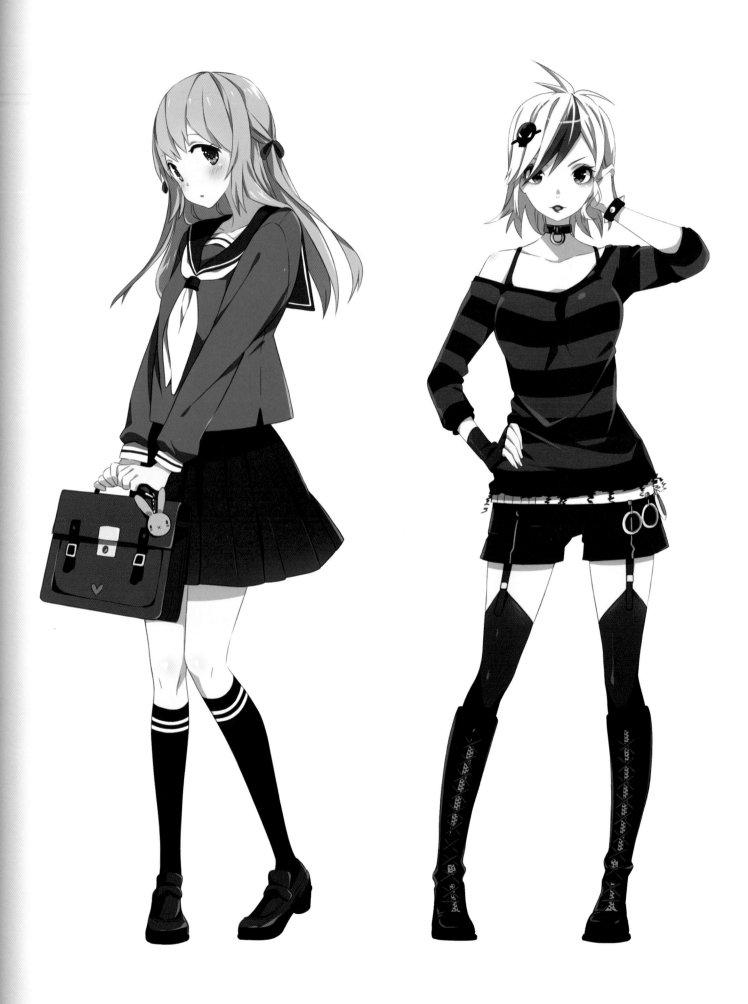

School Uniforms vs. Non-Traditonal Styles

There is no more essential outfit for a manga character than a stylish school uniform. This chapter will show you how to draw all of the popular variations, based on famous character types. It's fun to match fashions to personalities. We'll do this by adjusting the outfits, tinkering with the accessories, and by combining colors, patterns, and trims. Then we'll lose the traditional constraints and push the style envelope with more cool outfits.

SCHOOL COOL

Although the idea of a uniform means a standardized look, manga school uniforms vary greatly in style. Each style helps to establish a character's identity. In this section, you'll learn how small changes in a common fashion can create a popular personality type.

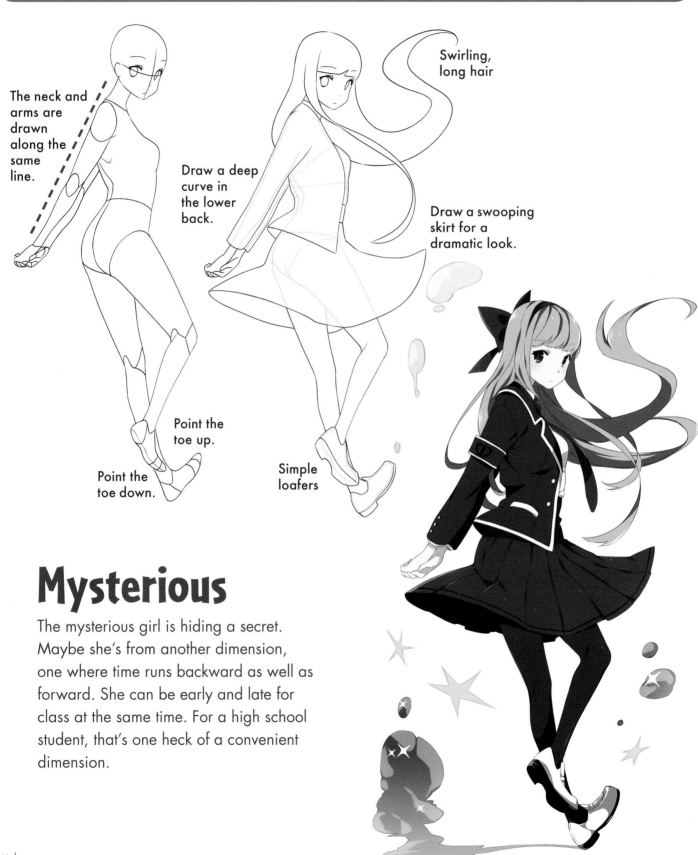

The neck and arms are drawn along the same line.

Draw a deep curve in the lower back.

Point the toe down.

Point the toe up.

Swirling, long hair

Draw a swooping skirt for a dramatic look.

Simple loafers

Mysterious

The mysterious girl is hiding a secret. Maybe she's from another dimension, one where time runs backward as well as forward. She can be early and late for class at the same time. For a high school student, that's one heck of a convenient dimension.

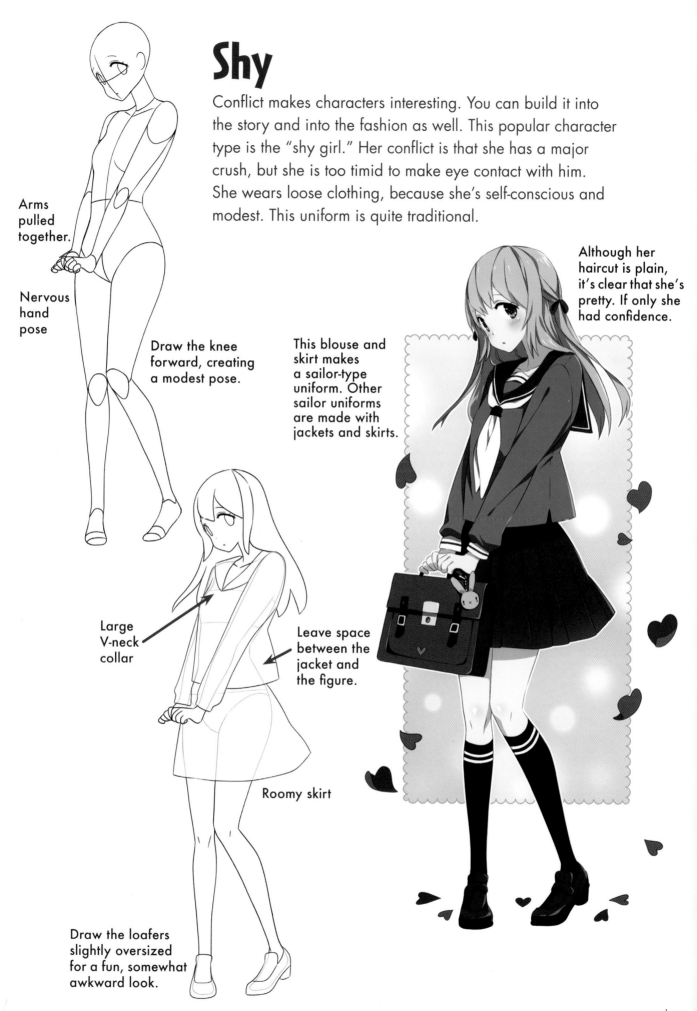

Shy

Conflict makes characters interesting. You can build it into the story and into the fashion as well. This popular character type is the "shy girl." Her conflict is that she has a major crush, but she is too timid to make eye contact with him. She wears loose clothing, because she's self-conscious and modest. This uniform is quite traditional.

Arms pulled together.

Nervous hand pose

Draw the knee forward, creating a modest pose.

This blouse and skirt makes a sailor-type uniform. Other sailor uniforms are made with jackets and skirts.

Although her haircut is plain, it's clear that she's pretty. If only she had confidence.

Large V-neck collar

Leave space between the jacket and the figure.

Roomy skirt

Draw the loafers slightly oversized for a fun, somewhat awkward look.

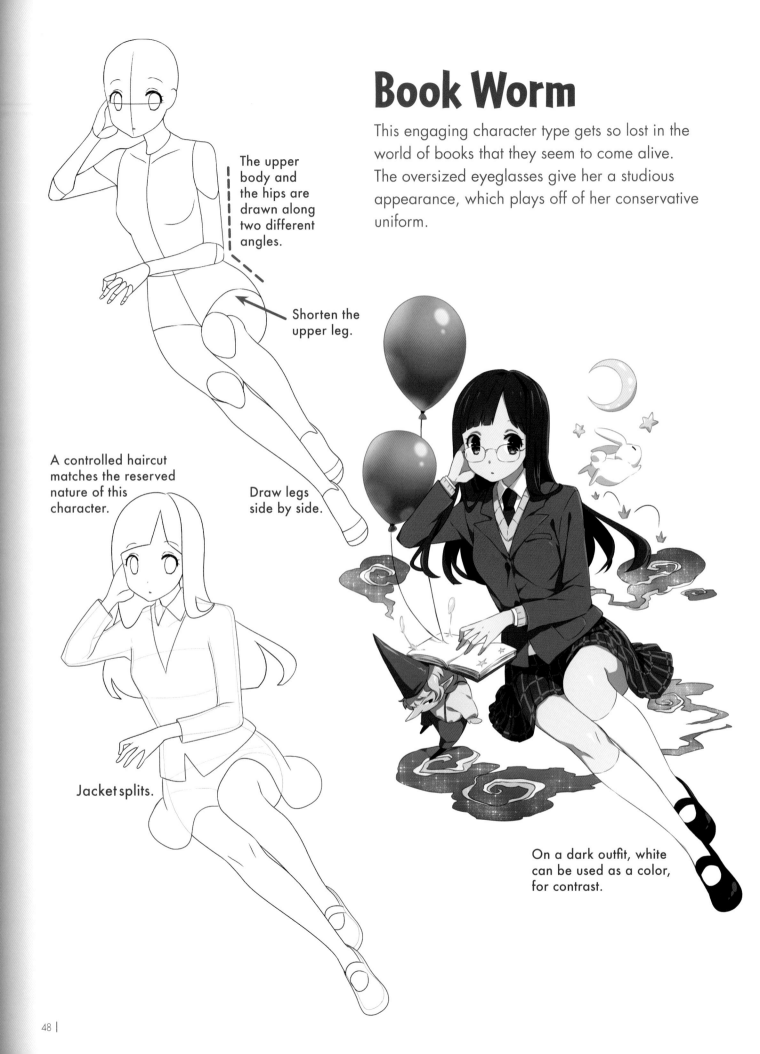

The upper body and the hips are drawn along two different angles.

Shorten the upper leg.

Book Worm

This engaging character type gets so lost in the world of books that they seem to come alive. The oversized eyeglasses give her a studious appearance, which plays off of her conservative uniform.

A controlled haircut matches the reserved nature of this character.

Draw legs side by side.

Jacket splits.

On a dark outfit, white can be used as a color, for contrast.

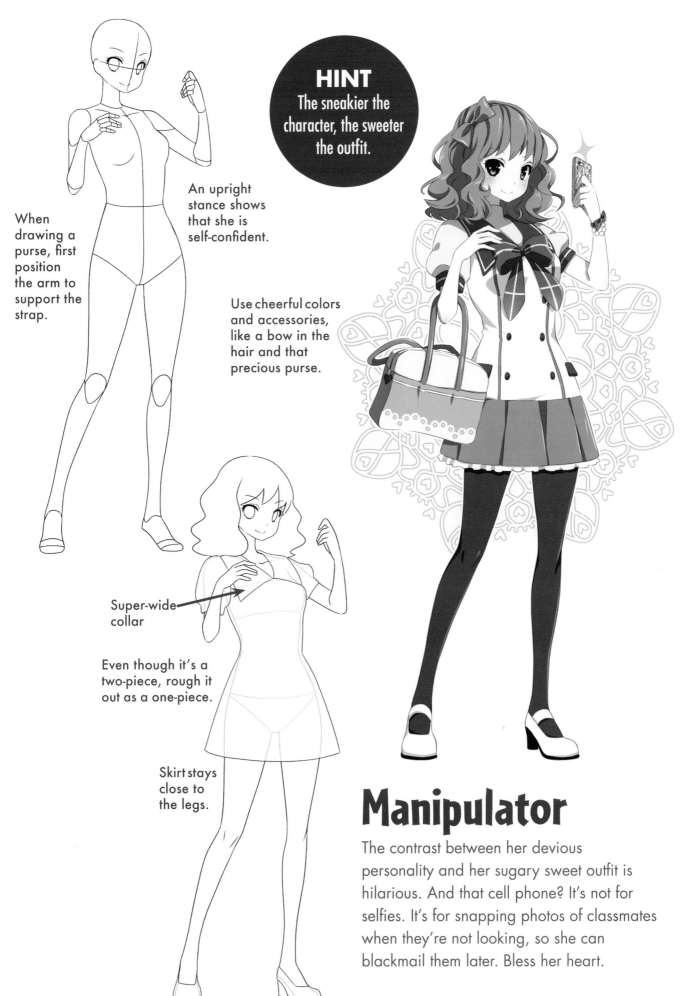

When drawing a purse, first position the arm to support the strap.

An upright stance shows that she is self-confident.

HINT
The sneakier the character, the sweeter the outfit.

Use cheerful colors and accessories, like a bow in the hair and that precious purse.

Super-wide collar

Even though it's a two-piece, rough it out as a one-piece.

Skirt stays close to the legs.

Manipulator

The contrast between her devious personality and her sugary sweet outfit is hilarious. And that cell phone? It's not for selfies. It's for snapping photos of classmates when they're not looking, so she can blackmail them later. Bless her heart.

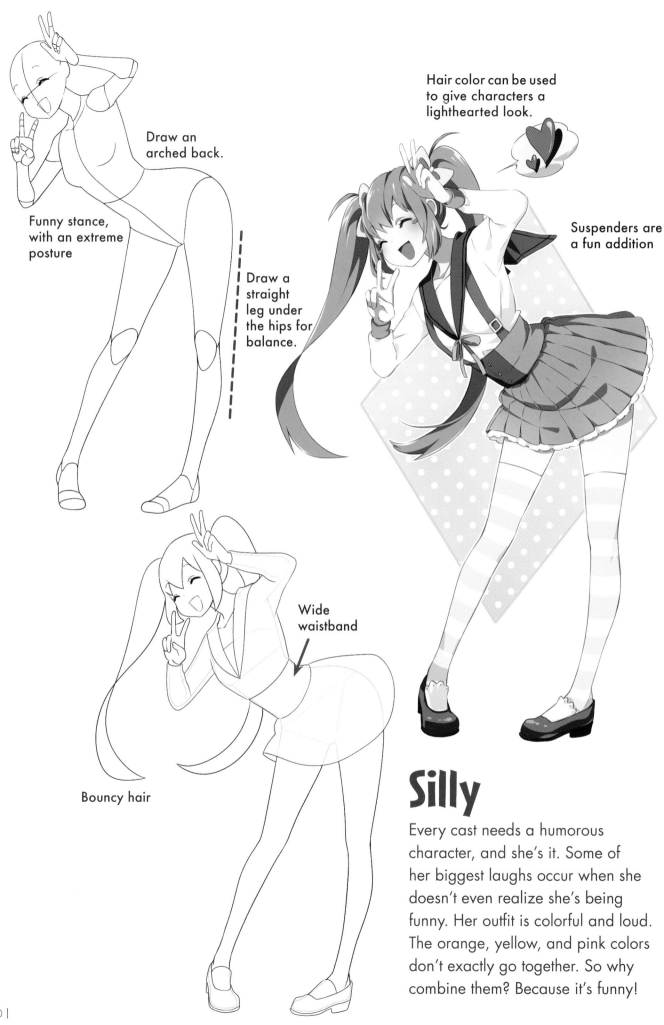

Draw an arched back.

Funny stance, with an extreme posture

Draw a straight leg under the hips for balance.

Hair color can be used to give characters a lighthearted look.

Suspenders are a fun addition

Wide waistband

Bouncy hair

Silly

Every cast needs a humorous character, and she's it. Some of her biggest laughs occur when she doesn't even realize she's being funny. Her outfit is colorful and loud. The orange, yellow, and pink colors don't exactly go together. So why combine them? Because it's funny!

Head faces
page-left.

Honest

Good-natured characters are important, because they set a moral baseline from which the other characters inevitably deviate! An honest look is pretty but also modest. The colors are neutral. She doesn't want the spotlight. She's just happy to stay behind and clean the classroom. What planet is she from?

Body faces
page-right.

A few folds
gather at
the waist.

Sweater is
low on hips.

Sleeves at ¾
length (Show
the cuffs in
final step.)

Short,
pleated
skirt

Thick sole

Green shoelaces
are a fun addition.

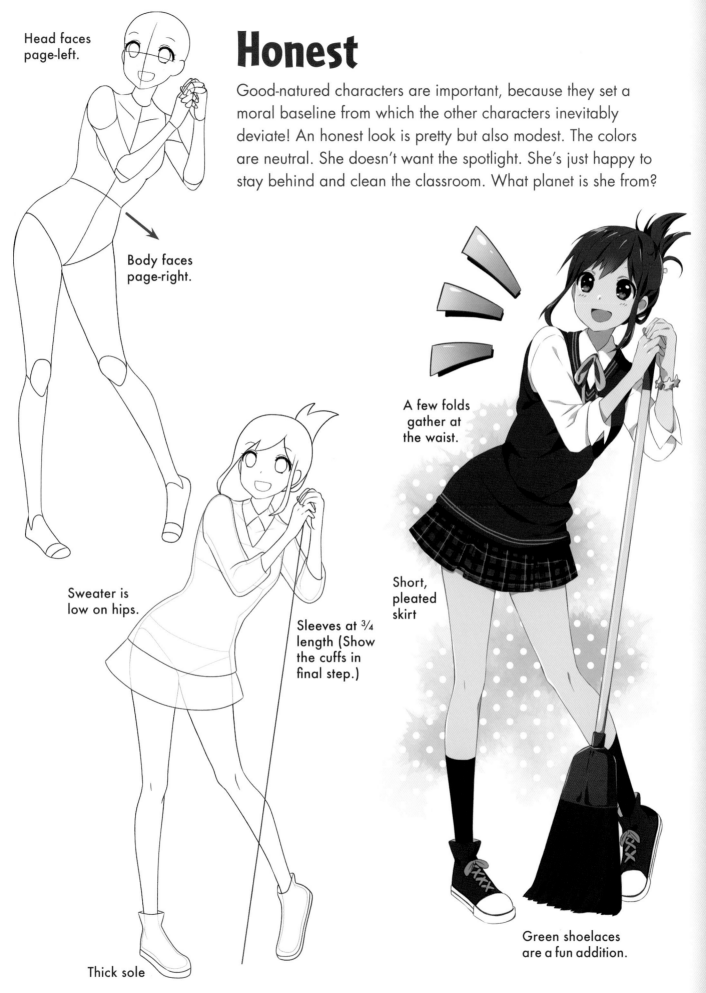

TRENDY OUTFITS

If school uniforms are traditional, then these outfits are the opposite. Here, you'll learn how to coordinate unlikely pieces to turn them into spellbinding outfits. The styles are a step above subculture, so they push the envelope of mainstream fashion. These cutting edge looks provide good contrast to schoolgirl characters.

Dark and Cute

The devilish hat has harmless, little horns. The large, white shapes on the cape are actually features that create a ghost-like face. Matching gloves, bags, and shoes complete the look.

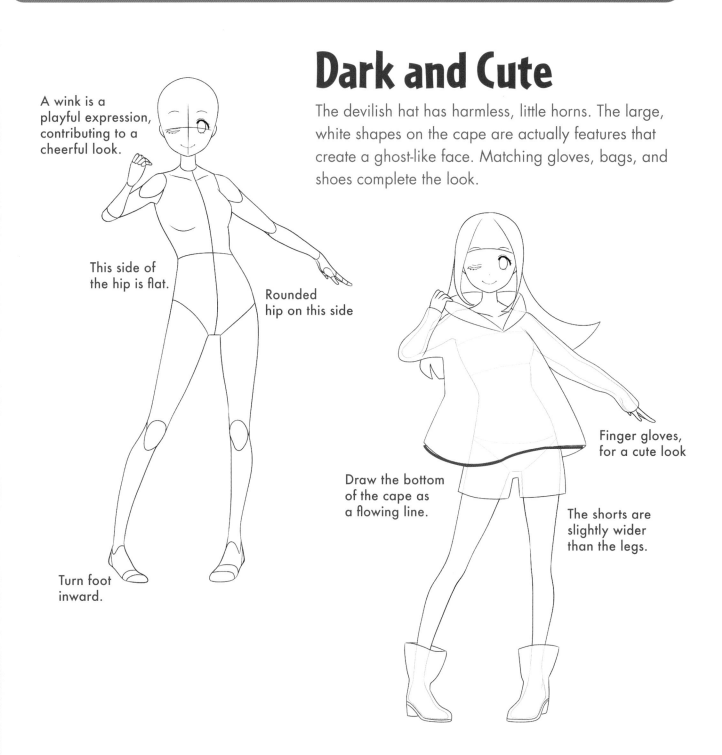

A wink is a playful expression, contributing to a cheerful look.

This side of the hip is flat.

Rounded hip on this side

Turn foot inward.

Finger gloves, for a cute look

Draw the bottom of the cape as a flowing line.

The shorts are slightly wider than the legs.

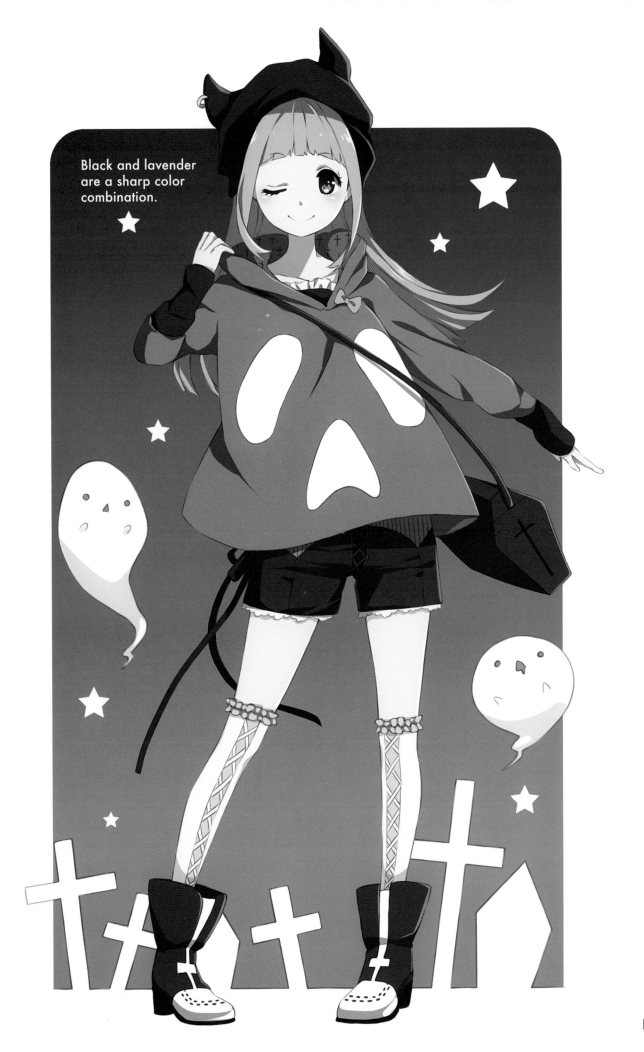

Black and lavender are a sharp color combination.

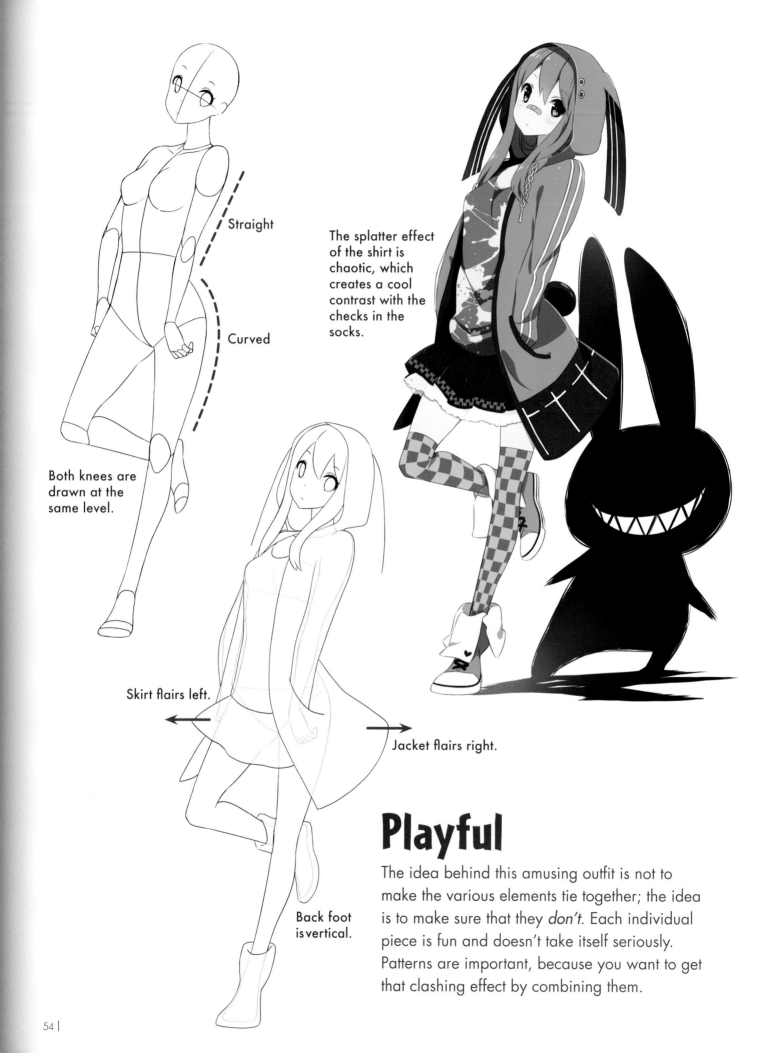

Straight

Curved

Both knees are drawn at the same level.

The splatter effect of the shirt is chaotic, which creates a cool contrast with the checks in the socks.

Skirt flairs left.

Jacket flairs right.

Back foot is vertical.

Playful

The idea behind this amusing outfit is not to make the various elements tie together; the idea is to make sure that they *don't*. Each individual piece is fun and doesn't take itself seriously. Patterns are important, because you want to get that clashing effect by combining them.

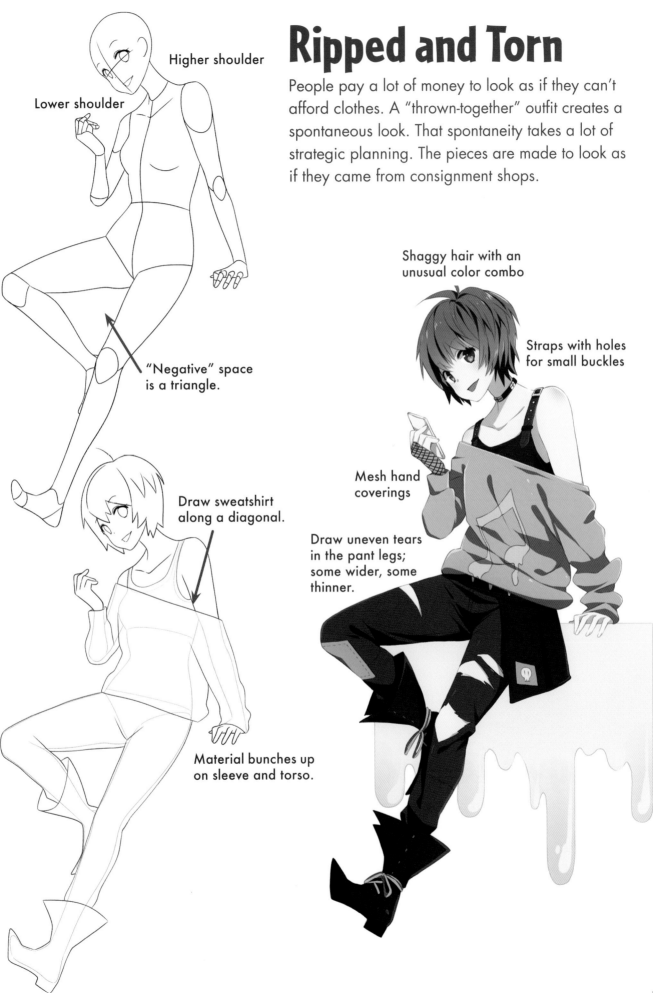

Ripped and Torn

People pay a lot of money to look as if they can't afford clothes. A "thrown-together" outfit creates a spontaneous look. That spontaneity takes a lot of strategic planning. The pieces are made to look as if they came from consignment shops.

Higher shoulder

Lower shoulder

"Negative" space is a triangle.

Draw sweatshirt along a diagonal.

Material bunches up on sleeve and torso.

Shaggy hair with an unusual color combo

Straps with holes for small buckles

Mesh hand coverings

Draw uneven tears in the pant legs; some wider, some thinner.

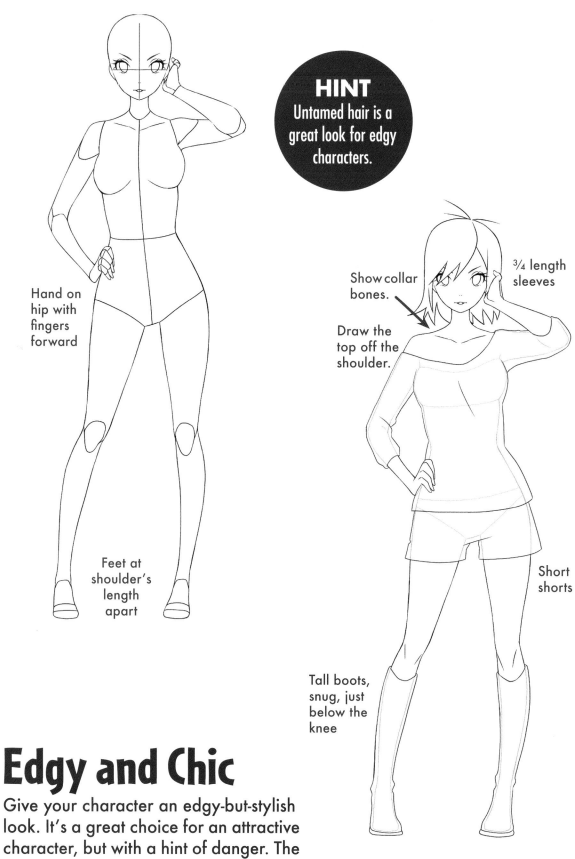

HINT
Untamed hair is a great look for edgy characters.

Hand on hip with fingers forward

Feet at shoulder's length apart

Show collar bones.

Draw the top off the shoulder.

¾ length sleeves

Short shorts

Tall boots, snug, just below the knee

Edgy and Chic

Give your character an edgy-but-stylish look. It's a great choice for an attractive character, but with a hint of danger. The style is severe, the patterns are bold, and the colors are vivid. (Black and red is always an intense color combo.)

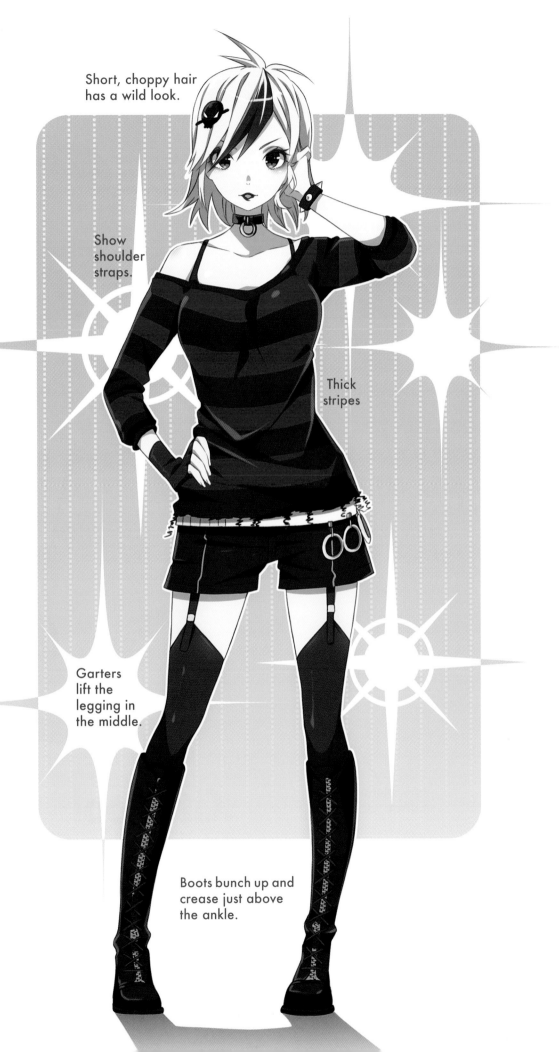

Short, choppy hair
has a wild look.

Show
shoulder
straps.

Thick
stripes

Garters
lift the
legging in
the middle.

Boots bunch up and
crease just above
the ankle.

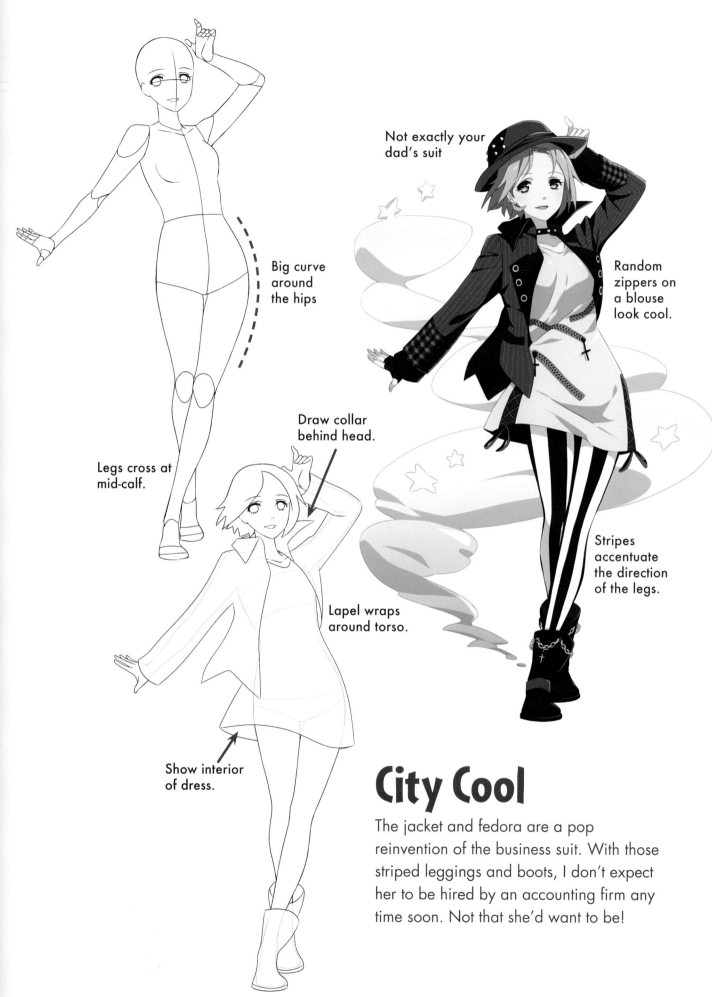

Big curve around the hips

Legs cross at mid-calf.

Draw collar behind head.

Not exactly your dad's suit

Random zippers on a blouse look cool.

Lapel wraps around torso.

Show interior of dress.

Stripes accentuate the direction of the legs.

City Cool

The jacket and fedora are a pop reinvention of the business suit. With those striped leggings and boots, I don't expect her to be hired by an accounting firm any time soon. Not that she'd want to be!

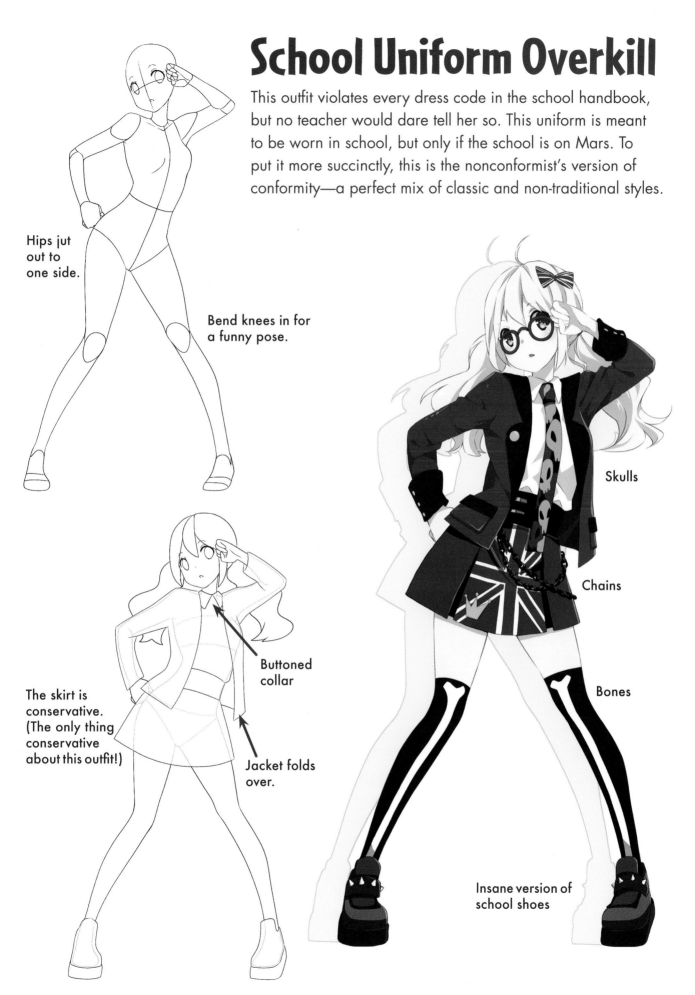

School Uniform Overkill

This outfit violates every dress code in the school handbook, but no teacher would dare tell her so. This uniform is meant to be worn in school, but only if the school is on Mars. To put it more succinctly, this is the nonconformist's version of conformity—a perfect mix of classic and non-traditional styles.

Hips jut out to one side.

Bend knees in for a funny pose.

The skirt is conservative. (The only thing conservative about this outfit!)

Buttoned collar

Jacket folds over.

Skulls

Chains

Bones

Insane version of school shoes

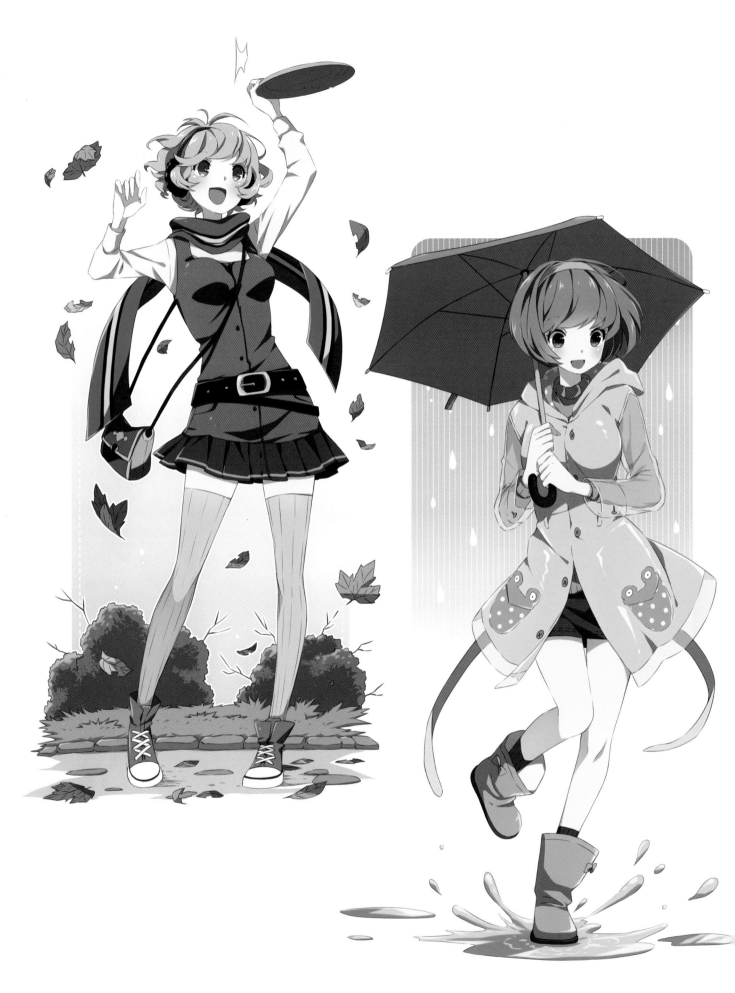

Seasonal...

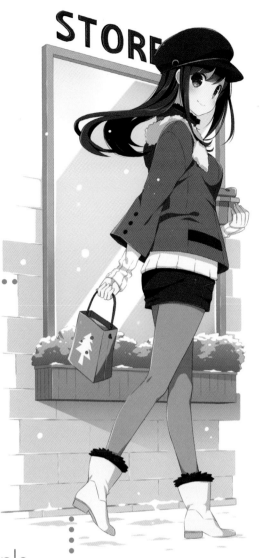

Seasons provide great opportunities for fashion themes. Each season offers something unique: summer for the beach, fall for apple picking, winter for holidays, and spring for paying taxes. (Note to self: need better example for spring!) Each season features unique color schemes as well. And weather effects, which we'll include, turn fashion poses into fun scenes.

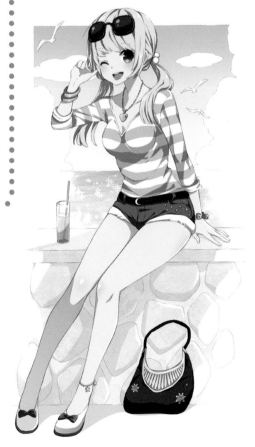

AUTUMN

The fall is filled with romance. Couples ride horse-drawn carriages through the park. Leaves swirl down from the trees. Outfits are alive with yellow, orange, and red colors in layers of clothing. It's a time for stopping at your local coffee franchise for a scalding hot chocolate with 1,200 calories worth of whipped cream. And, of course, there are festive holiday dinners with the relatives you've been avoiding all year.

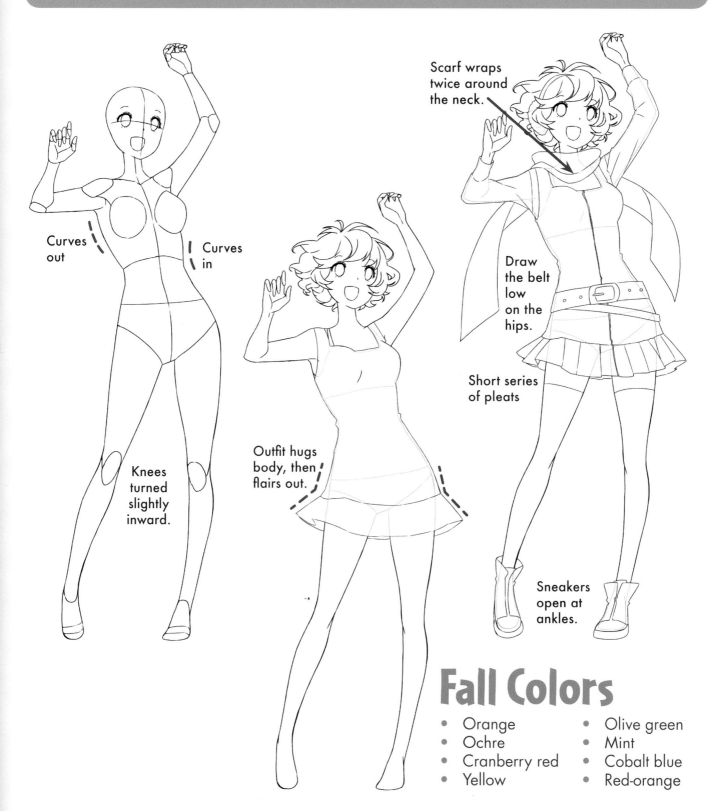

Curves out

Curves in

Knees turned slightly inward.

Outfit hugs body, then flairs out.

Scarf wraps twice around the neck.

Draw the belt low on the hips.

Short series of pleats

Sneakers open at ankles.

Fall Colors

- Orange
- Ochre
- Cranberry red
- Yellow
- Olive green
- Mint
- Cobalt blue
- Red-orange

HINT
You should be able to tell which season it is by the clothes your character is wearing.

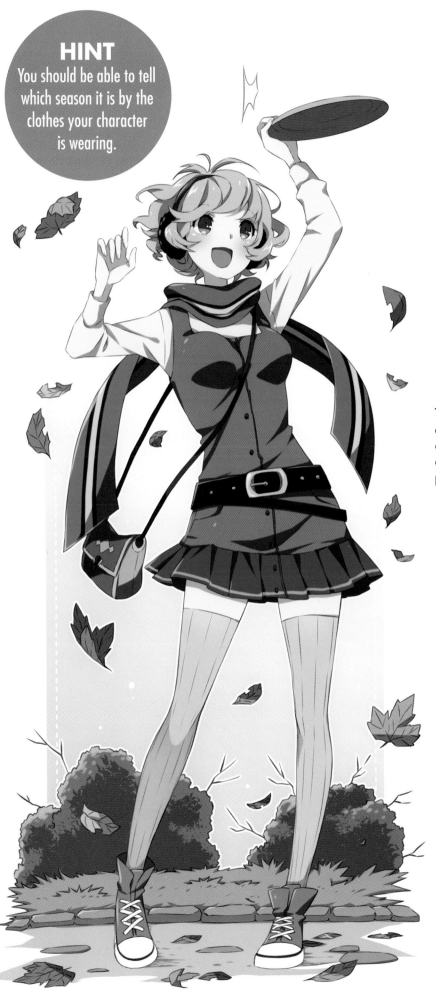

DETAILS: DRAW THE PURSE

Start with an unstructured form.

The flap is drawn ⅔rds of the way down the purse.

Shade the near side.

Add trim and decorate.

WINTER

Winter presents the same fashion problem for women each year: should I go for warmth or style? Here, we see a typical manga girl who, though chilled to the bone, looks quite chic in her short winter jacket. Layers are essential in winter, which is why a light sweater can be seen under the jacket. Draw a hat that matches the jacket, so that you're creating an outfit, not random pieces.

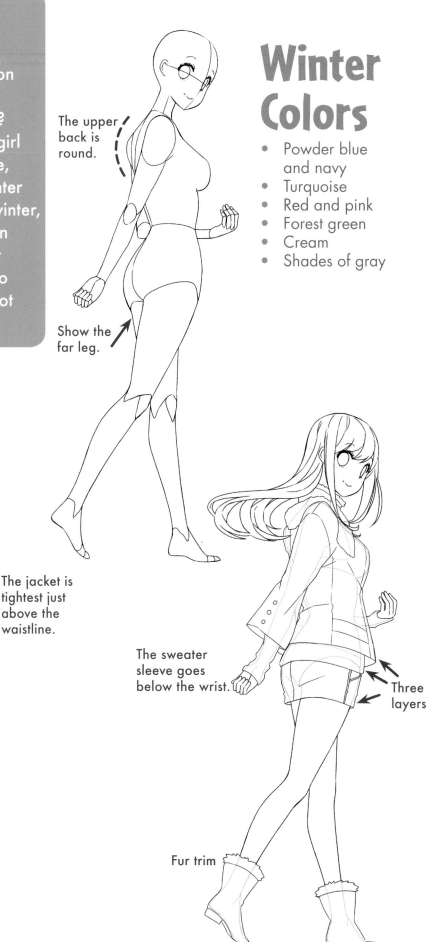

The upper back is round.

Show the far leg.

Winter Colors

- Powder blue and navy
- Turquoise
- Red and pink
- Forest green
- Cream
- Shades of gray

Narrow part of sleeve

Wide part of sleeve

The jacket is tightest just above the waistline.

The sweater sleeve goes below the wrist.

Three layers

Fur trim

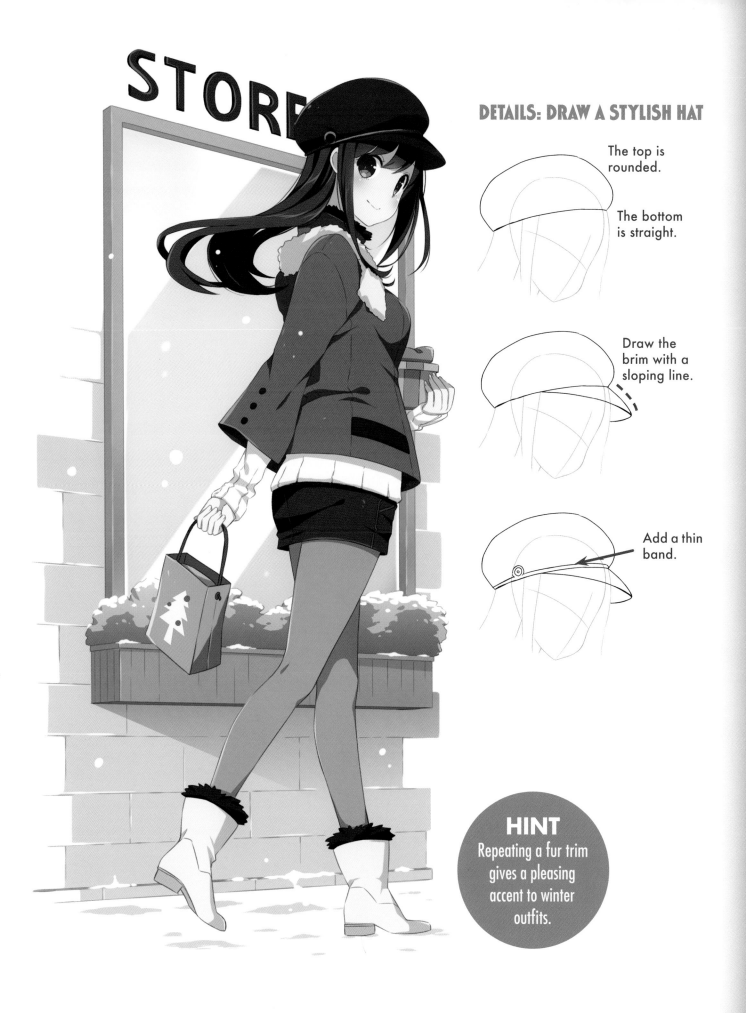

STORE

DETAILS: DRAW A STYLISH HAT

The top is rounded.

The bottom is straight.

Draw the brim with a sloping line.

Add a thin band.

HINT
Repeating a fur trim gives a pleasing accent to winter outfits.

SPRING

Like flowers in bloom, spring clothes are colorful. But spring is also a rainy season. After having been cooped up for months, people are undeterred by a little precipitation. They grab their umbrellas, stroll through the rain, and jump into puddles that splash on everyone else's outfits.

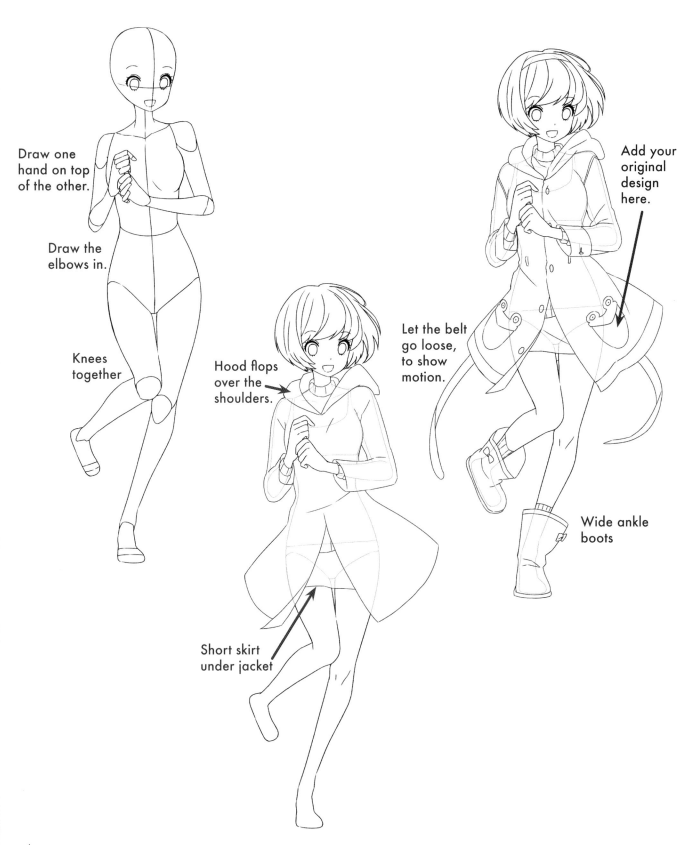

Draw one hand on top of the other.

Draw the elbows in.

Knees together

Hood flops over the shoulders.

Short skirt under jacket

Let the belt go loose, to show motion.

Add your original design here.

Wide ankle boots

Spring Colors

- Yellow
- Magenta
- Aqua green
- Coral
- Taupe
- Ice blue
- Lime green
- Sand

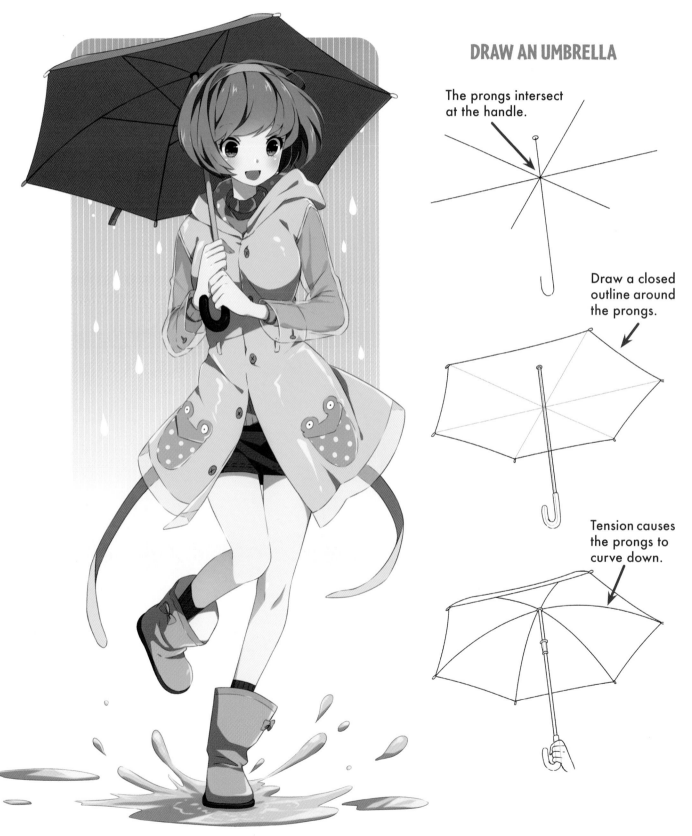

DRAW AN UMBRELLA

The prongs intersect at the handle.

Draw a closed outline around the prongs.

Tension causes the prongs to curve down.

SUMMER

Blue skies, white clouds, and glimmering seas are made for summer fashions. Combine bright clothes with bold patterns for a sunny look. Notice how her white and blue top matches the white and blue of the sky and sea.

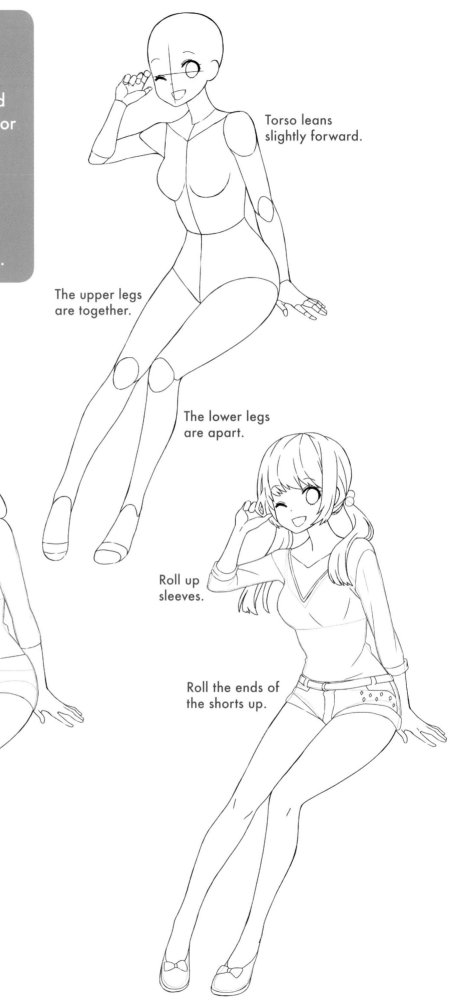

Torso leans slightly forward.

The upper legs are together.

The lower legs are apart.

V-collar

Shorts are worn low on the waist.

Roll up sleeves.

Roll the ends of the shorts up.

Summer Colors

- White
- Yellow-green
- Sky blue
- Gray
- Black

- Cyan
- Cerulean blue
- Neon pink
- Sand

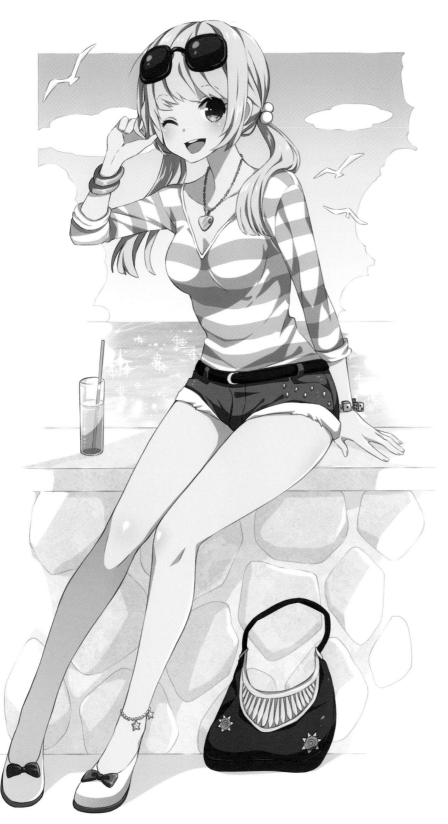

DRAW SUNGLASSES

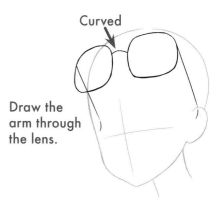

Curved

Draw the arm through the lens.

Draw the frames thinner on top...

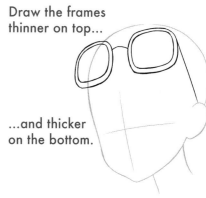

...and thicker on the bottom.

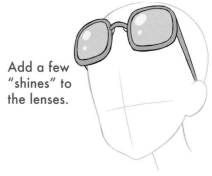

Add a few "shines" to the lenses.

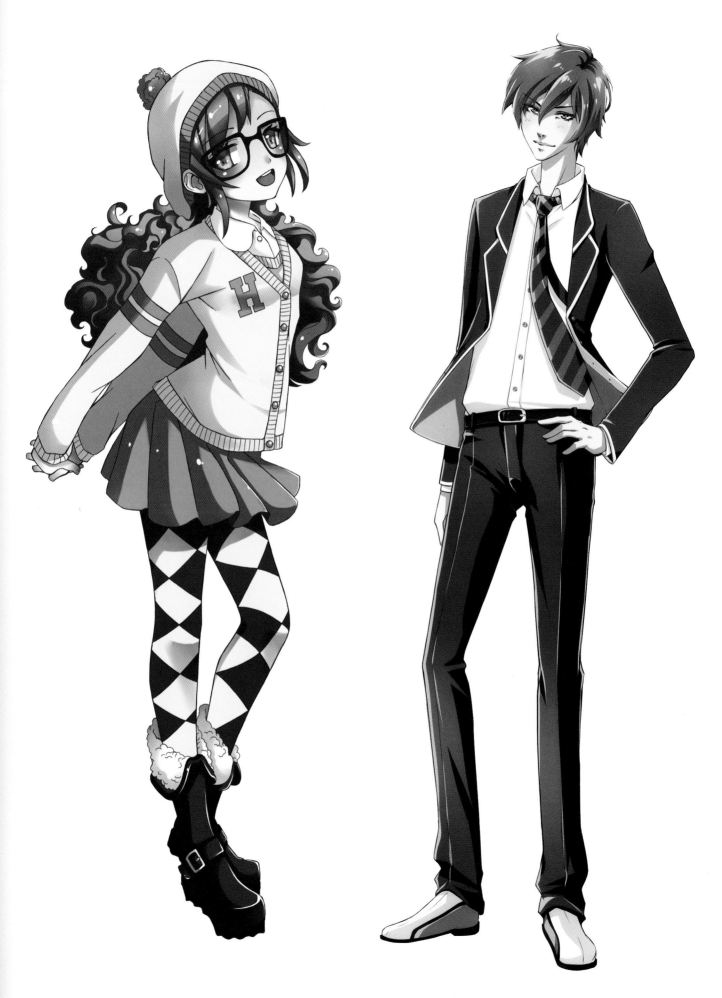

Fun With Fashion

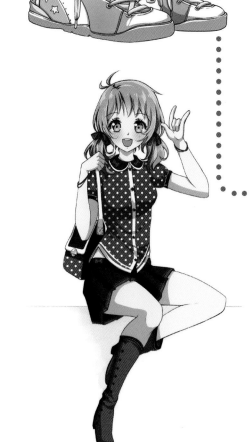

So far, we've been drawing established styles and genres. But people also choose to dress impulsively, reaching for this top or that skirt, and whipping something together—especially if they are on the go. Picture your character going through her closet and selecting her favorite casual items. She could be going to see some friends, taking her dog for a walk, or going to a movie.

We'll also learn to draw classic fashion poses, and we'll even add some male characters to the mix.

LOOSE TOP AND BELL BOTTOMS

This casual outfit is still smartly coordinated. The top is white and flowing, which gives it a silky look. Bell-bottoms are always in style.

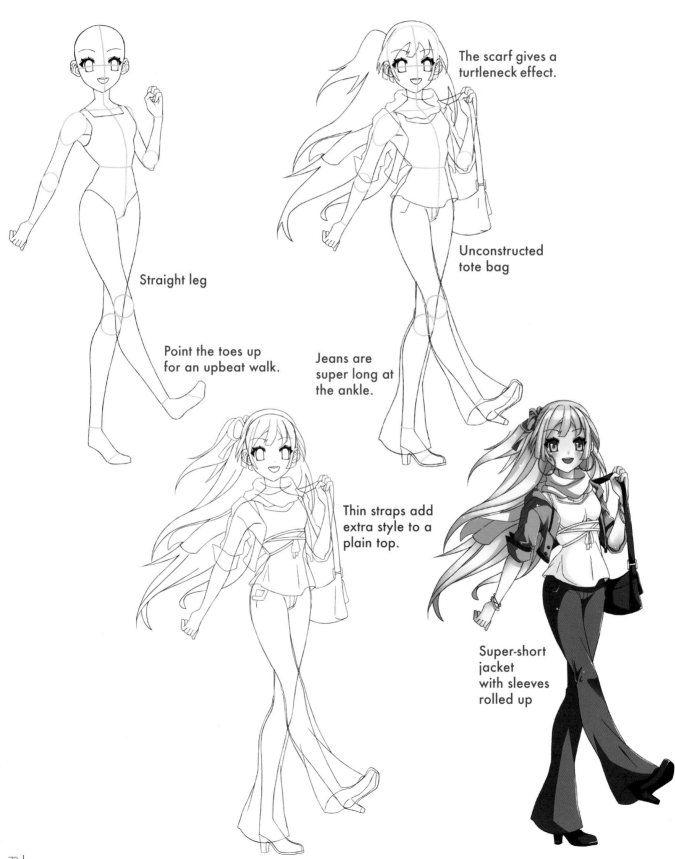

Straight leg

Point the toes up for an upbeat walk.

The scarf gives a turtleneck effect.

Unconstructed tote bag

Jeans are super long at the ankle.

Thin straps add extra style to a plain top.

Super-short jacket with sleeves rolled up

This is an artsy look. Suspenders and a beret add an unconventional touch to the outfit. And those tears at the knees were actually created by her, rather than the manufacturer. What an amazing concept.

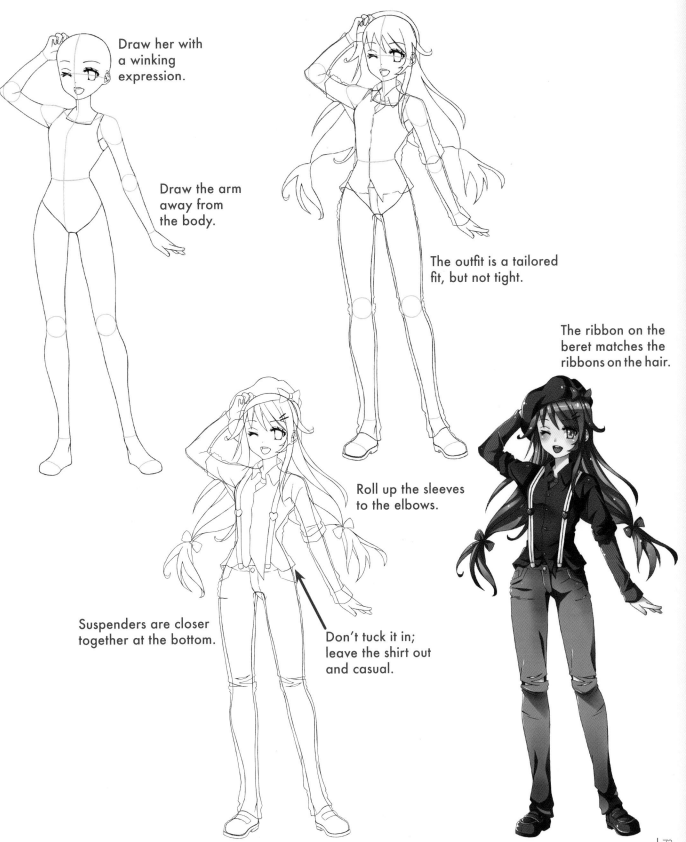

Draw her with a winking expression.

Draw the arm away from the body.

The outfit is a tailored fit, but not tight.

The ribbon on the beret matches the ribbons on the hair.

Roll up the sleeves to the elbows.

Suspenders are closer together at the bottom.

Don't tuck it in; leave the shirt out and casual.

CUTE DRESS

This dress strikes a happy medium between a proper look and a stylish look. The blouse has a buttoned collar and puffed up shoulders, but the dress is less tame, due to the color and the length. It's a spirited combination that doesn't look too crazy.

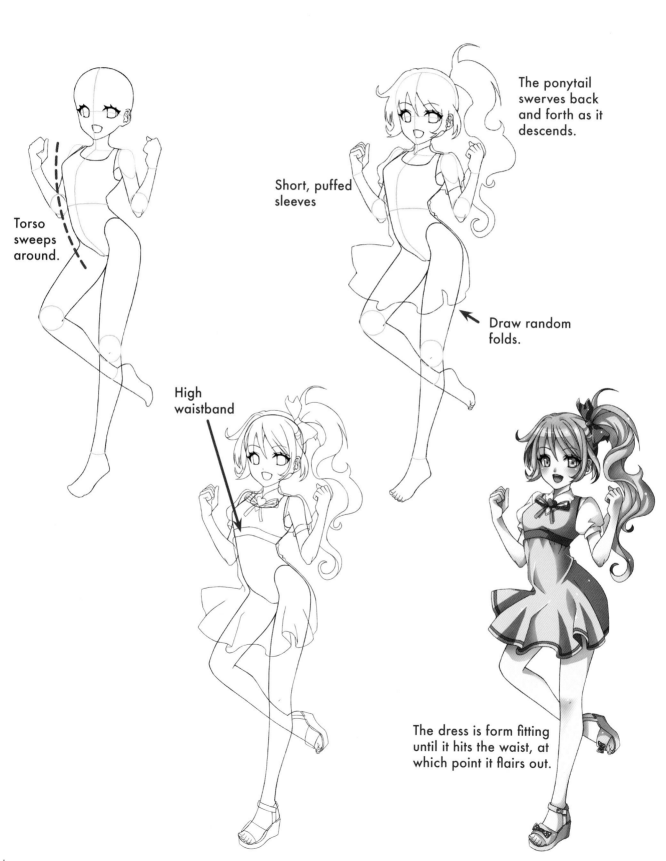

Torso sweeps around.

The ponytail swerves back and forth as it descends.

Short, puffed sleeves

Draw random folds.

High waistband

The dress is form fitting until it hits the waist, at which point it flairs out.

Go Hamsters! Okay, so the school could have come up with a better name for its football team. Nonetheless, combining a school uniform with jazzy elements is a good way to refresh and reinvent this popular school type.

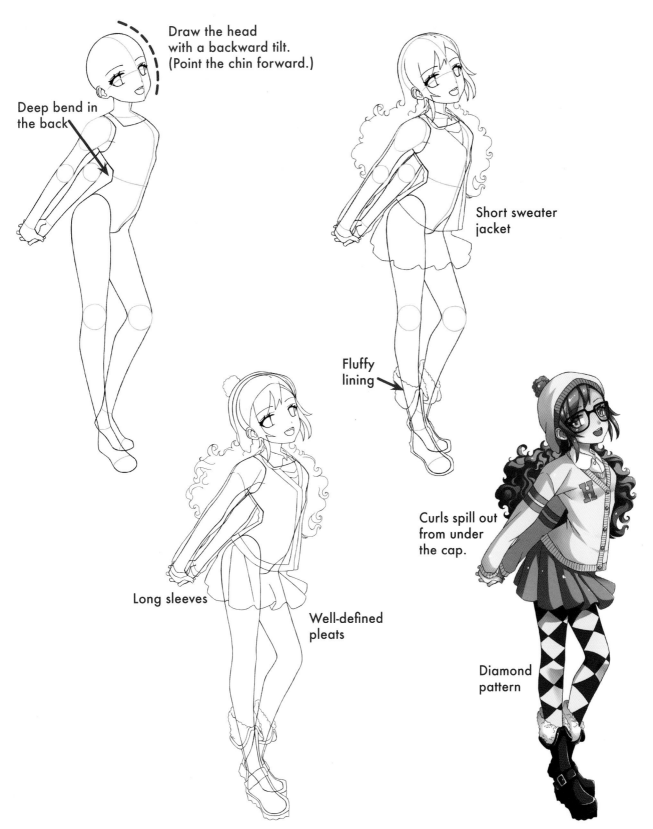

Draw the head with a backward tilt. (Point the chin forward.)

Deep bend in the back

Short sweater jacket

Fluffy lining

Curls spill out from under the cap.

Long sleeves

Well-defined pleats

Diamond pattern

NEKO POP

This catchy outfit touches on the *Neko* theme. Neko means *cat* in Japanese. Adding cat ears to an outfit is an easy way to infuse fun into your character's fashions. Audiences love it. Here, the Neko theme is repeated three times: on the hood, the shirt, and the leggings.

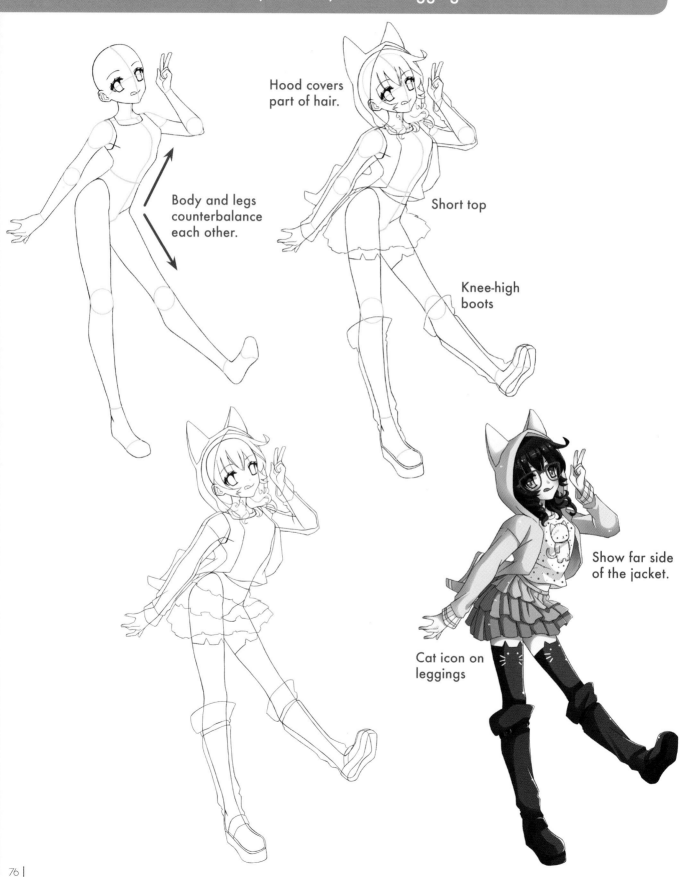

Body and legs counterbalance each other.

Hood covers part of hair.

Short top

Knee-high boots

Show far side of the jacket.

Cat icon on leggings

Shoes are the nerve center of fashion. They say a lot about the character wearing them. One pair of shoes says, "I'm a conscientious schoolgirl," while another shouts, "I defy traditions." By drawing fashionable shoes, you finish an outfit with style. Let's look at some snazzy examples.

Draw a straight line from the heel to the bottom of the post.

Leave extra length at the toe.

Draw a sharp arch.

The sole is drawn as a separate layer.

Point at which the shoes crease

Shoes—as cool as you can stand it.

Foot Structure Meets Shoe Structure

High-end shoes are super fashionable. But they can also be instruments of torture to the female foot. Let's see if we can make them more comfortable. Start by establishing the contour of the foot. Then draw the shoes to accommodate the shape.

Fun Footwear

Colors and cool designs aren't just for clothing. Check out these designs for shoes, sneakers, sandals, and boots.

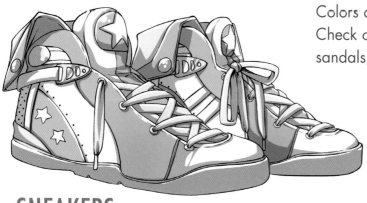

SNEAKERS

Sneakers are assembled in segments. Each color represents a different segment.

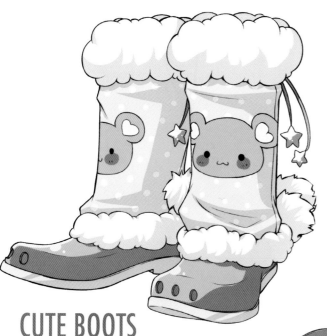

CUTE BOOTS

Adorable boots are made for playfulness and fun. The decorations give them a candy store look.

HIGH BOOTS

These skyscraper-tall laces become a design element. The plaid is bold, and the rubber soles lift off the ground.

HIGH-HEELED SANDALS

The straps create the design. But if you look closely, you'll see they're not really sandals at all, but open shoes with the top removed.

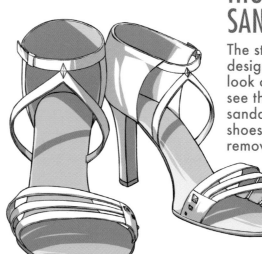

EVENING SHOES

Notice the sleek and sensual lines. The height of the shoe puts pressure on the balls of the feet, causing that part of the shoe to widen.

You don't have to wear stiletto heels to be cool– but it doesn't hurt, either. These edgy shoes and boots combine danger and style.

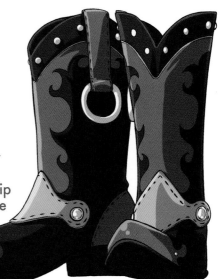

COWBOY BOOTS

A good pair of Western boots never goes out of style. Draw a dramatic design up the leg of the boots. The tip curls up to reveal the sole. Add some hardware.

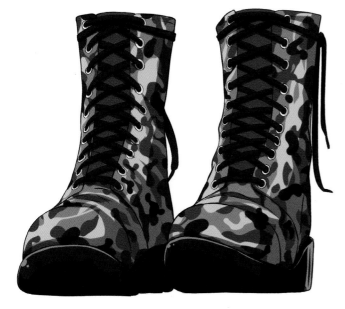

BOOTS WITH A GRUDGE

Don't get into an argument with someone wearing these. Ankle-high boots are typically worn by bad guys.

CAMOUFLAGE BOOTS

The colors are meant to look patchy— they don't blend together. The boot, in the front, is rounded and tall.

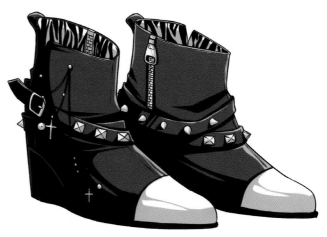

FASHION POSES

A good pose is the foundation for showcasing fashions—the more appealing the pose, the more flattering the view of the outfit. Different outfits work best with different poses. For example, a cheerful walking pose works well with a breezy outfit, while an introverted pose works well with an urban outfit.

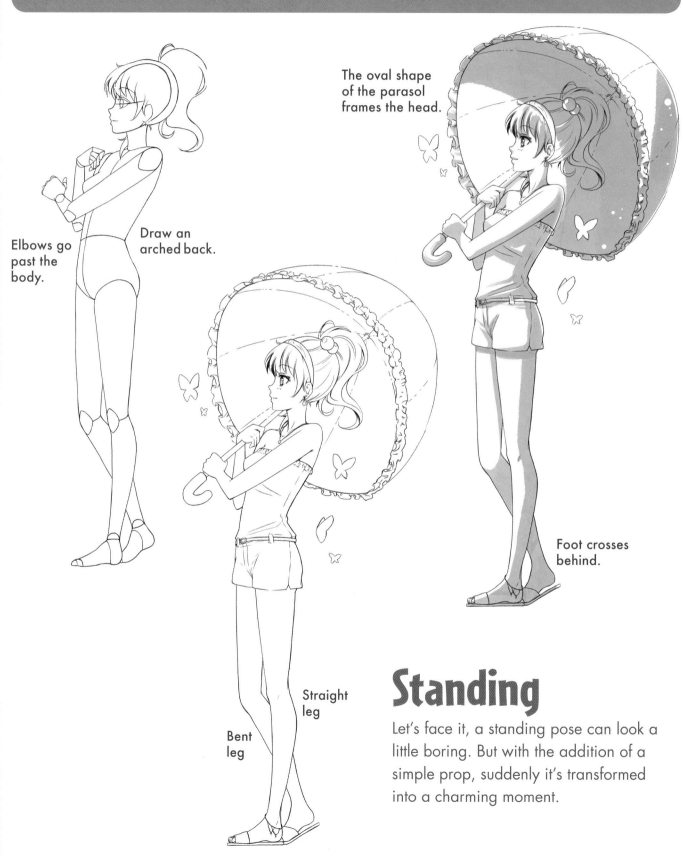

Elbows go past the body.

Draw an arched back.

The oval shape of the parasol frames the head.

Foot crosses behind.

Straight leg

Bent leg

Standing

Let's face it, a standing pose can look a little boring. But with the addition of a simple prop, suddenly it's transformed into a charming moment.

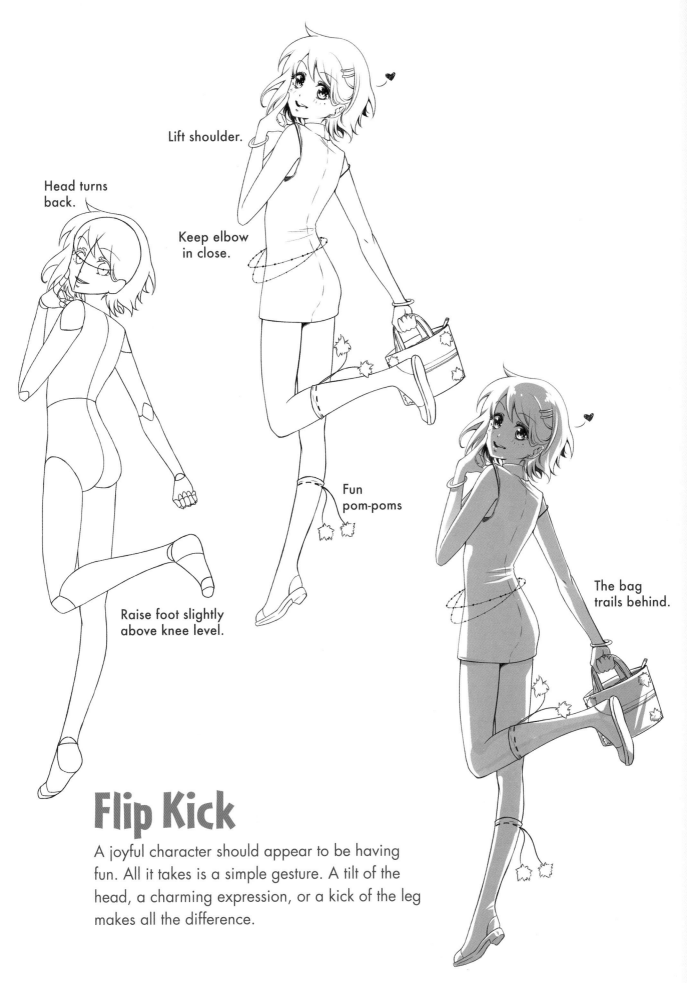

Lift shoulder.

Head turns back.

Keep elbow in close.

Fun pom-poms

Raise foot slightly above knee level.

The bag trails behind.

Flip Kick

A joyful character should appear to be having fun. All it takes is a simple gesture. A tilt of the head, a charming expression, or a kick of the leg makes all the difference.

ACTION

Many appealing poses are created by combining a typical action with a popular fashion pose. In this example, the action is walking, and the pose is the arm behind the head. To give the viewer a clear look at the outfit, position the arms away from the body.

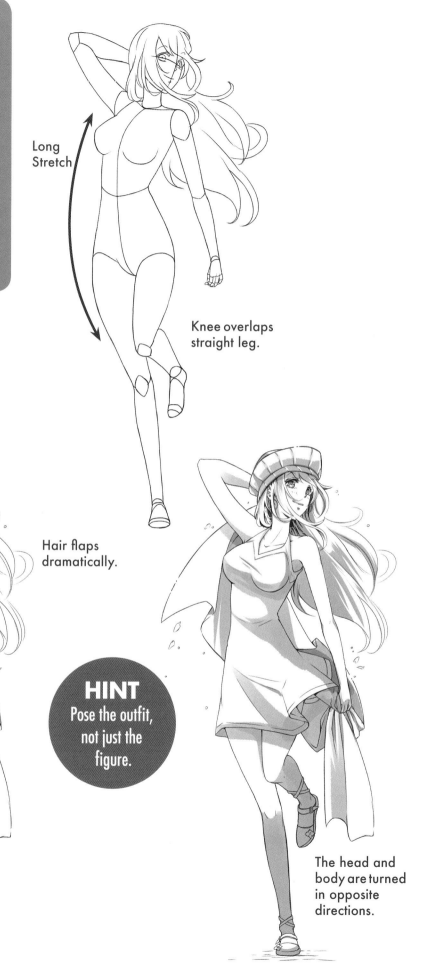

Long Stretch

Knee overlaps straight leg.

Point the elbow up.

Hair flaps dramatically.

HINT
Pose the outfit, not just the figure.

The head and body are turned in opposite directions.

To draw an attractive, seated pose, turn the legs to one side. A front view tends to compress the look of the legs, making them look shorter. It's also easier to position the legs when they are off to the side.

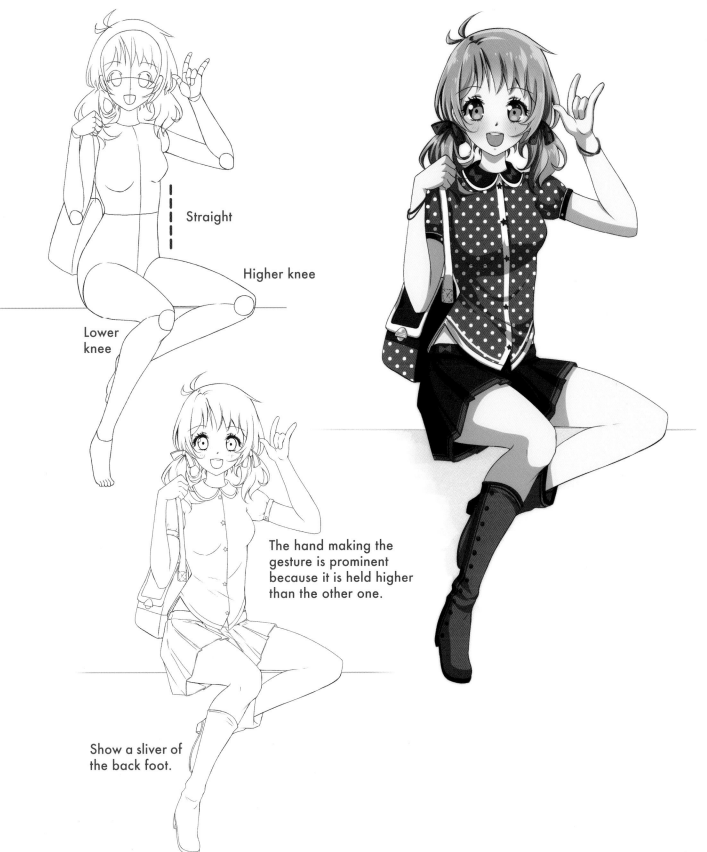

Straight

Higher knee

Lower knee

The hand making the gesture is prominent because it is held higher than the other one.

Show a sliver of the back foot.

GUY FASHIONS

If you want to draw cool guys, draw cool fashions. The key is to make them stylish and slender. A tailored look is also popular. These suggestions can be applied to any outfit, from traditional to cutting edge.

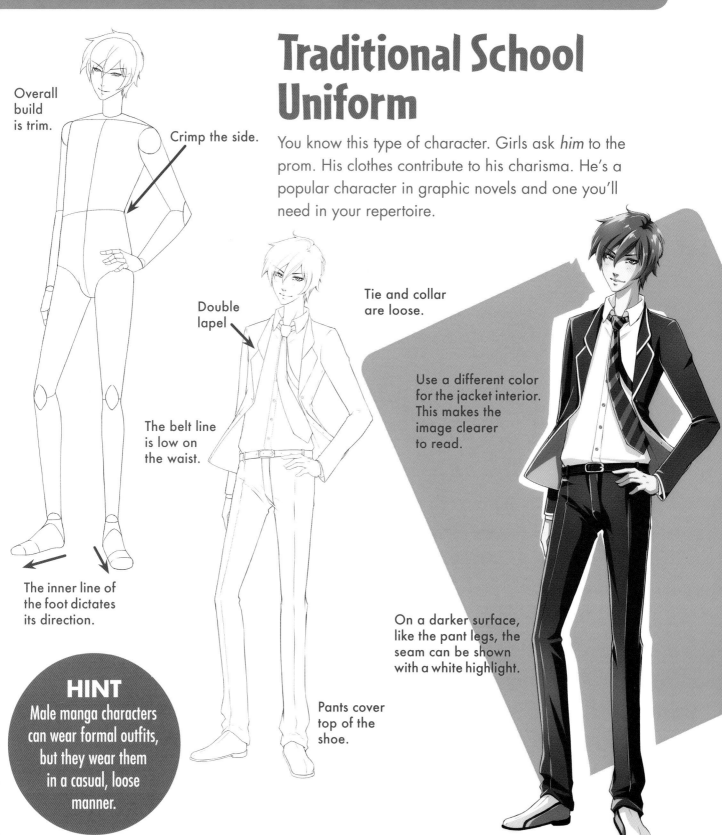

Overall build is trim.

Crimp the side.

The inner line of the foot dictates its direction.

Traditional School Uniform

You know this type of character. Girls ask *him* to the prom. His clothes contribute to his charisma. He's a popular character in graphic novels and one you'll need in your repertoire.

Double lapel

The belt line is low on the waist.

Tie and collar are loose.

Use a different color for the jacket interior. This makes the image clearer to read.

On a darker surface, like the pant legs, the seam can be shown with a white highlight.

Pants cover top of the shoe.

HINT
Male manga characters can wear formal outfits, but they wear them in a casual, loose manner.

Sports and Style

Many popular graphic novels feature star athletes. The heroes tend to wear bright, bold colors. The apparel is loose to allow for maximum movement. The shorts and sleeves—if there are any—are usually baggy. That doesn't exactly sound like a recipe for style. But it can be, if you are creative. Let's start by establishing the figure.

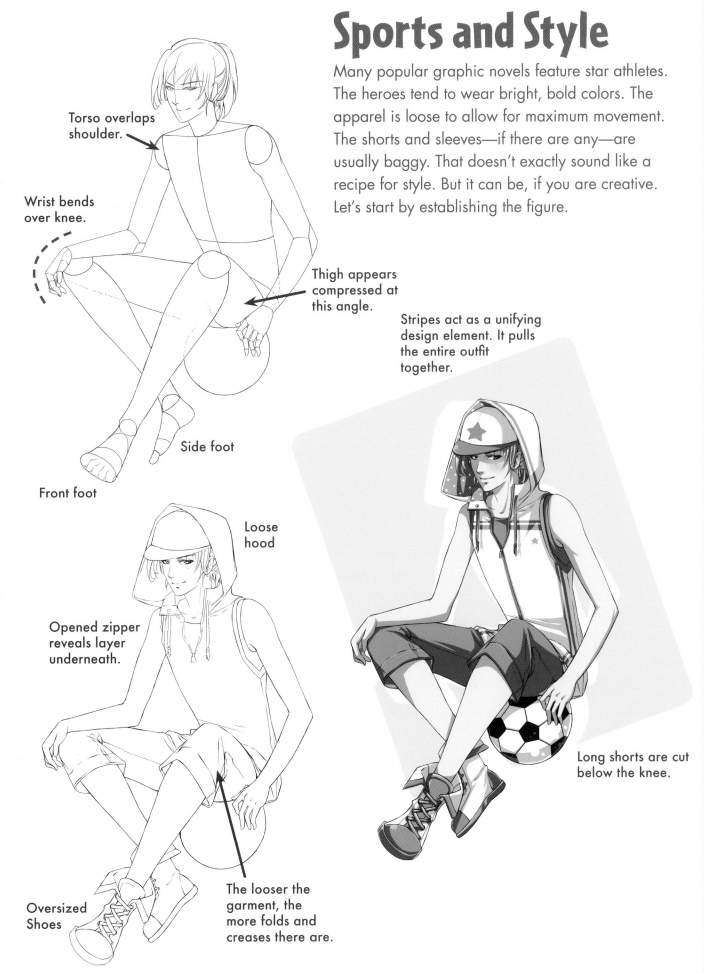

Torso overlaps shoulder.

Wrist bends over knee.

Thigh appears compressed at this angle.

Side foot

Front foot

Stripes act as a unifying design element. It pulls the entire outfit together.

Loose hood

Opened zipper reveals layer underneath.

The looser the garment, the more folds and creases there are.

Oversized Shoes

Long shorts are cut below the knee.

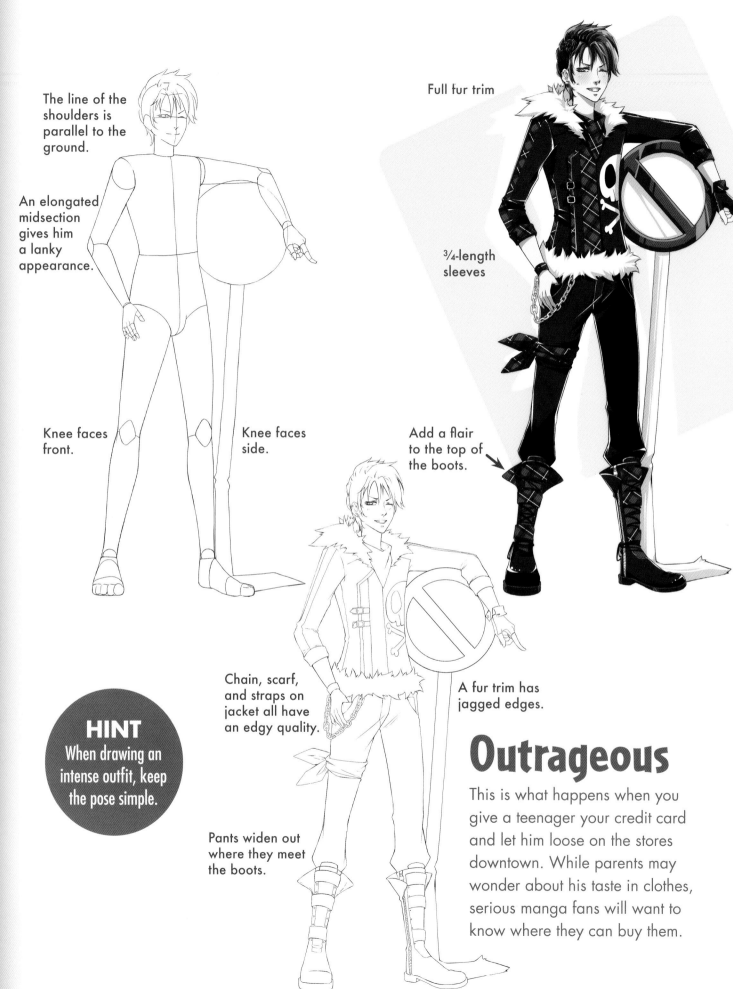

The line of the shoulders is parallel to the ground.

An elongated midsection gives him a lanky appearance.

Knee faces front.

Knee faces side.

Full fur trim

¾-length sleeves

Add a flair to the top of the boots.

Chain, scarf, and straps on jacket all have an edgy quality.

A fur trim has jagged edges.

HINT
When drawing an intense outfit, keep the pose simple.

Pants widen out where they meet the boots.

Outrageous

This is what happens when you give a teenager your credit card and let him loose on the stores downtown. While parents may wonder about his taste in clothes, serious manga fans will want to know where they can buy them.

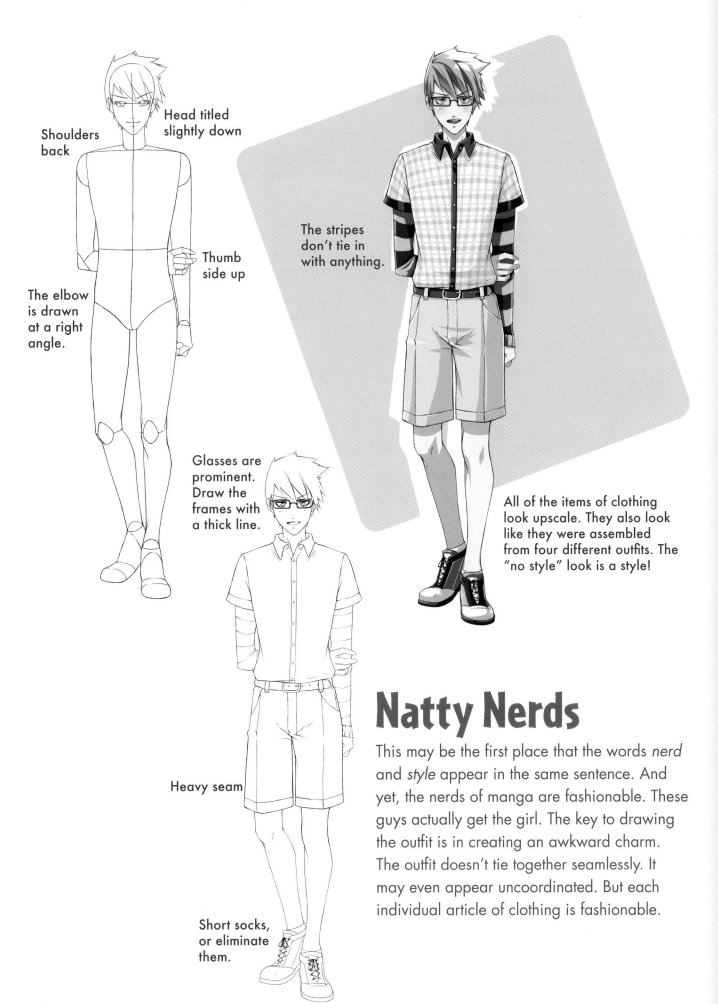

Shoulders back

Head titled slightly down

Thumb side up

The elbow is drawn at a right angle.

The stripes don't tie in with anything.

Glasses are prominent. Draw the frames with a thick line.

All of the items of clothing look upscale. They also look like they were assembled from four different outfits. The "no style" look is a style!

Heavy seam

Short socks, or eliminate them.

Natty Nerds

This may be the first place that the words *nerd* and *style* appear in the same sentence. And yet, the nerds of manga are fashionable. These guys actually get the girl. The key to drawing the outfit is in creating an awkward charm. The outfit doesn't tie together seamlessly. It may even appear uncoordinated. But each individual article of clothing is fashionable.

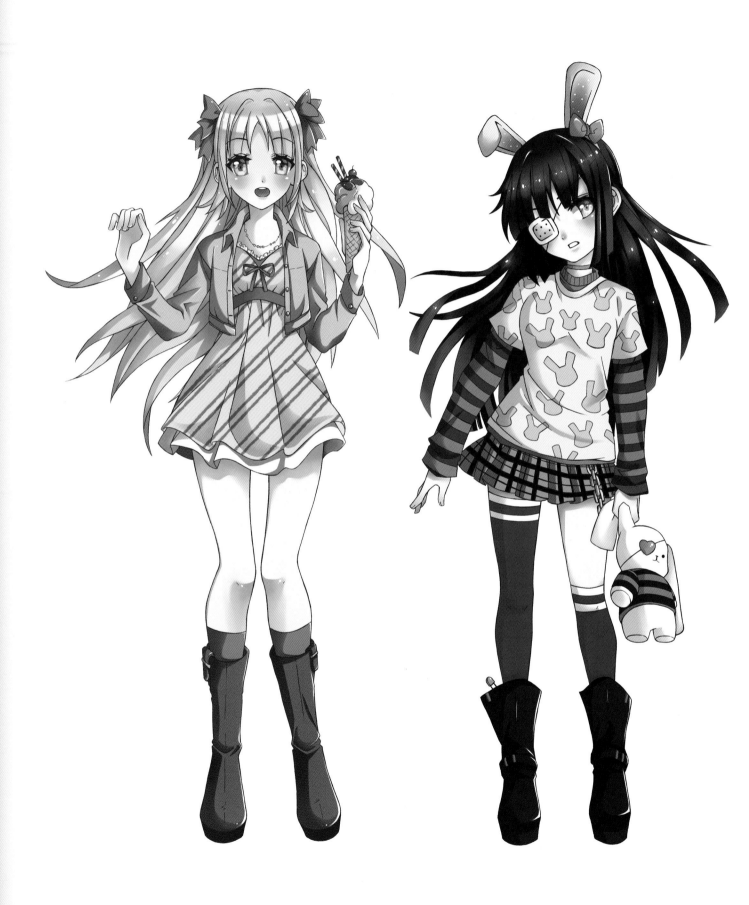

Patterns and Designs

Patterns turn ordinary outfits into vibrant outfits. You can create a limitless number of them, from cheerful designs and splashy styles to delicate motifs. Some patterns are organic, such as flowers, while others are geometrical, such as plaids or stripes. Large patterns only repeat themselves a few times, while small patterns can repeat many times.

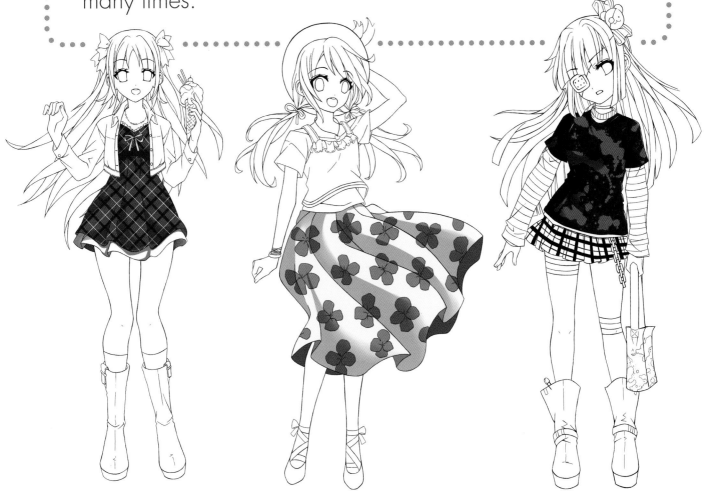

PATTERNS FOR DRESSES

Suppose you've drawn a dress. It's pleasing but plain. It doesn't catch the eye. How do you punch it up? Many artists will redraw the entire dress, but that may not be necessary. A good pattern can jazz up an ordinary outfit, and it's easier than redrawing it. Let's check out how it's done.

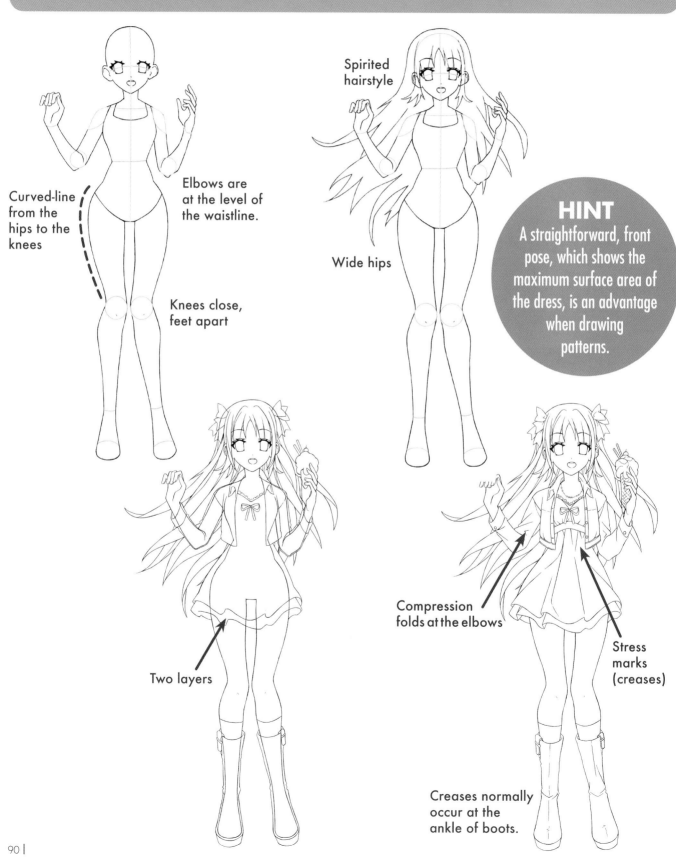

Curved-line from the hips to the knees

Elbows are at the level of the waistline.

Knees close, feet apart

Spirited hairstyle

Wide hips

HINT
A straightforward, front pose, which shows the maximum surface area of the dress, is an advantage when drawing patterns.

Two layers

Compression folds at the elbows

Stress marks (creases)

Creases normally occur at the ankle of boots.

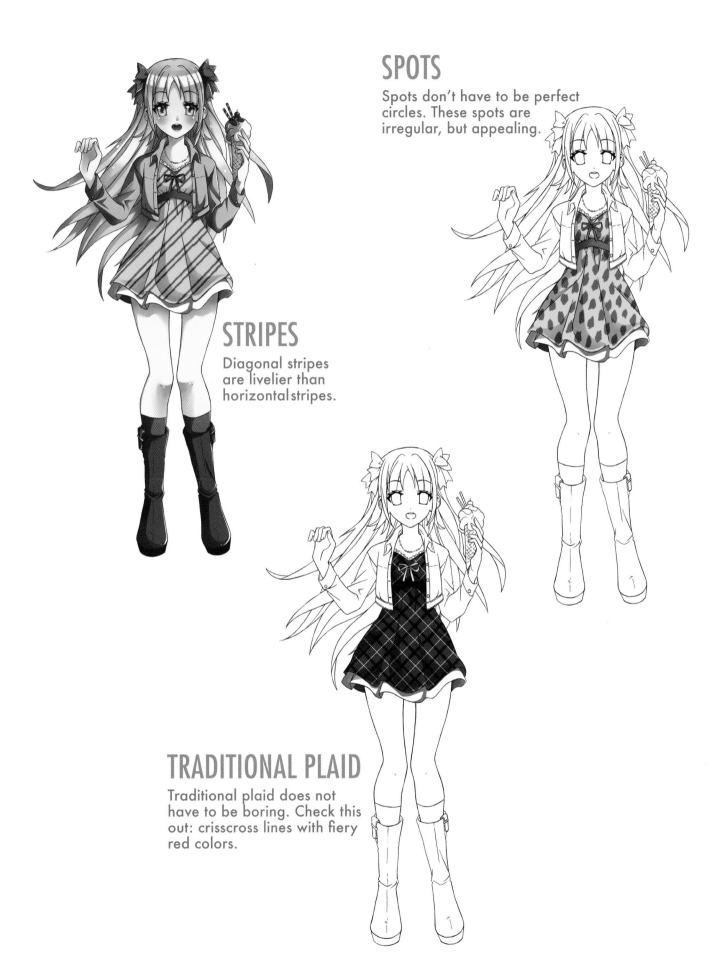

SPOTS

Spots don't have to be perfect circles. These spots are irregular, but appealing.

STRIPES

Diagonal stripes are livelier than horizontal stripes.

TRADITIONAL PLAID

Traditional plaid does not have to be boring. Check this out: crisscross lines with fiery red colors.

PATTERNS FOR SKIRTS

As skirts move left or right with the breeze, they form folds. These folds cut off some of the patterns so that they don't align perfectly. This gives the outfit a realistic look.

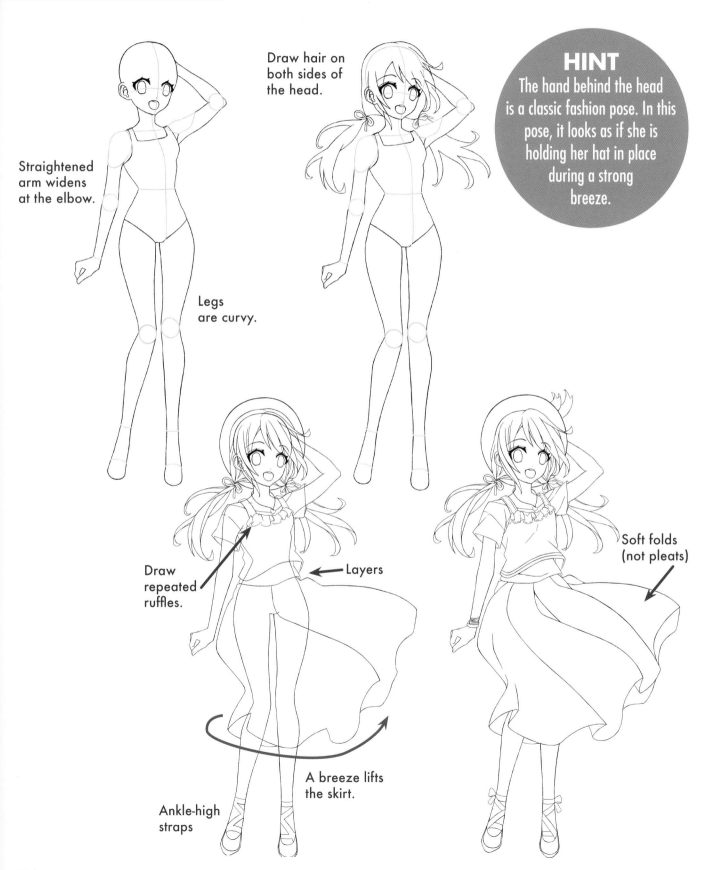

HINT
The hand behind the head is a classic fashion pose. In this pose, it looks as if she is holding her hat in place during a strong breeze.

Draw hair on both sides of the head.

Straightened arm widens at the elbow.

Legs are curvy.

Draw repeated ruffles.

Layers

Soft folds (not pleats)

A breeze lifts the skirt.

Ankle-high straps

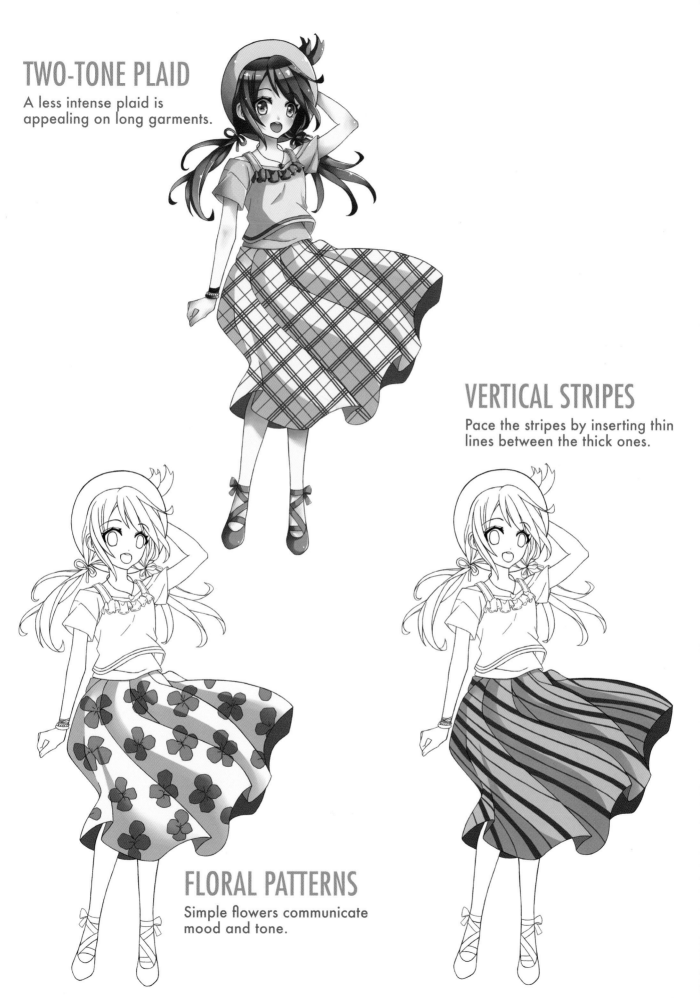

TWO-TONE PLAID

A less intense plaid is appealing on long garments.

VERTICAL STRIPES

Pace the stripes by inserting thin lines between the thick ones.

FLORAL PATTERNS

Simple flowers communicate mood and tone.

PATTERNS FOR TOPS

A tilt of the head gives this pose a cute look. And it's extreme to offset the somewhat severe outfit in the following examples.

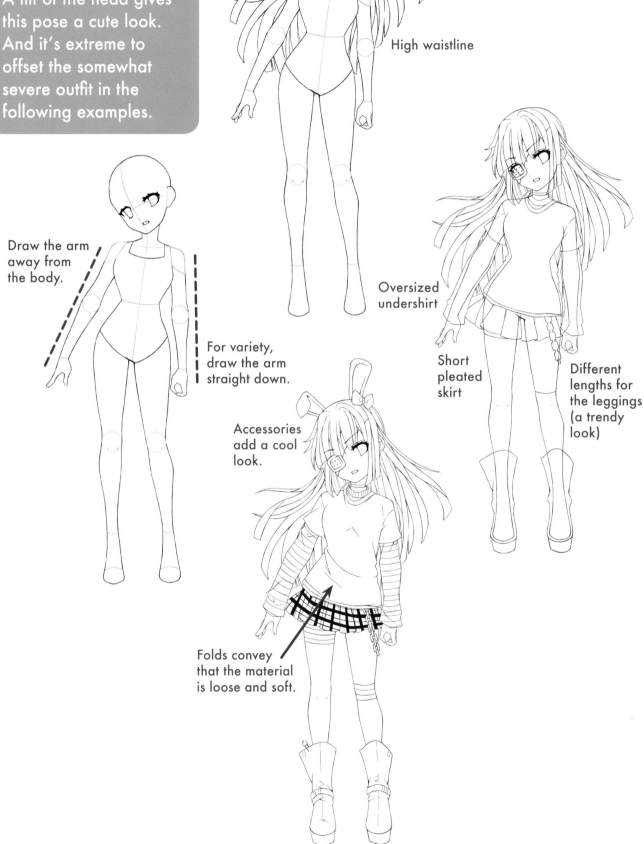

High waistline

Draw the arm away from the body.

For variety, draw the arm straight down.

Oversized undershirt

Short pleated skirt

Different lengths for the leggings (a trendy look)

Accessories add a cool look.

Folds convey that the material is loose and soft.

SPLASHY PATTERNS

Controlled chaos is the term for this type of pattern. It's eye catching and severe.

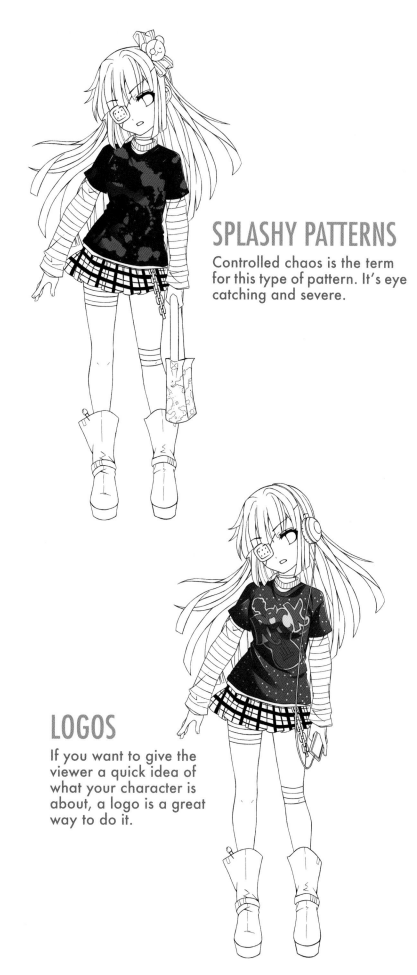

THEMES

The rabbit symbols on her shirt, the doll in her hand, and the rabbit ears work to create a cute design theme.

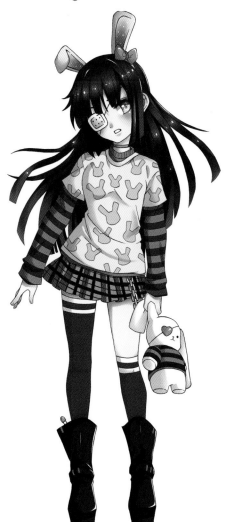

LOGOS

If you want to give the viewer a quick idea of what your character is about, a logo is a great way to do it.

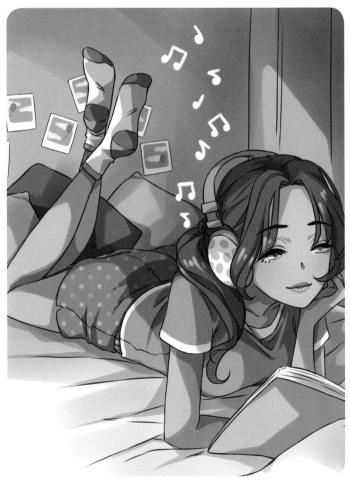

Pajamas and Nightwear

Pajamas make characters look cozy. They are soft and oversized—sometimes a lot oversized. Think of an old, familiar blanket. It just *feels* good. The designs are playful, colorful, and even humorous. Pajamas can also enhance a scene. A teenage girl having ice cream is no big deal. But the same girl, in pajamas, eating ice cream late at night, is being a bit naughty.

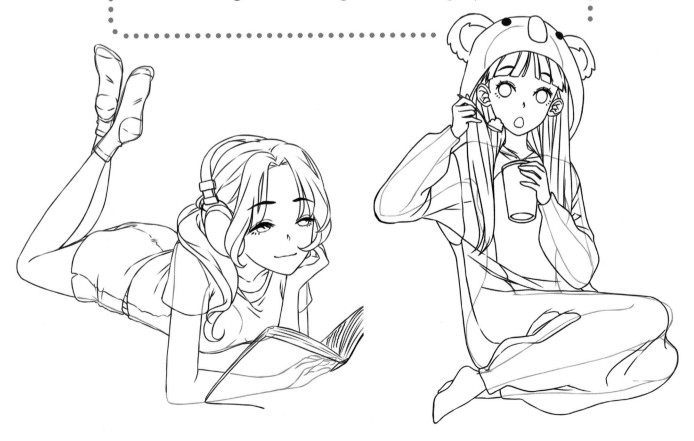

KOALA PAJAMAS

These koala pajamas are infused with a double dose of cuteness. They're cuddly and warm. Draw the folds using long lines, for a soft look. Such a big outfit looks like a cross between pajamas and a comforter.

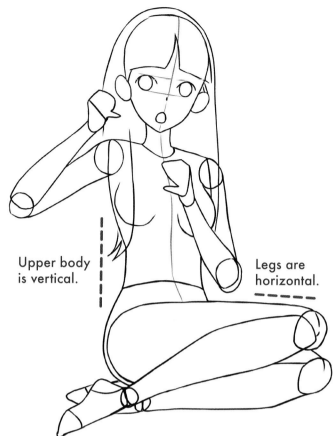

Upper body is vertical.

Legs are horizontal.

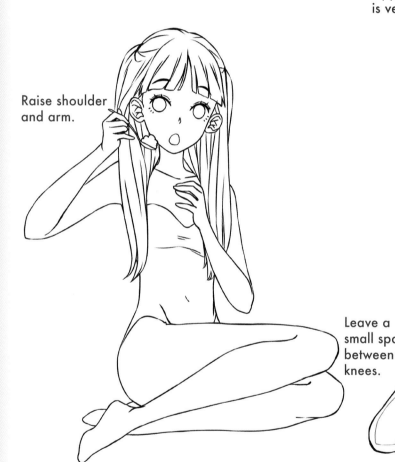

Raise shoulder and arm.

Leave a small space between knees.

Avoid the instinct to draw the pajamas narrower at the waist. A big part of their appeal is that the one-piece is not form fitting.

Draw the features high on the hood.

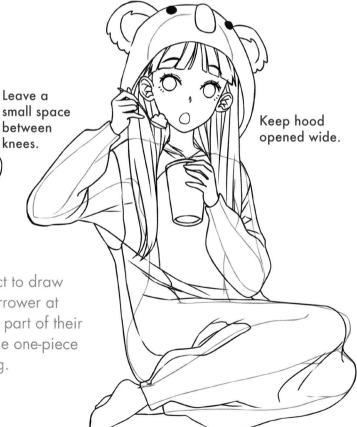

Keep hood opened wide.

The fabric gathers at the bottom.

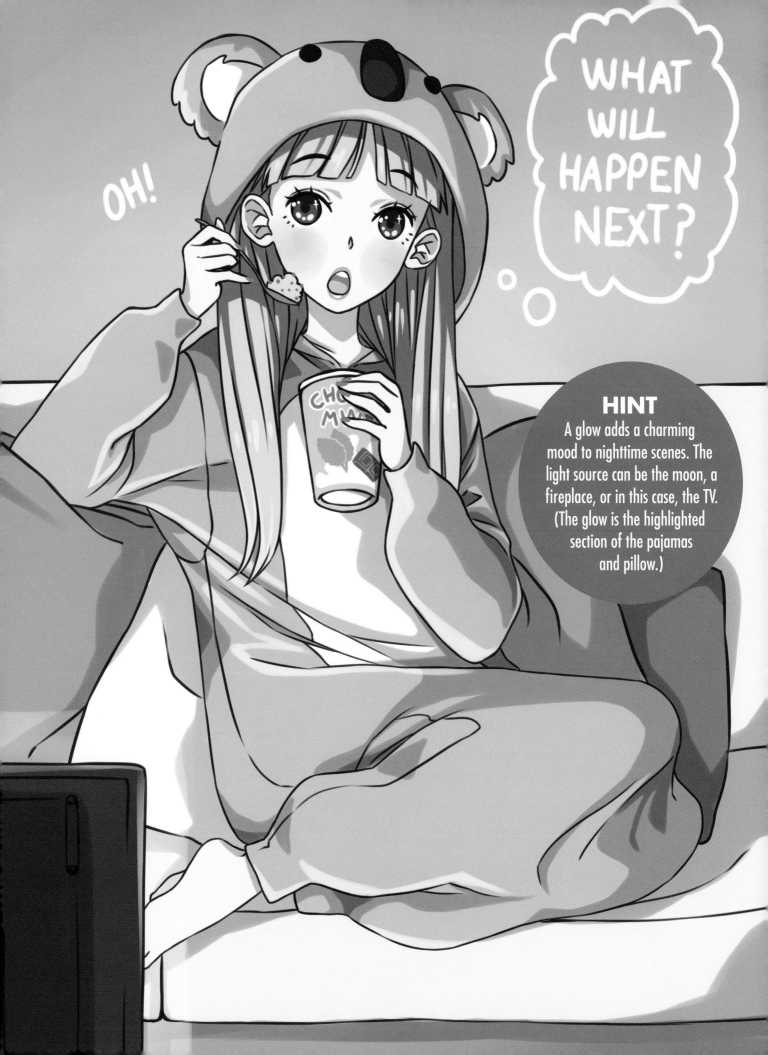

BUTTONED PAJAMAS

A yawn is a popular expression for characters who are about to hit the bed. It's also used for characters in math class. The classic yawning pose is drawn with one arm stretching and the other rubbing a sleepy eye.

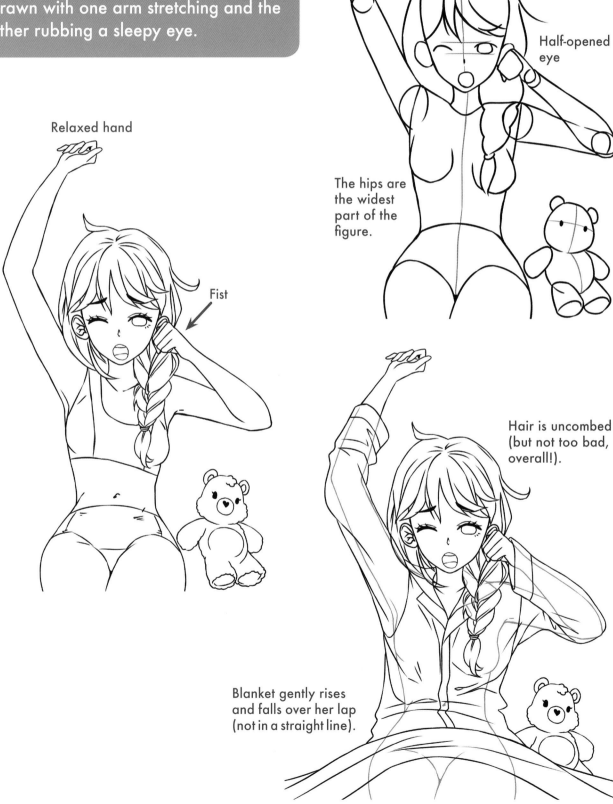

Half-opened eye

The hips are the widest part of the figure.

Relaxed hand

Fist

Hair is uncombed (but not too bad, overall!).

Blanket gently rises and falls over her lap (not in a straight line).

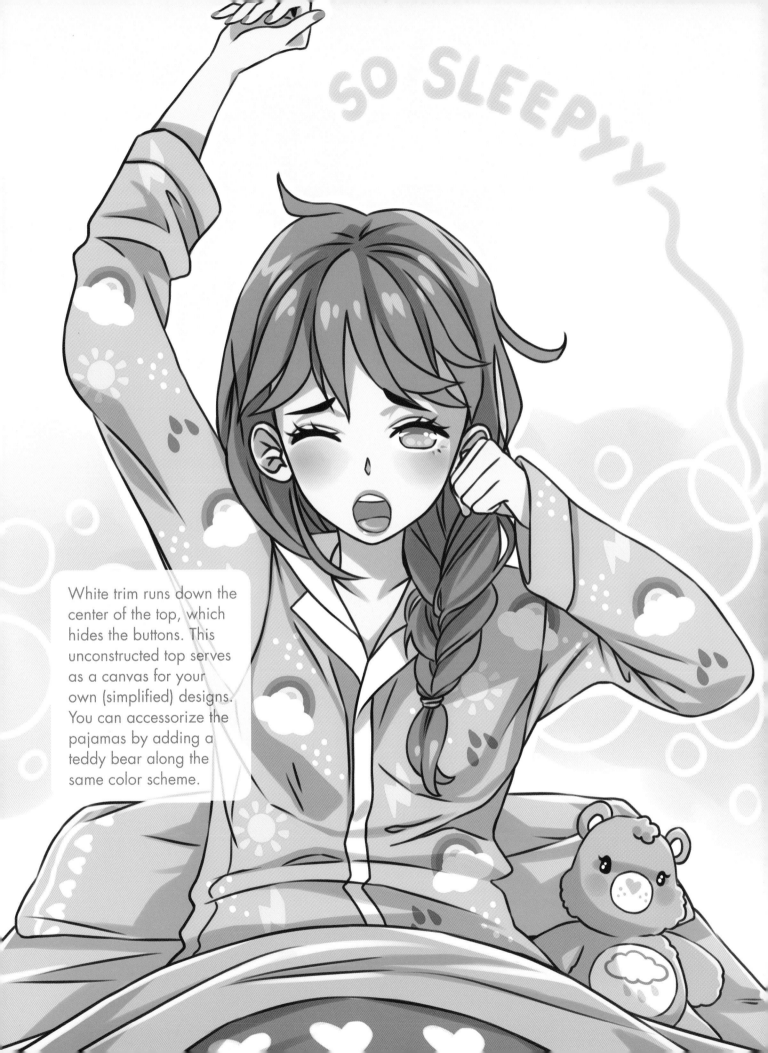

White trim runs down the center of the top, which hides the buttons. This unconstructed top serves as a canvas for your own (simplified) designs. You can accessorize the pajamas by adding a teddy bear along the same color scheme.

CROPPED TOP

Here's a popular variation: You can transform workout clothes into pajamas by combining a tank top with stretch pants. It's a casual look, often used by people who have misplaced part of their pajamas due to laundry gremlins.

Draw the figure along a gentle, upward slope.

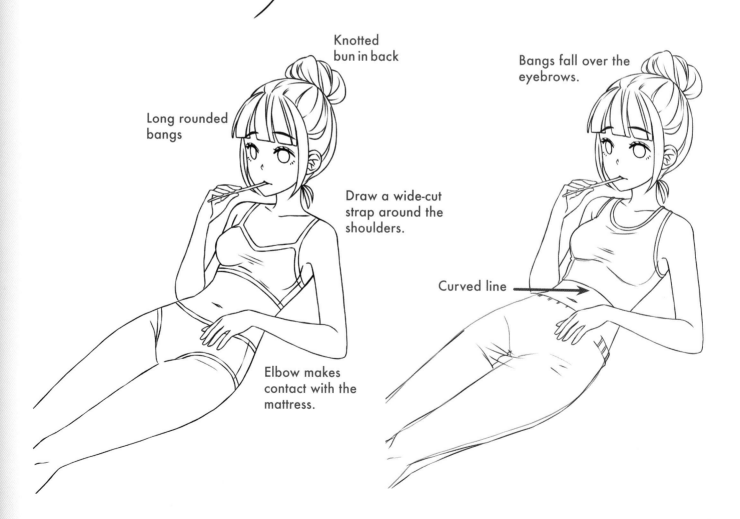

Knotted bun in back

Long rounded bangs

Bangs fall over the eyebrows.

Draw a wide-cut strap around the shoulders.

Curved line

Elbow makes contact with the mattress.

BORING

HINTS
• Pajamas are colorful, but not bright. Bright colors are too energetic for sleep.
• Dim lighting conditions create heavier shadows.

Poki

T-SHIRT AND SHORTS

This is what happens when your favorite clothes are too worn-out to be seen in public, but you can't bring yourself to throw them out. They become pajamas. It's a fun look, but slightly quirky. It doesn't need to make fashion sense. The top and shorts don't share a common pattern, because they wore out at different times! The top is drawn with a trim, and the bottom with dots. Socks are the ultimate accessory for pajamas.

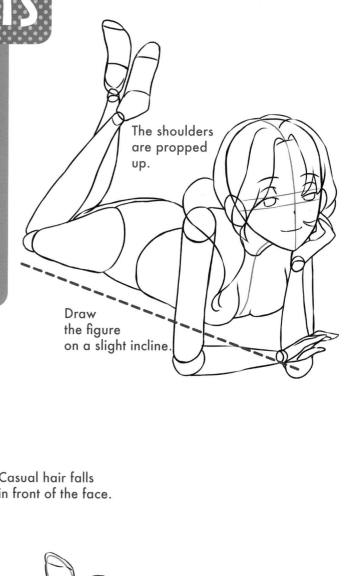

The shoulders are propped up.

Draw the figure on a slight incline.

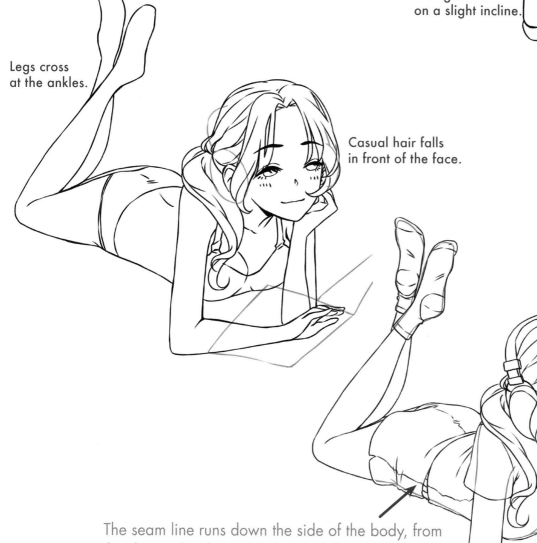

Legs cross at the ankles.

Casual hair falls in front of the face.

The seam line runs down the side of the body, from the shirt to the shorts. It helps to define the side of the figure as a separate plane from the back of the figure, creating a three-dimensional look.

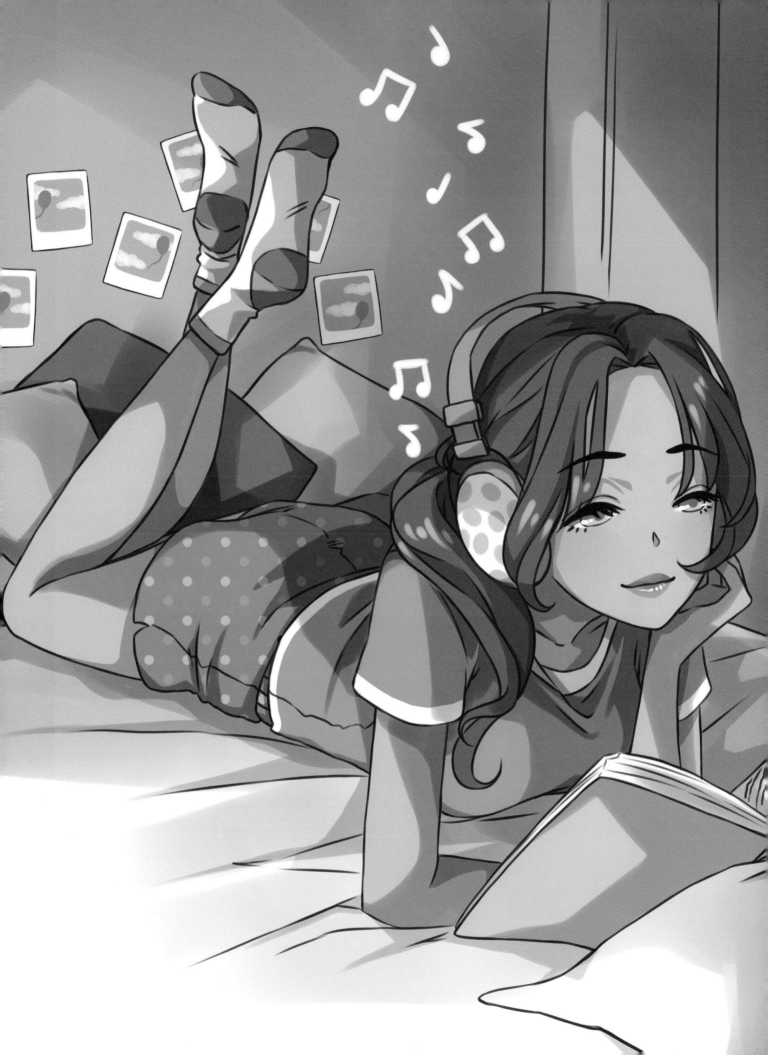

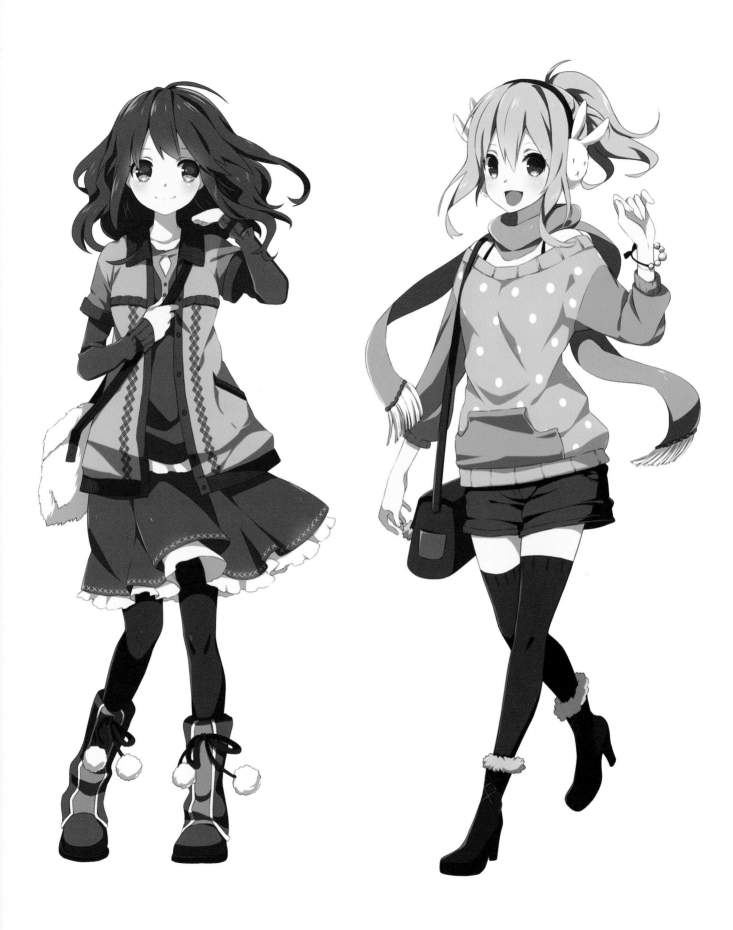

Clothes Are Meant to Move

In this section, we'll see how to create dynamic looking clothes for active characters on the move. Clothes aren't static. They move. They flap, they billow, they tug, and they pull. Motion can enhance a pose. For example, a scarf that flaps in the breeze makes a walking pose look stylish. Motion is another useful tool in your set of drawing techniques.

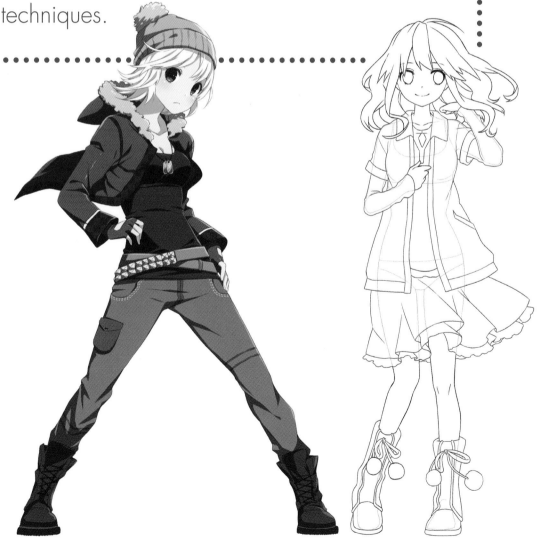

THE EFFECT OF WIND ON AN OUTFIT

Wind has a pleasing visual effect on clothes. It causes lighter items and outer layers to lift and blow to the left or right. Heavier clothing resists the wind, and shows less movement. Let's see the effect on a character type in a popular outfit.

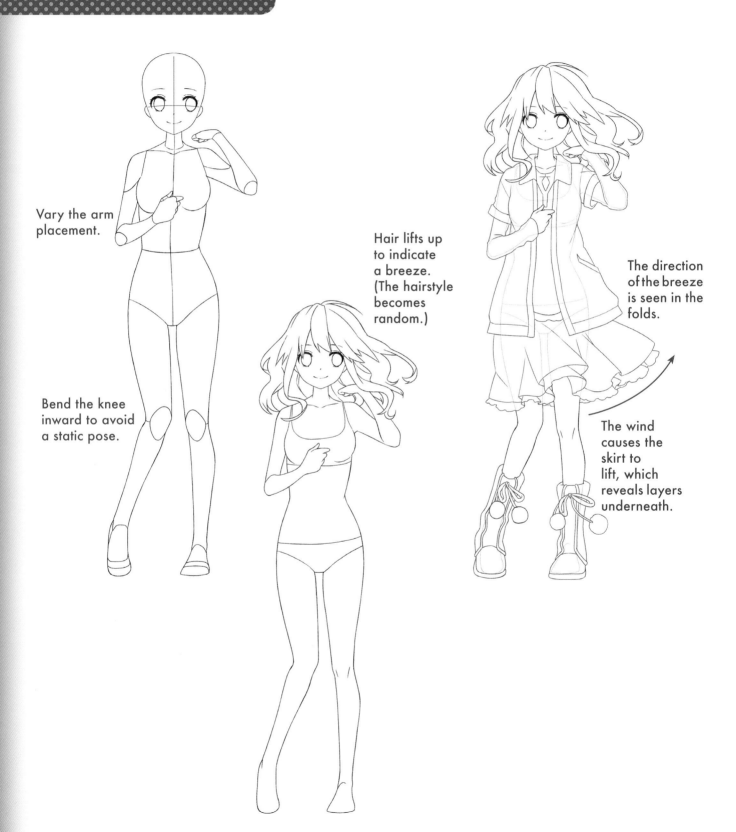

Vary the arm placement.

Bend the knee inward to avoid a static pose.

Hair lifts up to indicate a breeze. (The hairstyle becomes random.)

The direction of the breeze is seen in the folds.

The wind causes the skirt to lift, which reveals layers underneath.

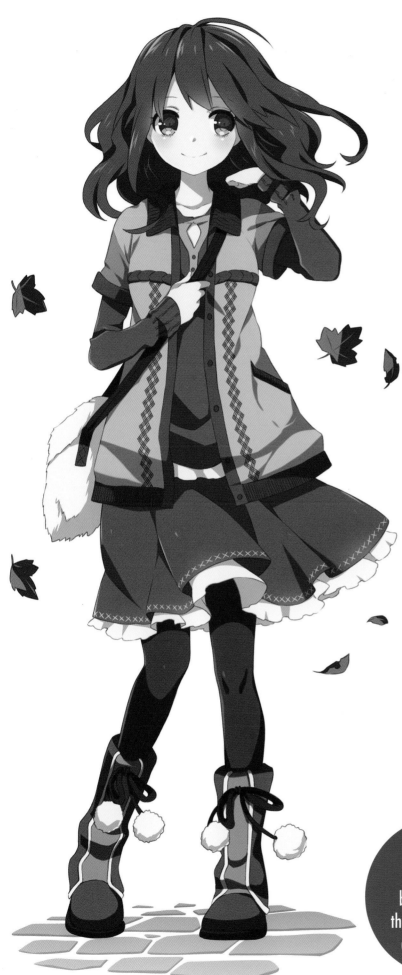

DRAWING THE BILLOWING SKIRT

As a skirt billows, the folds (pleats) get wider.

Start by drawing a skirt without dimension.

Indicate the interior, shown in gray.

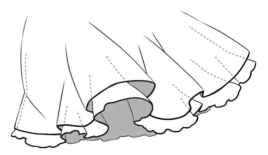

Draw a thin, second layer under the skirt. Add ruffles to this layer.

HINT
A strong breeze affects the hair, giving it a poetic look.

SCARVES AND FLOWING THINGS

A scarf can be an eye-catching accessory. Draw it so that it curves and flows, showing both the top and bottom sides. The eye naturally follows a swirling line, which can be drawn to create a random flapping effect. In this image, it's the walking action, rather than a breeze, which causes the scarf to flap.

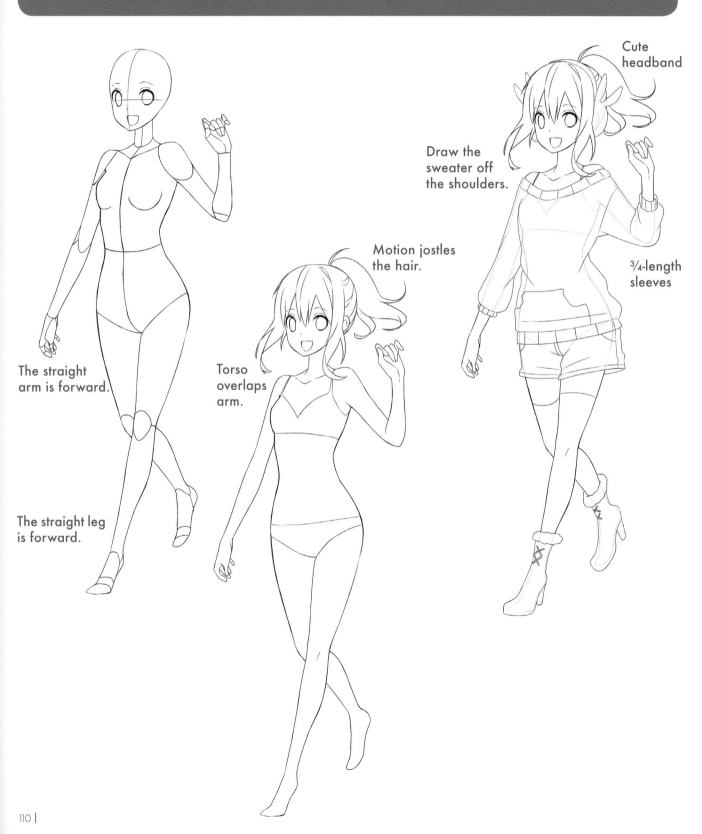

Cute headband

Draw the sweater off the shoulders.

Motion jostles the hair.

¾-length sleeves

The straight arm is forward.

Torso overlaps arm.

The straight leg is forward.

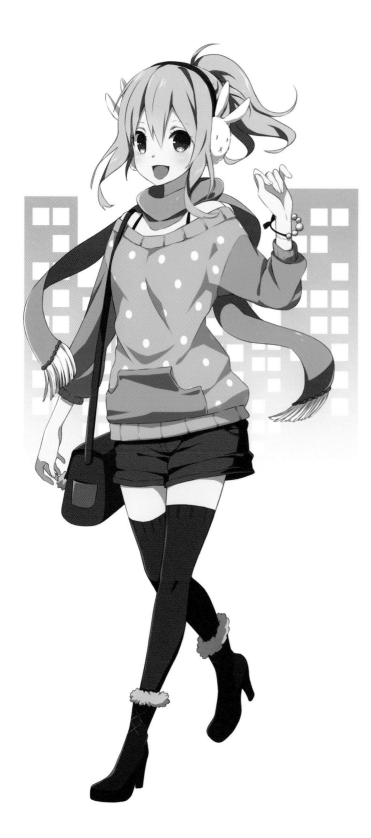

DRAWING A SCARF

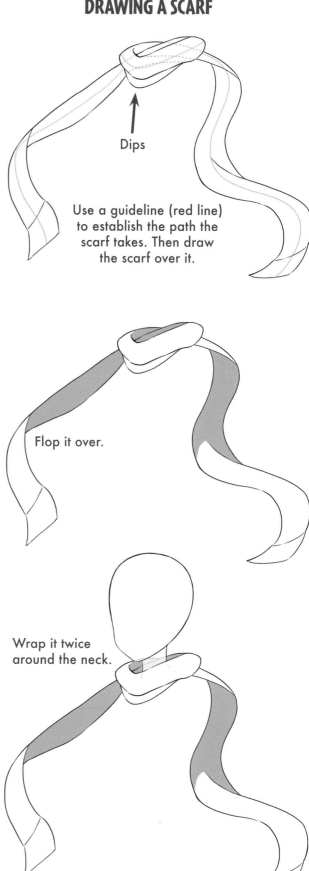

Dips

Use a guideline (red line) to establish the path the scarf takes. Then draw the scarf over it.

Flop it over.

Wrap it twice around the neck.

REACTING TO FORCE

An outfit can become an "actor" in a scene by "reacting" to the character's pose. In this example, the character's intense mood causes the jacket to react by jumping up, which raises the energy in the scene, making it eye-catching.

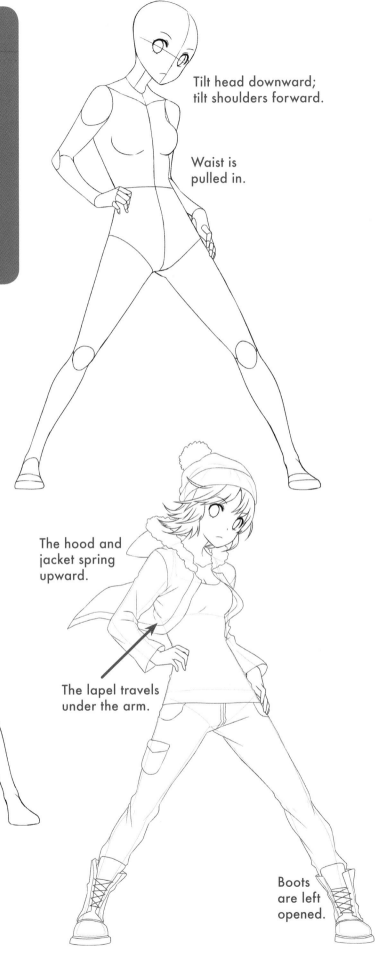

Tilt head downward; tilt shoulders forward.

Waist is pulled in.

The hair rustles.

The hood and jacket spring upward.

The lapel travels under the arm.

Feet are facing forward.

Boots are left opened.

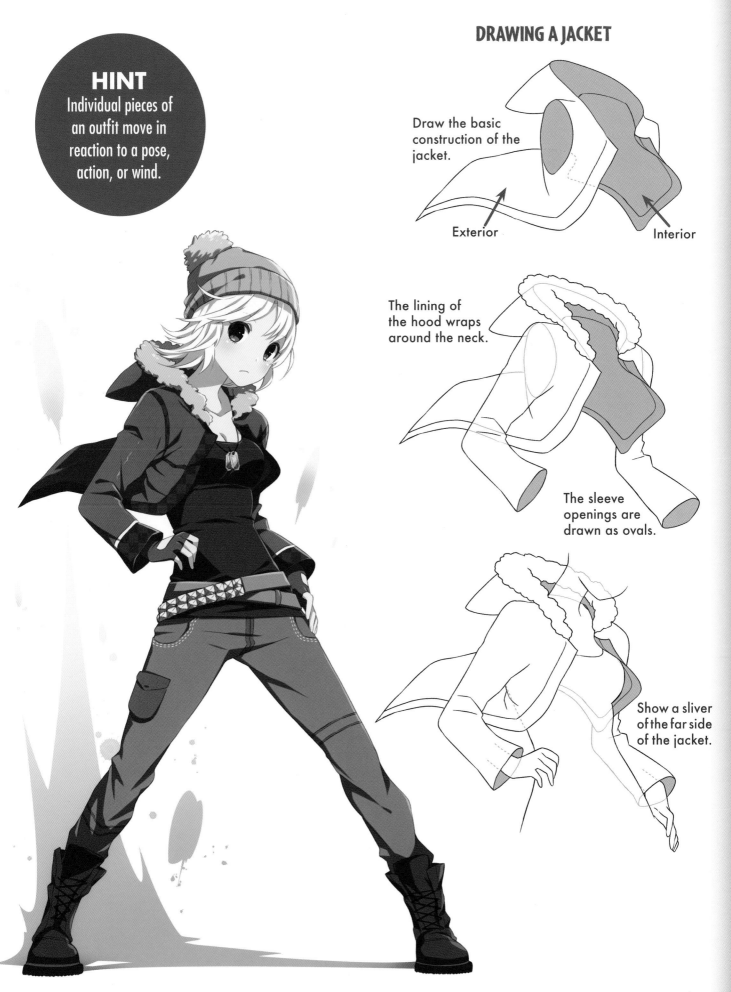

HINT
Individual pieces of an outfit move in reaction to a pose, action, or wind.

Draw the basic construction of the jacket.

Exterior

Interior

The lining of the hood wraps around the neck.

The sleeve openings are drawn as ovals.

Show a sliver of the far side of the jacket.

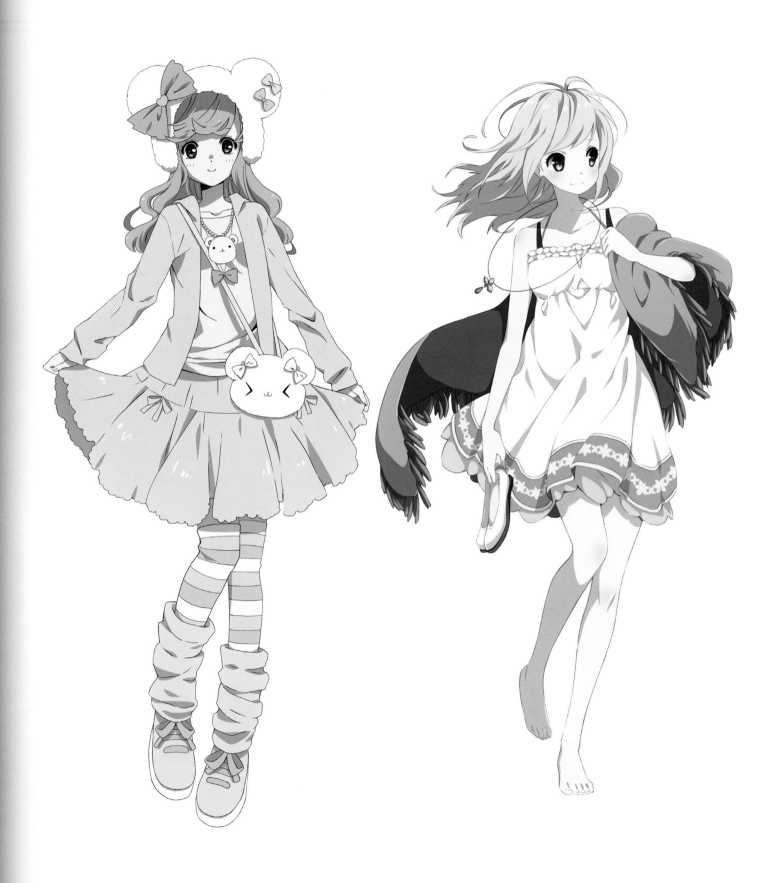

Fashion Trends from Japan

In the following section, we'll explore the popular manga fashion trends in Japan. Each style is distinct and labeled as a separate category, such as Mori, J-Pop, or Lolita. Few artists outside of Japan know about these style trends. Now, you're going to be one of those few. Get ready to dig in.

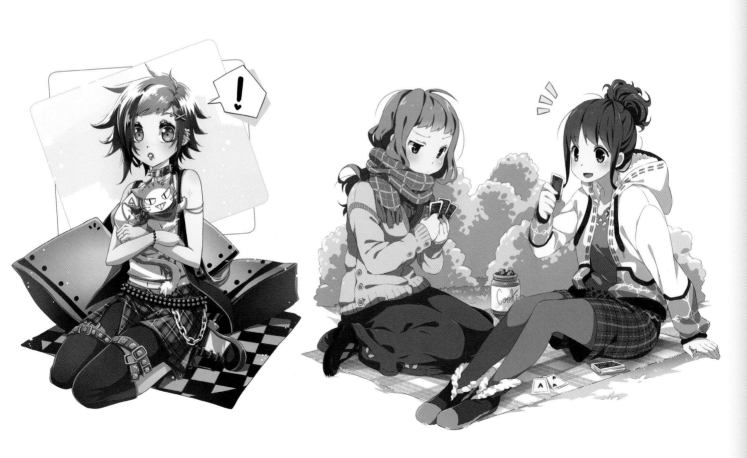

THE MORI STYLE

Mori is a popular fashion style among manga artists in Japan. In the United States, you would refer to it as "comfort clothes." But in Japan, Mori also means *style*. It features relaxed, casual outfits, often layered, which are smartly coordinated. It's an understated, but highly stylish look.

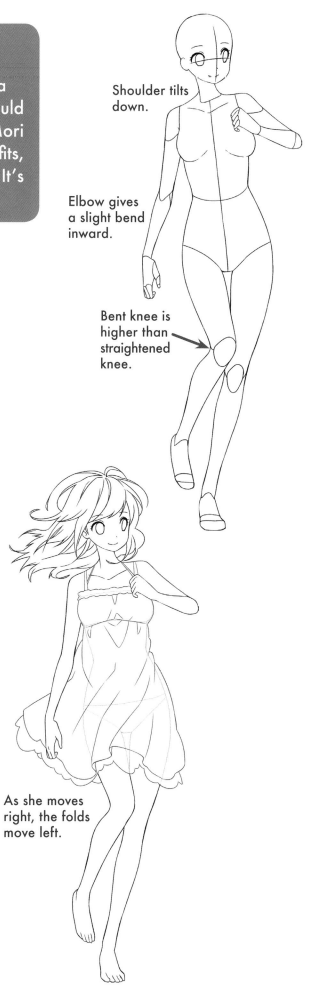

Shoulder tilts down.

Elbow gives a slight bend inward.

Bent knee is higher than straightened knee.

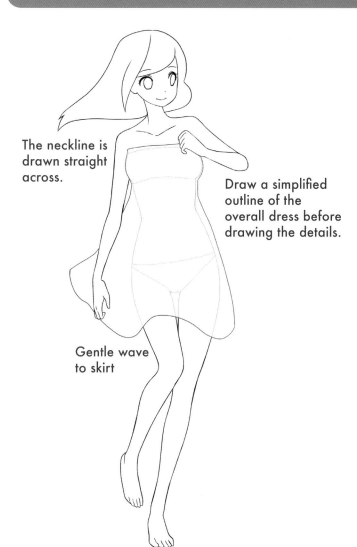

The neckline is drawn straight across.

Draw a simplified outline of the overall dress before drawing the details.

Gentle wave to skirt

As she moves right, the folds move left.

Breezy Look

This scene calls for an understated outfit, which is perfect for the Mori style. The soft, relaxed fabric of the Mori summer outfit flows with the breeze and captures the moment. It has a subdued elegance.

DRAWING A GIANT SCARF

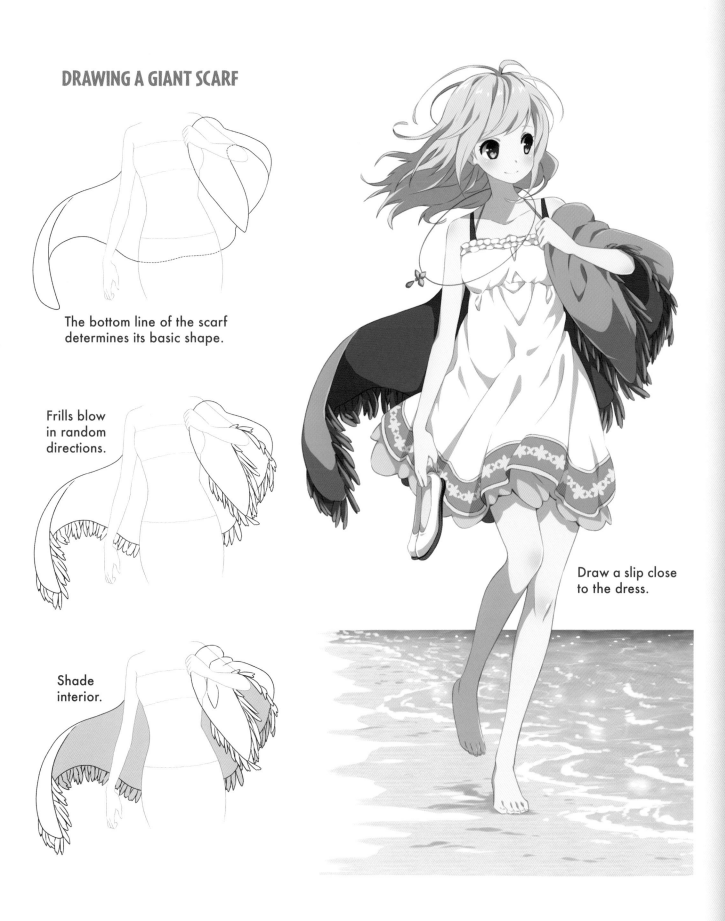

The bottom line of the scarf determines its basic shape.

Frills blow in random directions.

Shade interior.

Draw a slip close to the dress.

Weekend Wear

The Mori style is also for hanging out with friends. This outfit is a medley of colors and textures. The quilted patches, random patterns, and pieces that don't quite match give the outfit a fun, improvised look.

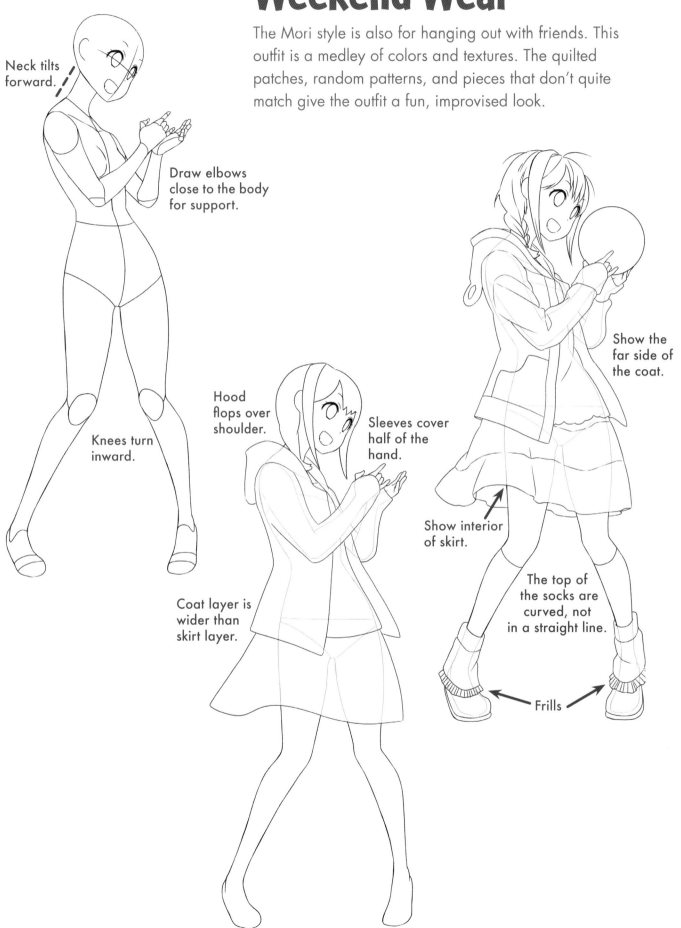

Neck tilts forward.

Draw elbows close to the body for support.

Knees turn inward.

Hood flops over shoulder.

Sleeves cover half of the hand.

Show the far side of the coat.

Show interior of skirt.

The top of the socks are curved, not in a straight line.

Coat layer is wider than skirt layer.

Frills

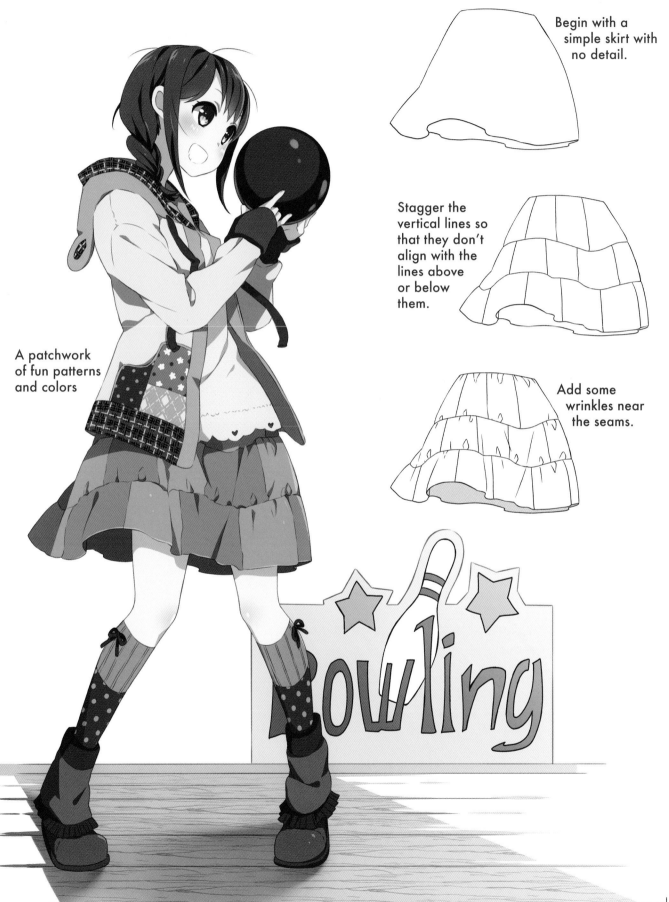

DRAWING A LAYERED SKIRT

Begin with a simple skirt with no detail.

Stagger the vertical lines so that they don't align with the lines above or below them.

A patchwork of fun patterns and colors

Add some wrinkles near the seams.

Cozy Outfit

Cozy clothes are a big part of Mori style. A thick sweater is a good choice. A skirt with a fur trim is also a nice touch. To complete the outfit, add warm leggings and soft boots with wrap-around knots on the ankles.

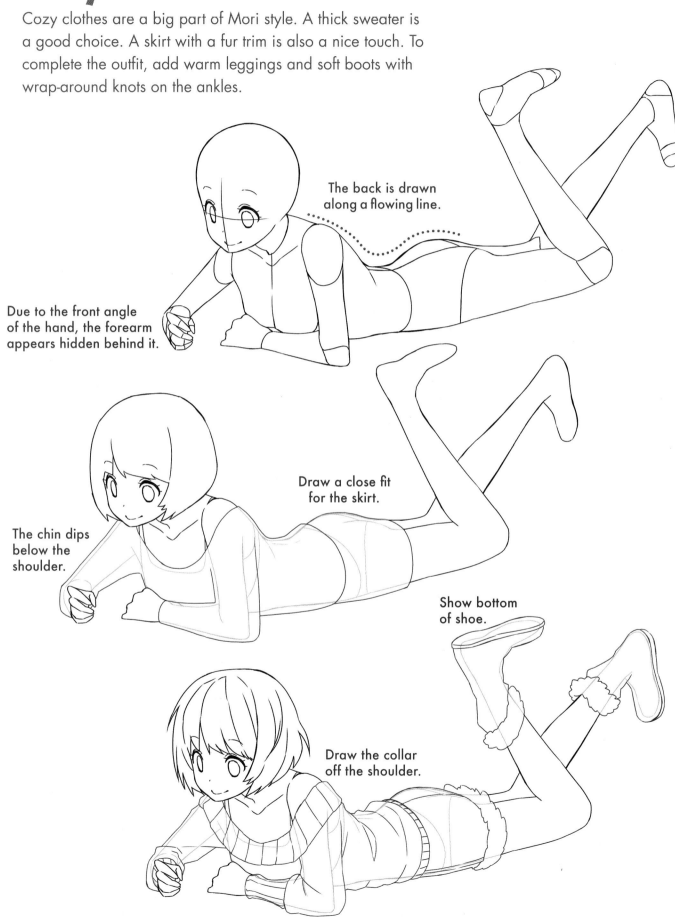

The back is drawn along a flowing line.

Due to the front angle of the hand, the forearm appears hidden behind it.

Draw a close fit for the skirt.

The chin dips below the shoulder.

Show bottom of shoe.

Draw the collar off the shoulder.

DRAWING A BOW

Start with two triangles.

Relax the straight lines, and add a knot in the middle.

Add creases coming from the knot in the middle.

The headband goes behind the ear.

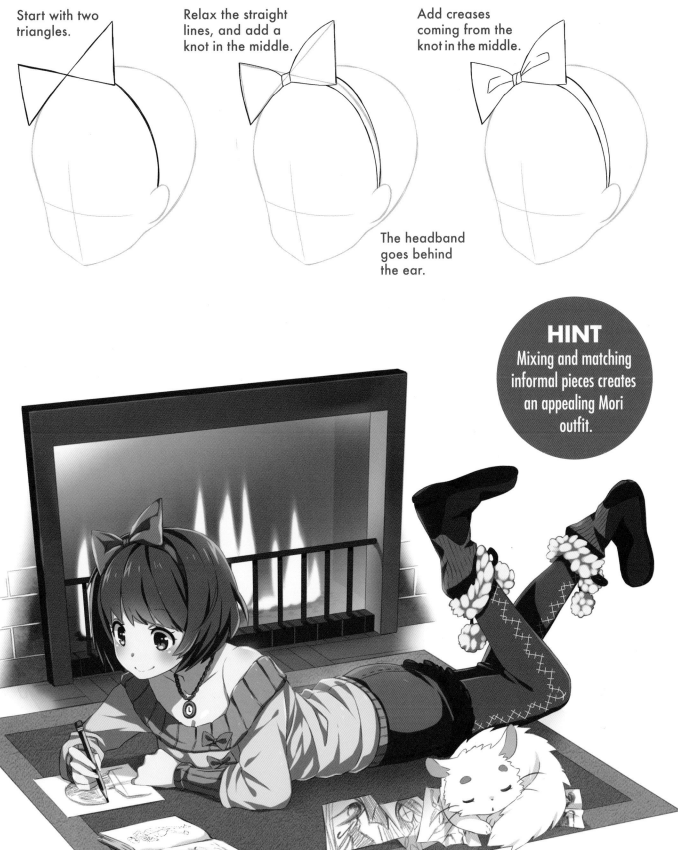

HINT
Mixing and matching informal pieces creates an appealing Mori outfit.

Pullover Dress

The pullover dress fans out into a cascade of ruffles. The basic construction of the dress is simple. The collar and arm openings are large scoops. The pockets are simple rectangles. The detail lies in the two sets of blue and pink ruffles at the bottom of the hem.

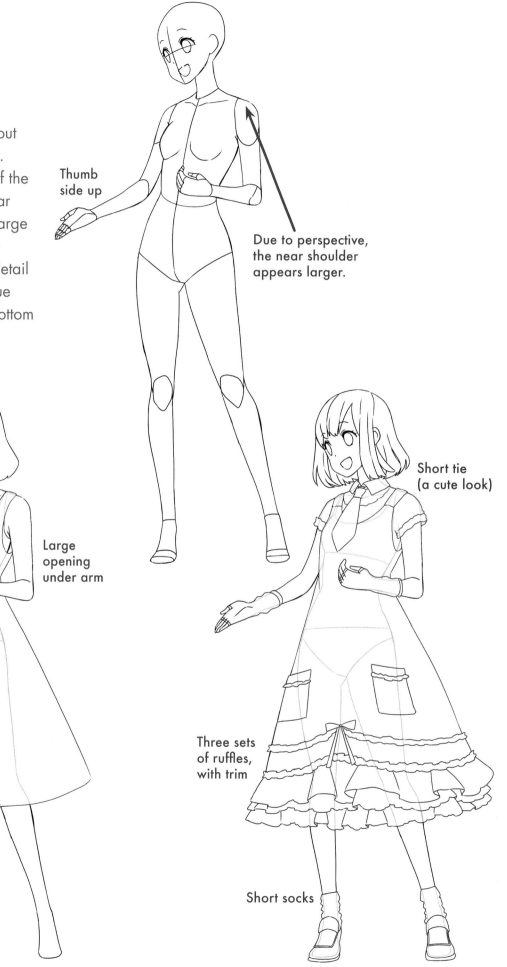

Thumb side up

Due to perspective, the near shoulder appears larger.

Wide, crew neck collar

High waistline

Large opening under arm

Short tie (a cute look)

Three sets of ruffles, with trim

Short socks

DRAWING A HAT

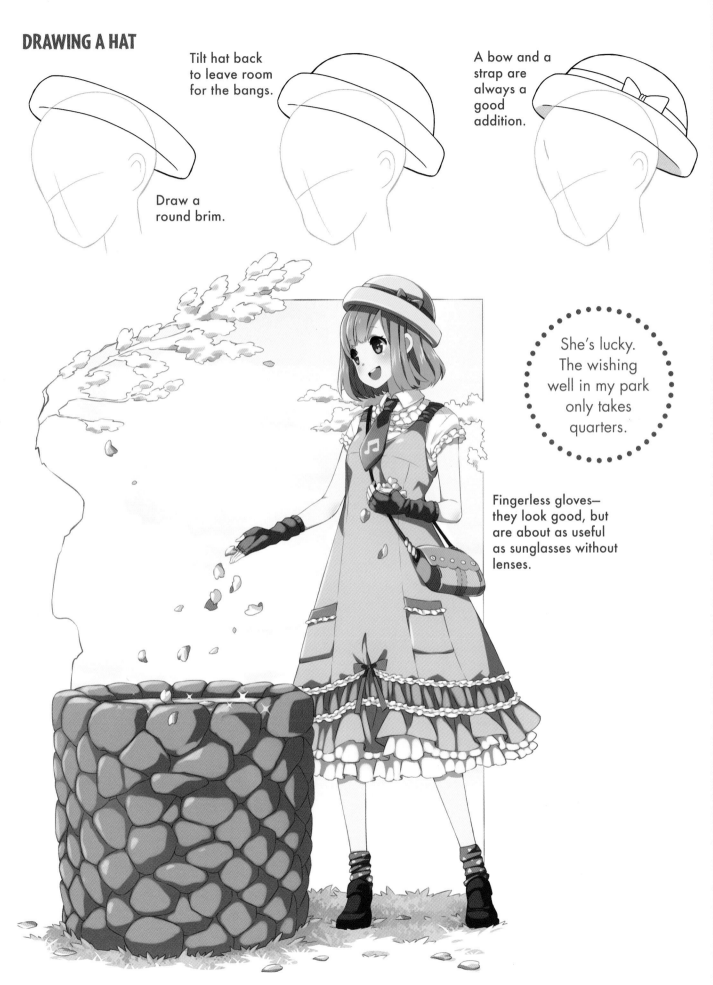

Tilt hat back to leave room for the bangs.

Draw a round brim.

A bow and a strap are always a good addition.

She's lucky. The wishing well in my park only takes quarters.

Fingerless gloves—they look good, but are about as useful as sunglasses without lenses.

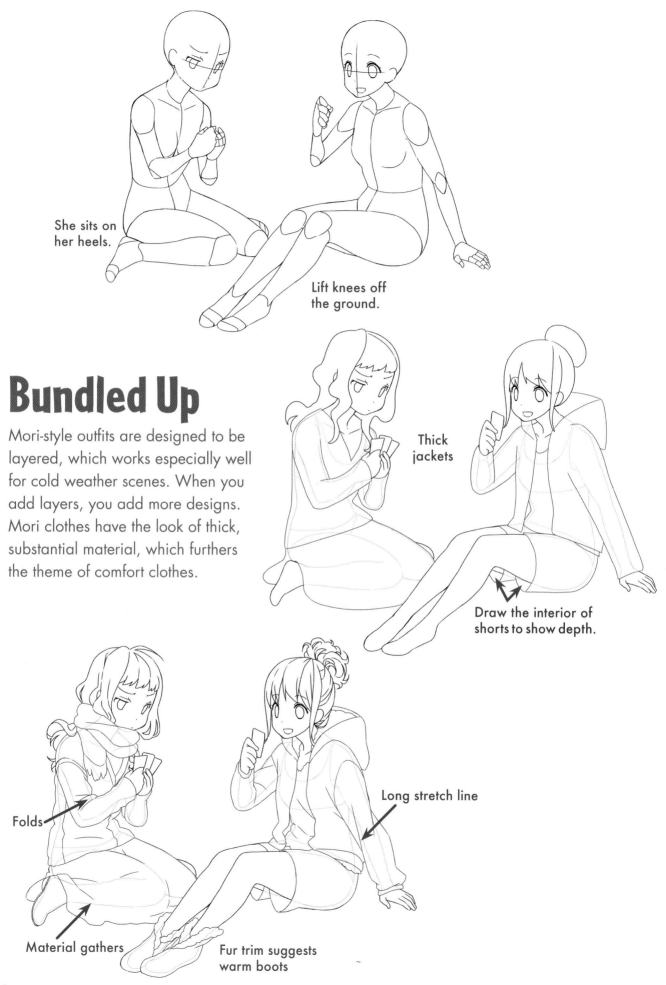

She sits on her heels.

Lift knees off the ground.

Bundled Up

Mori-style outfits are designed to be layered, which works especially well for cold weather scenes. When you add layers, you add more designs. Mori clothes have the look of thick, substantial material, which furthers the theme of comfort clothes.

Thick jackets

Draw the interior of shorts to show depth.

Folds

Material gathers

Fur trim suggests warm boots

Long stretch line

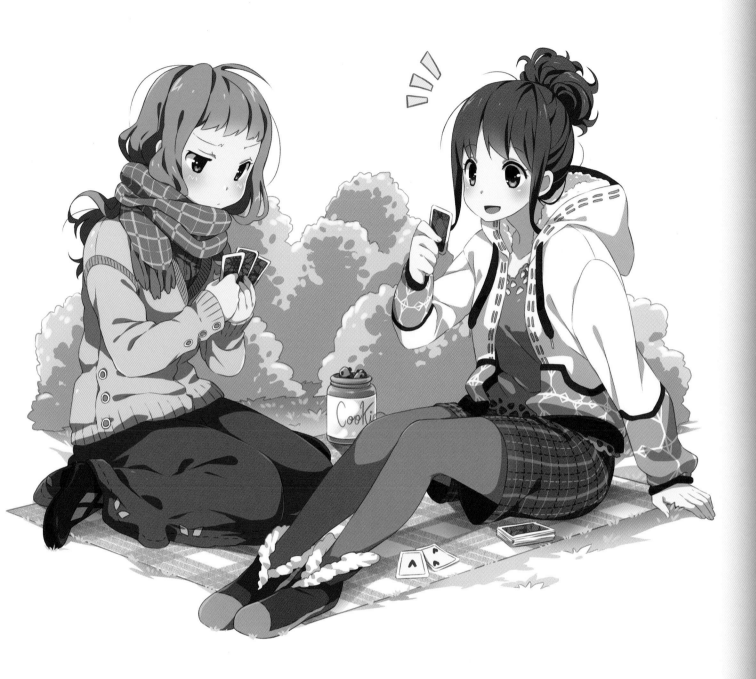

DRAWING FUR-TRIMMED BOOTS

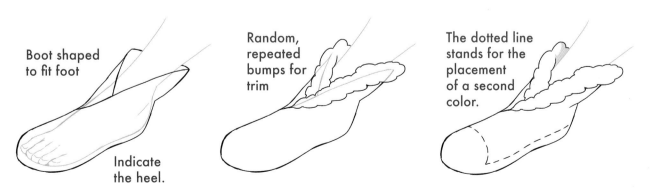

Boot shaped
to fit foot

Indicate
the heel.

Random,
repeated
bumps for
trim

The dotted line
stands for the
placement
of a second
color.

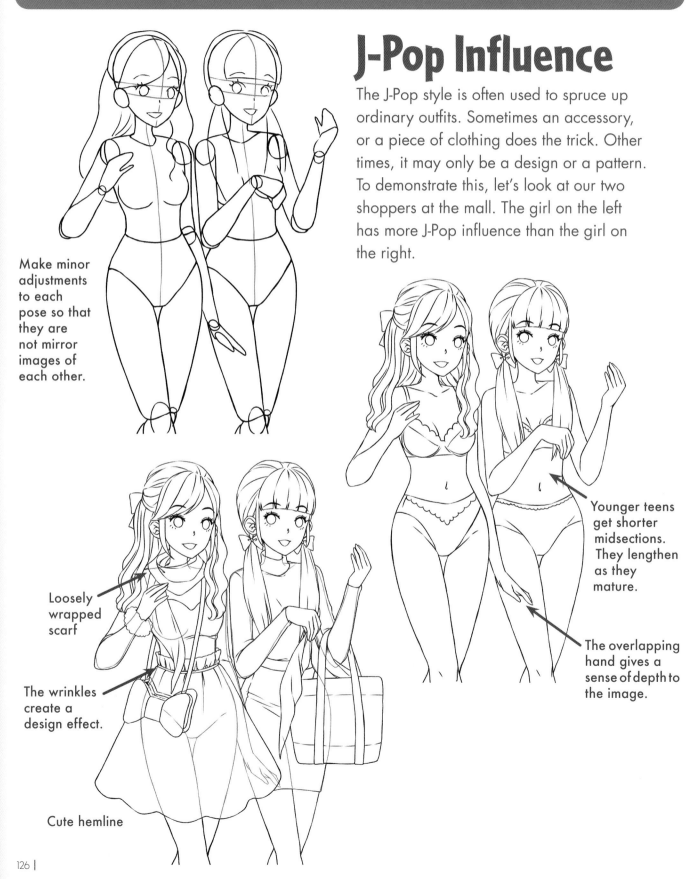

J-POP

The *J-Pop* style can be used as an accent to an outfit or as a full-blown style. Some characters look fashionable wearing just a few J-Pop accessories, while others look super-cool with the complete look. We'll start off by adding a few accents and work our way up to the whole shebang.

J-Pop Influence

The J-Pop style is often used to spruce up ordinary outfits. Sometimes an accessory, or a piece of clothing does the trick. Other times, it may only be a design or a pattern. To demonstrate this, let's look at our two shoppers at the mall. The girl on the left has more J-Pop influence than the girl on the right.

Make minor adjustments to each pose so that they are not mirror images of each other.

Younger teens get shorter midsections. They lengthen as they mature.

The overlapping hand gives a sense of depth to the image.

Loosely wrapped scarf

The wrinkles create a design effect.

Cute hemline

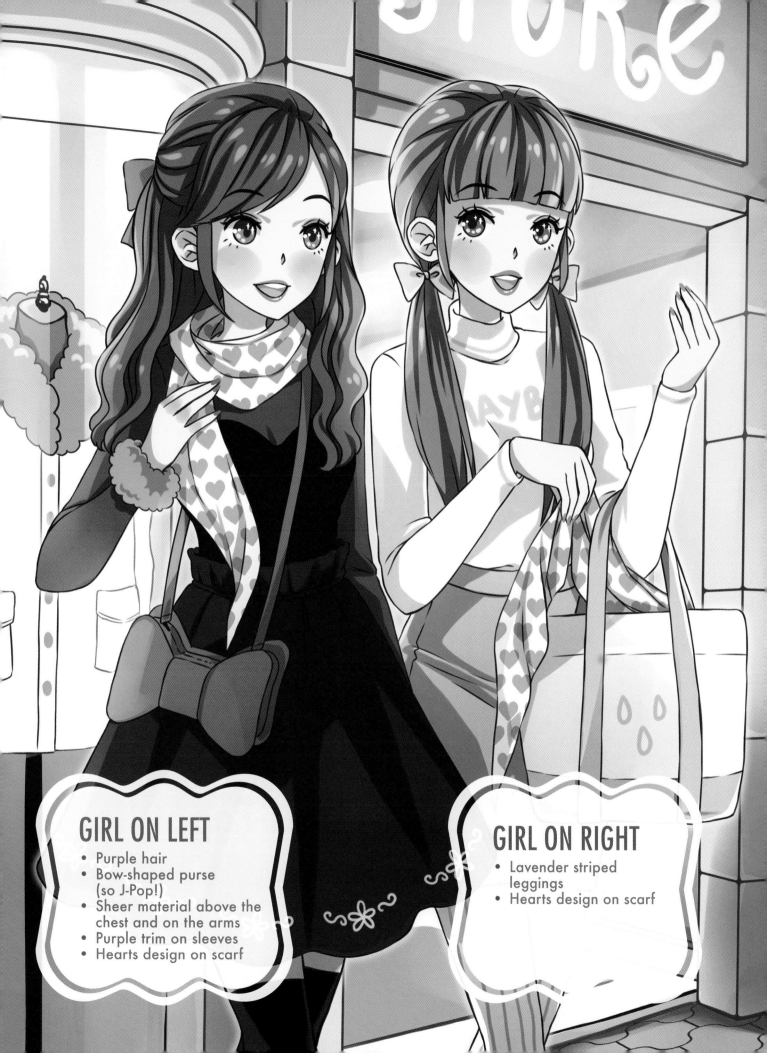

GIRL ON LEFT

- Purple hair
- Bow-shaped purse (so J-Pop!)
- Sheer material above the chest and on the arms
- Purple trim on sleeves
- Hearts design on scarf

GIRL ON RIGHT

- Lavender striped leggings
- Hearts design on scarf

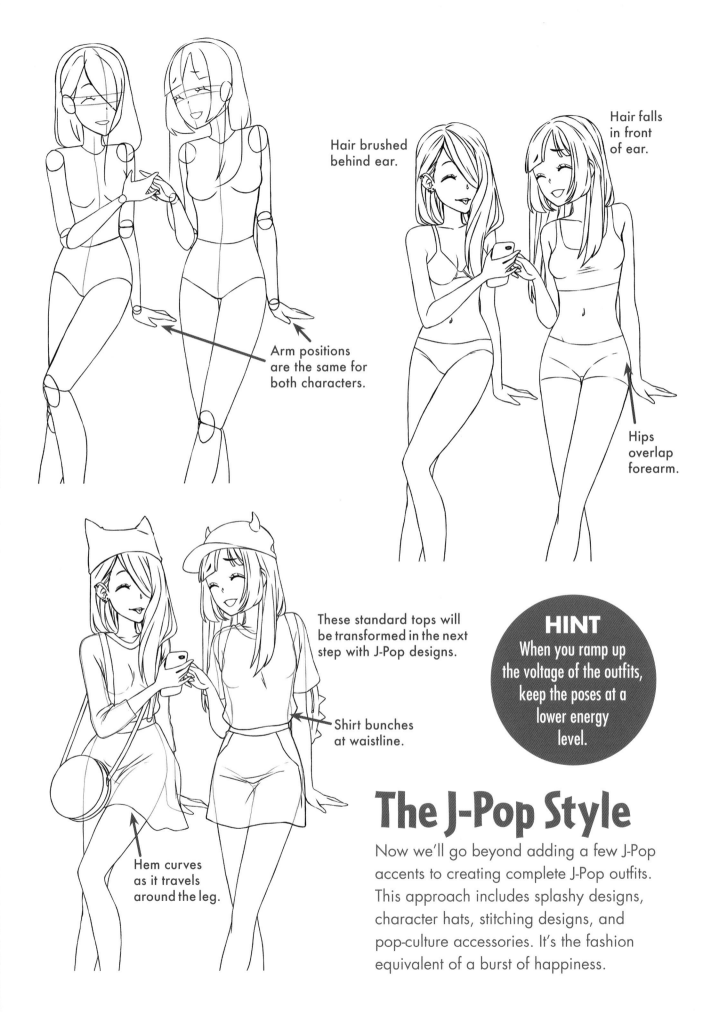

Hair brushed behind ear.

Hair falls in front of ear.

Arm positions are the same for both characters.

Hips overlap forearm.

These standard tops will be transformed in the next step with J-Pop designs.

Shirt bunches at waistline.

Hem curves as it travels around the leg.

HINT
When you ramp up the voltage of the outfits, keep the poses at a lower energy level.

The J-Pop Style

Now we'll go beyond adding a few J-Pop accents to creating complete J-Pop outfits. This approach includes splashy designs, character hats, stitching designs, and pop-culture accessories. It's the fashion equivalent of a burst of happiness.

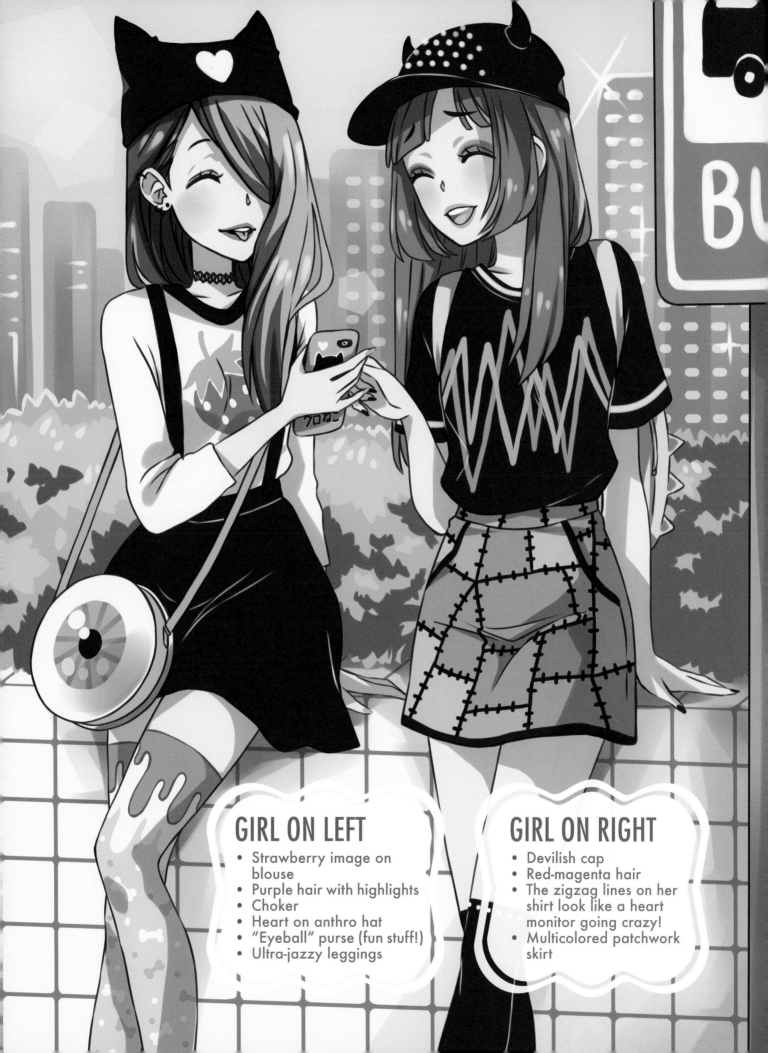

GIRL ON LEFT

- Strawberry image on blouse
- Purple hair with highlights
- Choker
- Heart on anthro hat
- "Eyeball" purse (fun stuff!)
- Ultra-jazzy leggings

GIRL ON RIGHT

- Devilish cap
- Red-magenta hair
- The zigzag lines on her shirt look like a heart monitor going crazy!
- Multicolored patchwork skirt

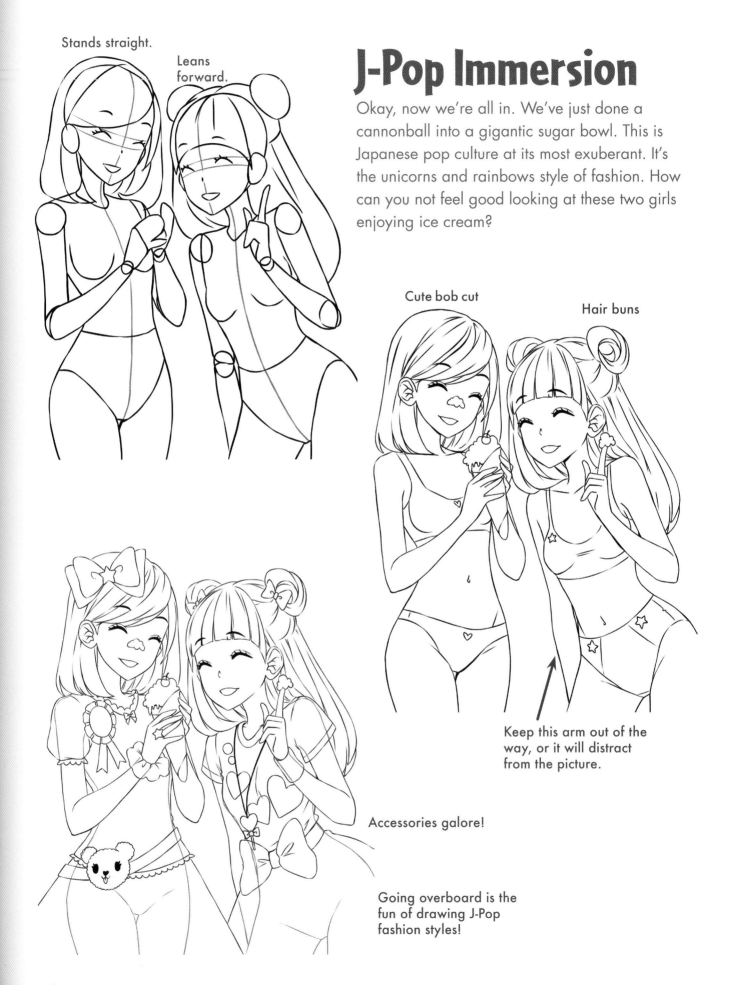

Stands straight.

Leans forward.

J-Pop Immersion

Okay, now we're all in. We've just done a cannonball into a gigantic sugar bowl. This is Japanese pop culture at its most exuberant. It's the unicorns and rainbows style of fashion. How can you not feel good looking at these two girls enjoying ice cream?

Cute bob cut

Hair buns

Keep this arm out of the way, or it will distract from the picture.

Accessories galore!

Going overboard is the fun of drawing J-Pop fashion styles!

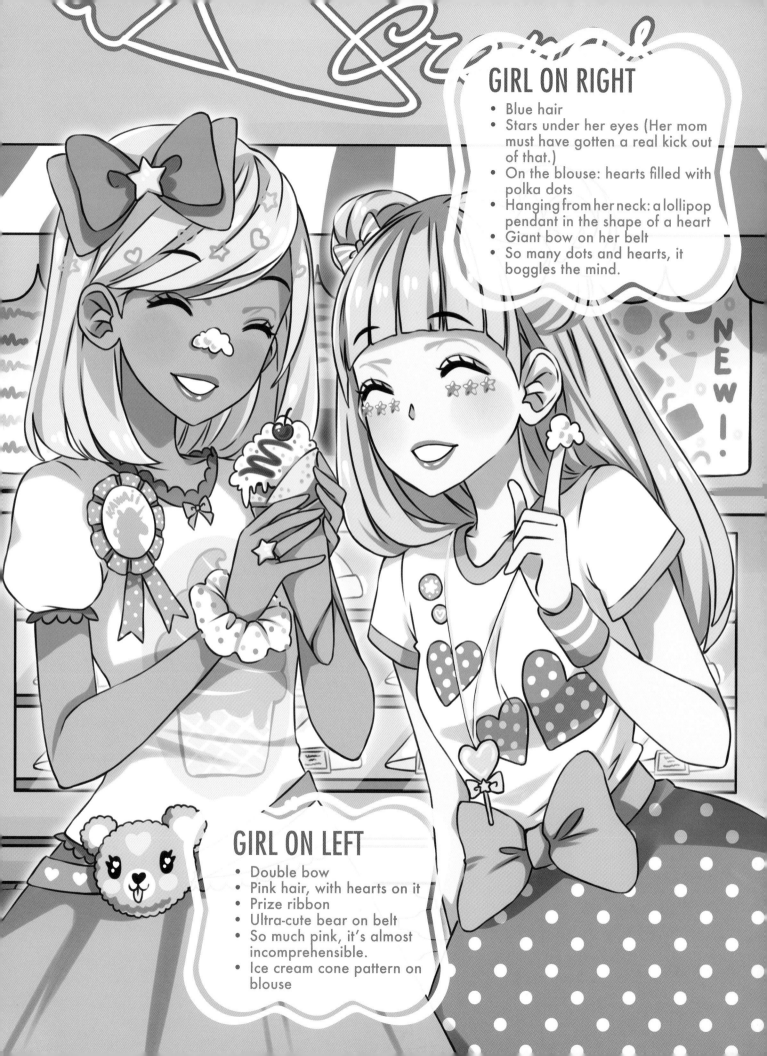

GIRL ON RIGHT

- Blue hair
- Stars under her eyes (Her mom must have gotten a real kick out of that.)
- On the blouse: hearts filled with polka dots
- Hanging from her neck: a lollipop pendant in the shape of a heart
- Giant bow on her belt
- So many dots and hearts, it boggles the mind.

GIRL ON LEFT

- Double bow
- Pink hair, with hearts on it
- Prize ribbon
- Ultra-cute bear on belt
- So much pink, it's almost incomprehensible.
- Ice cream cone pattern on blouse

PUNK AND GOTH

Parents shudder at the idea of their son or daughter dating a punk. Therefore, you know it must be a cool style. *Punk* makes a subversive fashion statement. It can look colorful and cute but it's always got a rebellious flair. It's a mainstay of manga and one of its most extreme fashions.

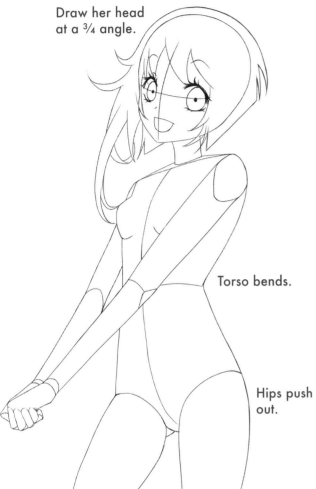

Draw her head at a ¾ angle.

Torso bends.

Hips push out.

Cute Punk

This outfit could be called *Intro to Punk 101*, but I doubt you'll find it in your average fashion school. The look is defiant of convention, and yet, there's a bouncy feel to it. There are degrees of punk. Not all of them push the fashion envelope—although some certainly do.

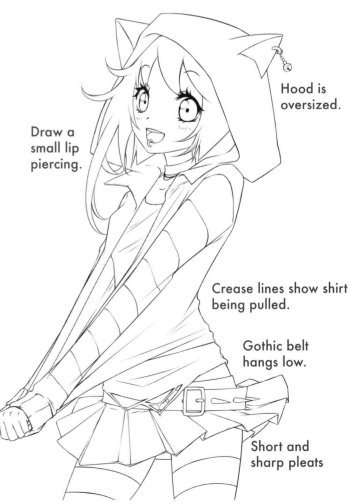

Hood is oversized.

Draw a small lip piercing.

Crease lines show shirt being pulled.

Gothic belt hangs low.

Short and sharp pleats

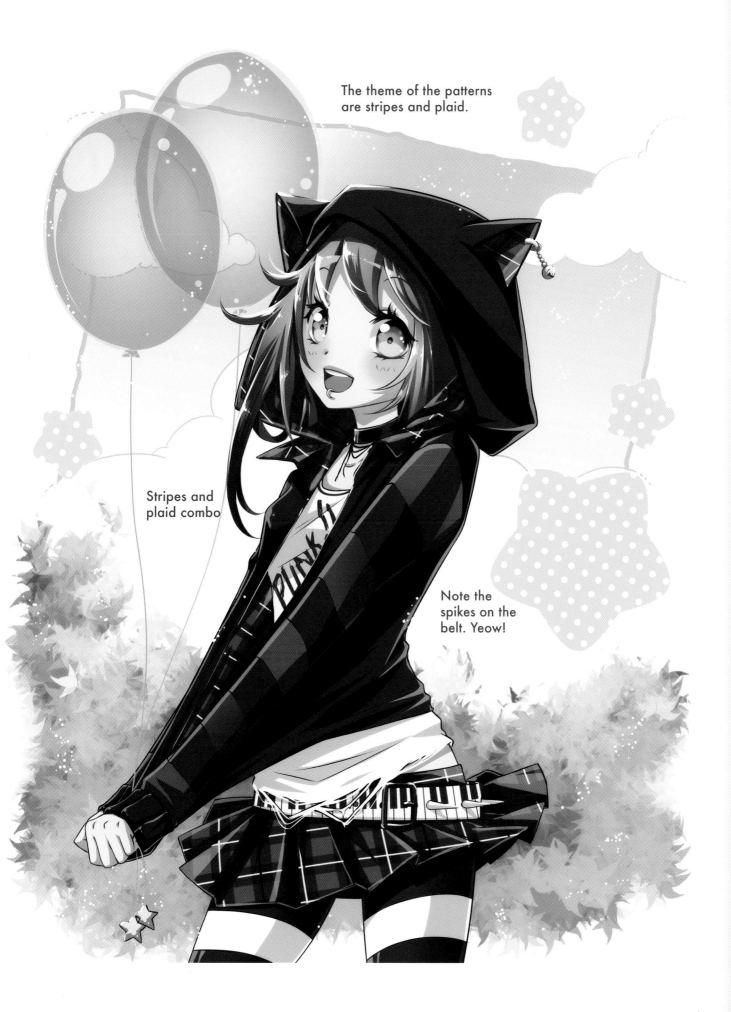

The theme of the patterns are stripes and plaid.

Stripes and plaid combo

Note the spikes on the belt. Yeow!

Draw an abundance of elegant hair on both sides of the head.

Torso bends inward.

Straight

Curve

Wealthy Punk

Why the glum face? Could it be because his pet spider died? I sure hope he takes better care of his scorpion. Some of the most dramatic and charismatic punks come from wealthy means. This fashion can be a high style—even glamorous.

Draw the scarf high on the neck.

Wide straps

Shirt (first layer)

Vest (second layer)

Trench coat (third layer)

Crisscross the ties on side of leg.

HINT
"Extras", such as buckles and straps, don't need to be practical. They can be used purely as decoration.

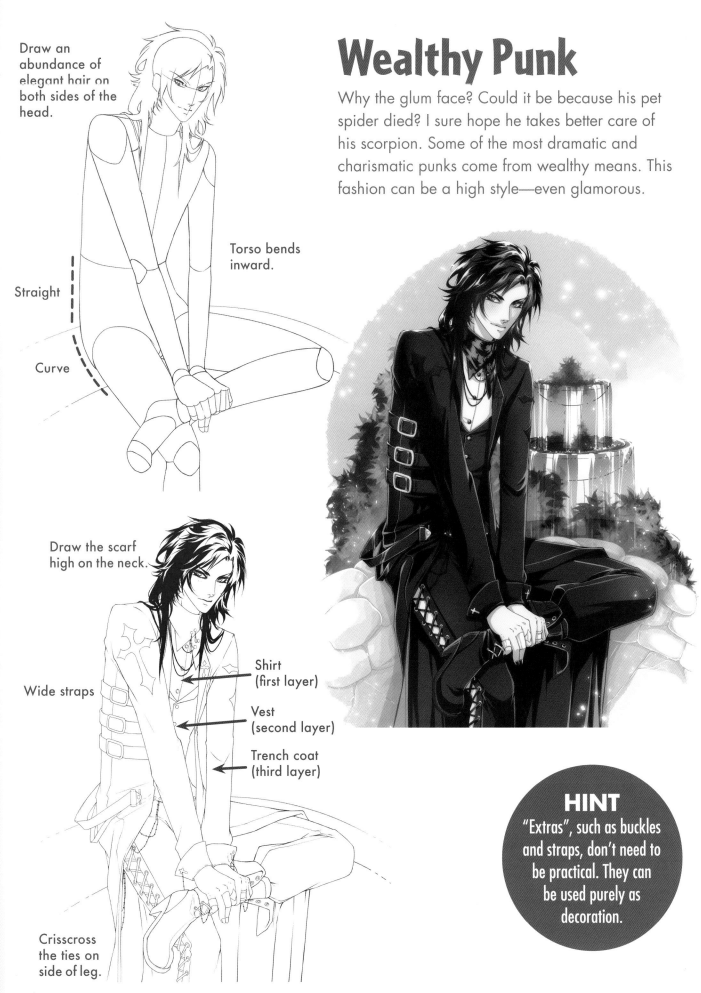

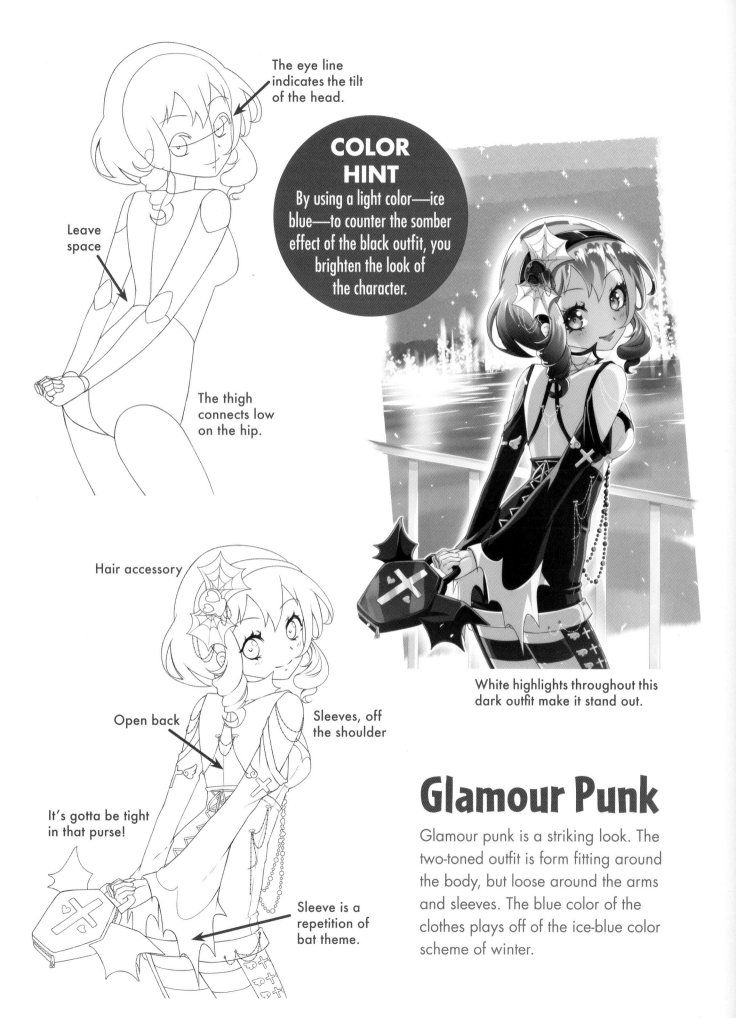

The eye line indicates the tilt of the head.

Leave space

COLOR HINT

By using a light color—ice blue—to counter the somber effect of the black outfit, you brighten the look of the character.

The thigh connects low on the hip.

Hair accessory

Open back

Sleeves, off the shoulder

It's gotta be tight in that purse!

Sleeve is a repetition of bat theme.

White highlights throughout this dark outfit make it stand out.

Glamour Punk

Glamour punk is a striking look. The two-toned outfit is form fitting around the body, but loose around the arms and sleeves. The blue color of the clothes plays off of the ice-blue color scheme of winter.

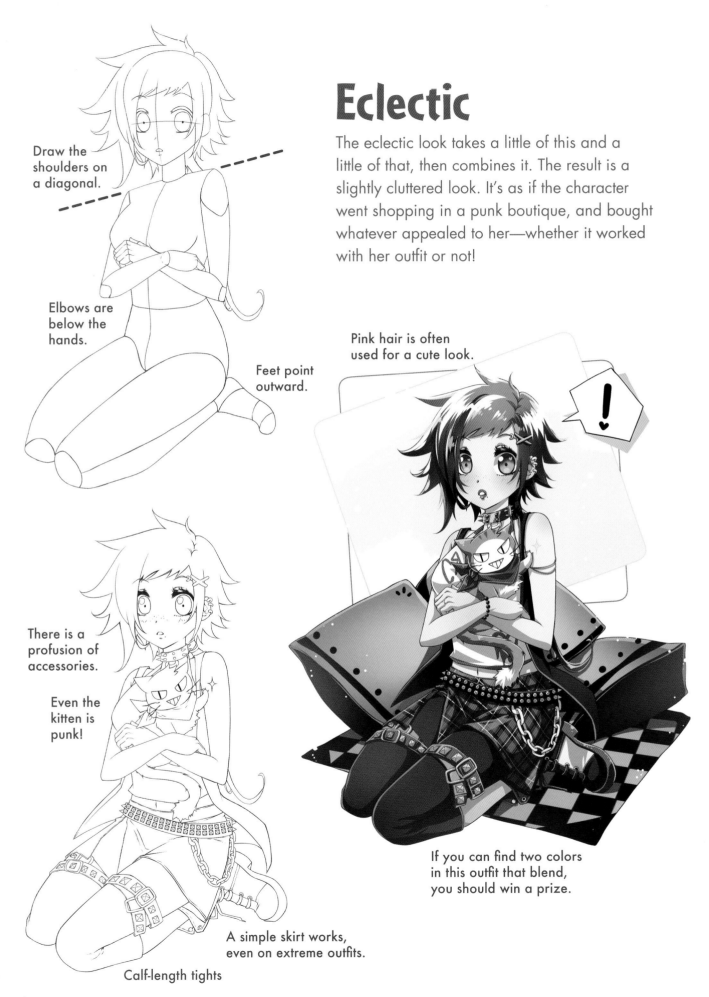

Draw the shoulders on a diagonal.

Elbows are below the hands.

Feet point outward.

Eclectic

The eclectic look takes a little of this and a little of that, then combines it. The result is a slightly cluttered look. It's as if the character went shopping in a punk boutique, and bought whatever appealed to her—whether it worked with her outfit or not!

Pink hair is often used for a cute look.

There is a profusion of accessories.

Even the kitten is punk!

A simple skirt works, even on extreme outfits.

Calf-length tights

If you can find two colors in this outfit that blend, you should win a prize.

If you thought J-Pop was cute, take a look at the *Lolita* style. Lolita fashions are intensely sweet. It's like combining a birthday cake with an outfit. The difference between Lolita and J-Pop is that Lolita features a heightened look of innocence and youthfulness. Sometimes the creations are frilly, sometimes they're casual, but they're always charming. Each outfit is candy colored. The more intense this style gets, the more dreamy it becomes, as we'll soon see! Brace yourself for a tsunami of chic cuteness.

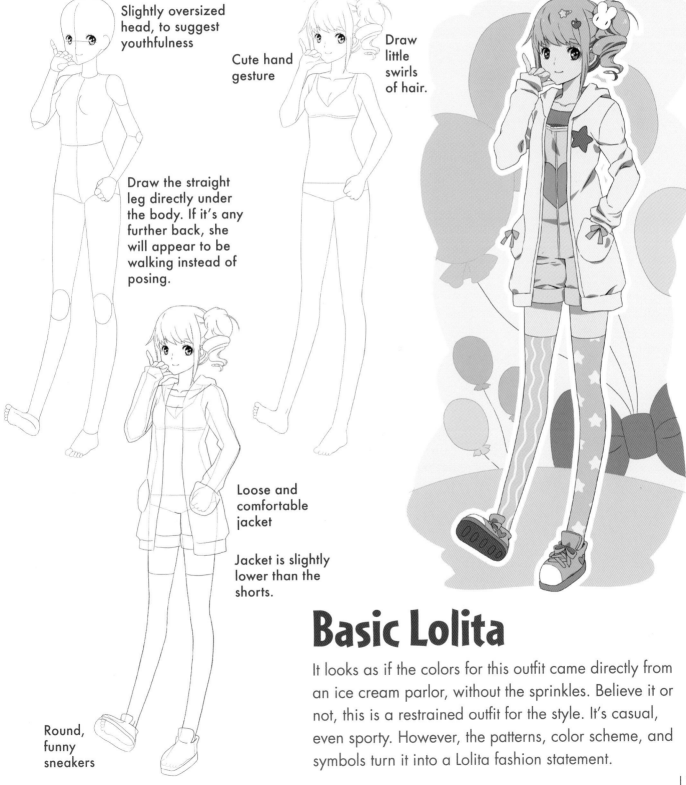

LOLITA

Slightly oversized head, to suggest youthfulness

Cute hand gesture

Draw little swirls of hair.

Draw the straight leg directly under the body. If it's any further back, she will appear to be walking instead of posing.

Loose and comfortable jacket

Jacket is slightly lower than the shorts.

Round, funny sneakers

Basic Lolita

It looks as if the colors for this outfit came directly from an ice cream parlor, without the sprinkles. Believe it or not, this is a restrained outfit for the style. It's casual, even sporty. However, the patterns, color scheme, and symbols turn it into a Lolita fashion statement.

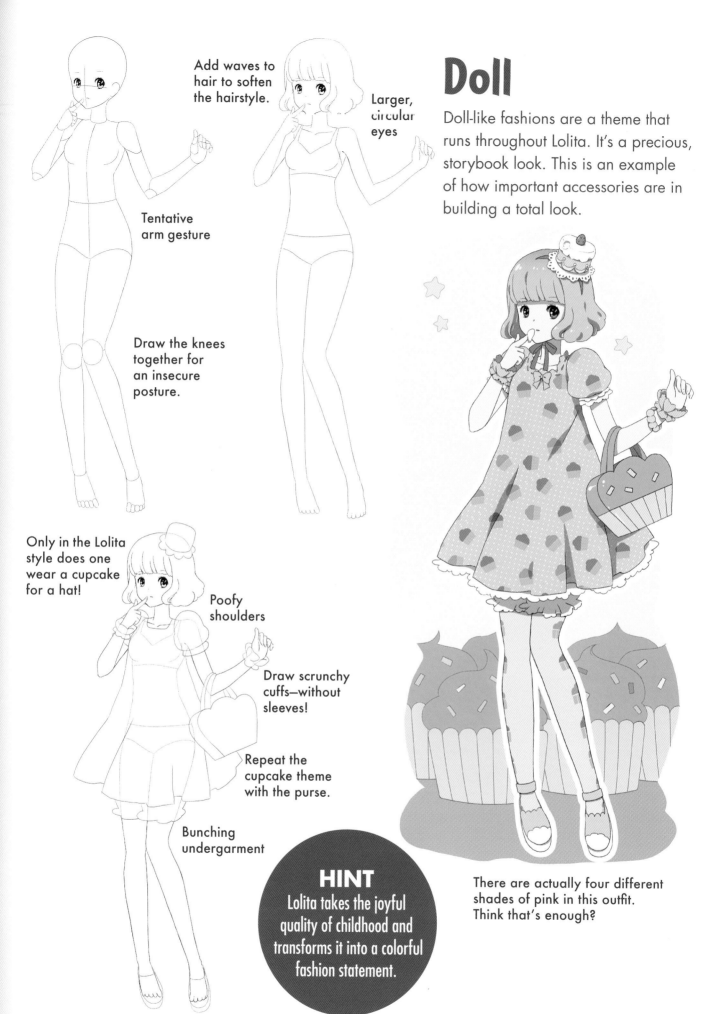

Add waves to hair to soften the hairstyle.

Larger, circular eyes

Tentative arm gesture

Draw the knees together for an insecure posture.

Doll

Doll-like fashions are a theme that runs throughout Lolita. It's a precious, storybook look. This is an example of how important accessories are in building a total look.

Only in the Lolita style does one wear a cupcake for a hat!

Poofy shoulders

Draw scrunchy cuffs—without sleeves!

Repeat the cupcake theme with the purse.

Bunching undergarment

HINT
Lolita takes the joyful quality of childhood and transforms it into a colorful fashion statement.

There are actually four different shades of pink in this outfit. Think that's enough?

ANTHRO-LOLITA

You just knew the anthro hood was coming, didn't you? This is the warm and fuzzy look of Lolita. Every part of the outfit is oversized and soft. These clothes are so comfy that people who wear them have fallen asleep standing up.

Brush the bangs to one side.

Hair widens out into curls.

Bent leg overlaps straight leg.

Draw oversized hood with bear ears.

Feet turn slightly inward for a coy look.

Repeat bear motif in purse.

Rounded pleats

Bunched up legwarmers

Load up on the accessories for a girlish accent.

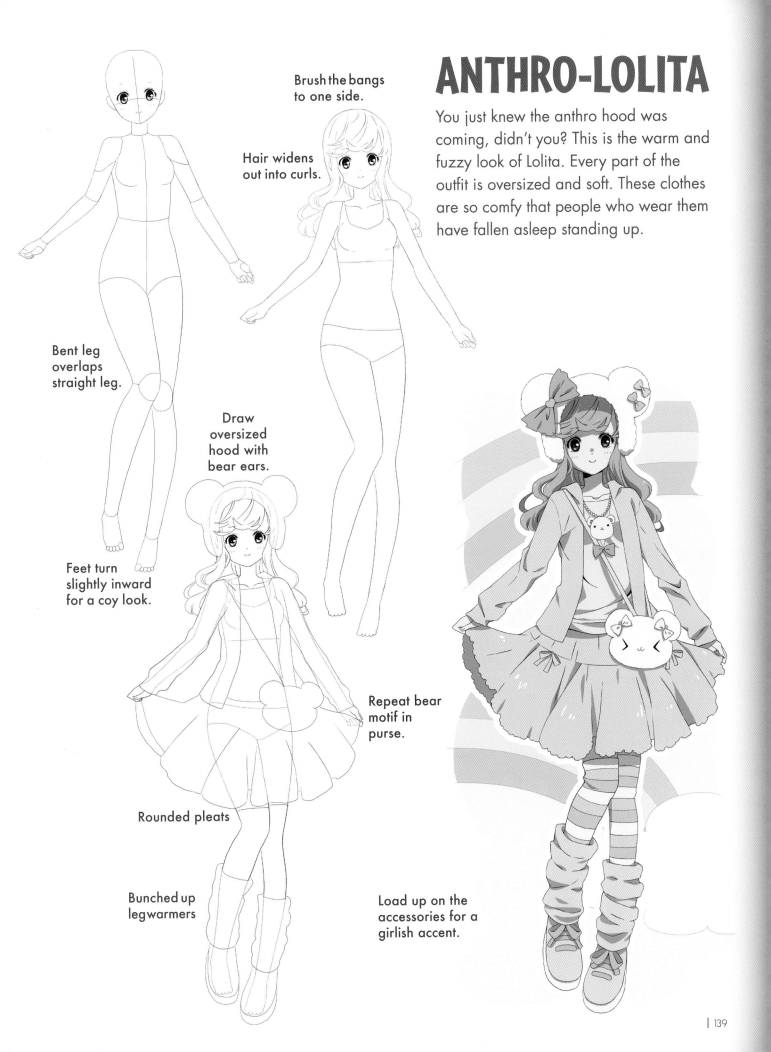

Arm tapers down to the hand (the effect of perspective).

Thumb up

Dreamy

The Lolita style allows you to live out your dreams through fashion. This dazzling look is wildly vivid, just like your dreams. It has a heightened intensity because red is the singular color theme. Combined with an overabundance of stripes, the look becomes astounding.

Hair flows behind.

Thumb down

Add a slight bend of the knee for a playful pose.

Add a crimp at the bottom of the sleeve.

High waistline

The tips of the hems stick out.

The stripes are drawn as sets going in different directions. For example, the bows have horizontal stripes while the torso has vertical stripes.

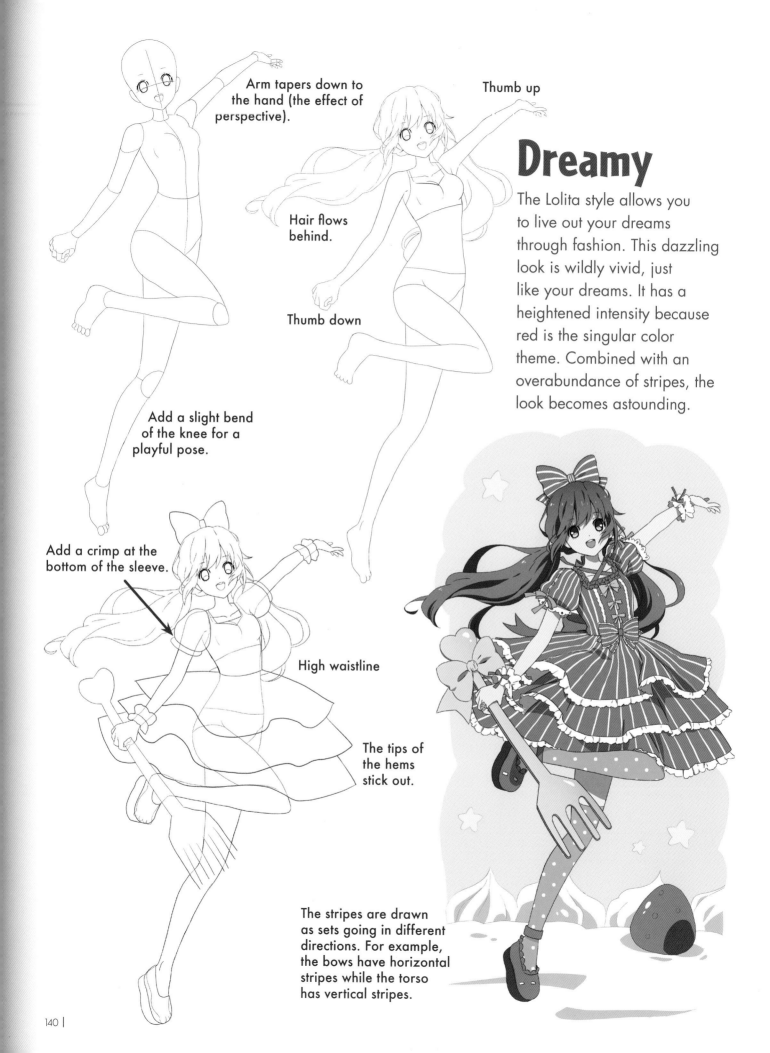

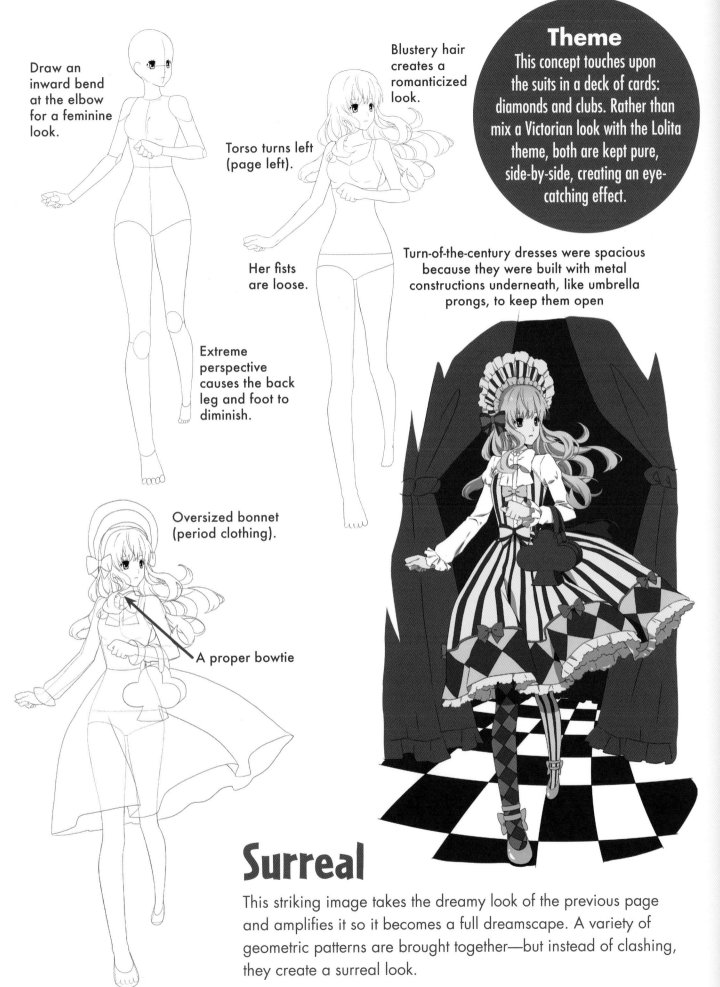

Draw an inward bend at the elbow for a feminine look.

Torso turns left (page left).

Her fists are loose.

Blustery hair creates a romanticized look.

Extreme perspective causes the back leg and foot to diminish.

Oversized bonnet (period clothing).

A proper bowtie

Theme
This concept touches upon the suits in a deck of cards: diamonds and clubs. Rather than mix a Victorian look with the Lolita theme, both are kept pure, side-by-side, creating an eye-catching effect.

Turn-of-the-century dresses were spacious because they were built with metal constructions underneath, like umbrella prongs, to keep them open

Surreal

This striking image takes the dreamy look of the previous page and amplifies it so it becomes a full dreamscape. A variety of geometric patterns are brought together—but instead of clashing, they create a surreal look.

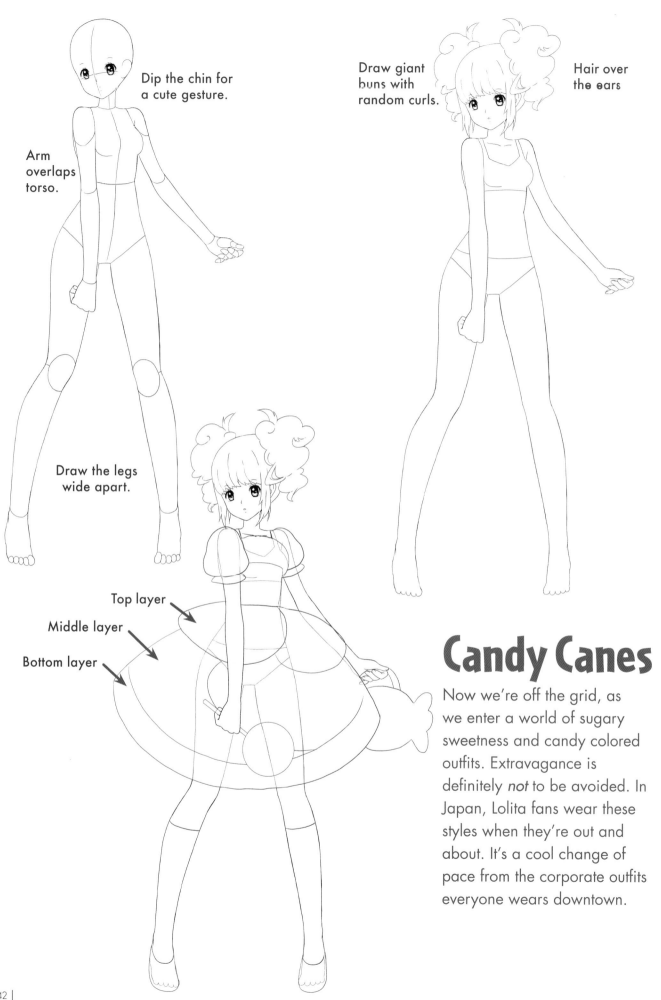

Dip the chin for a cute gesture.

Arm overlaps torso.

Draw the legs wide apart.

Draw giant buns with random curls.

Hair over the ears

Top layer

Middle layer

Bottom layer

Candy Canes

Now we're off the grid, as we enter a world of sugary sweetness and candy colored outfits. Extravagance is definitely *not* to be avoided. In Japan, Lolita fans wear these styles when they're out and about. It's a cool change of pace from the corporate outfits everyone wears downtown.

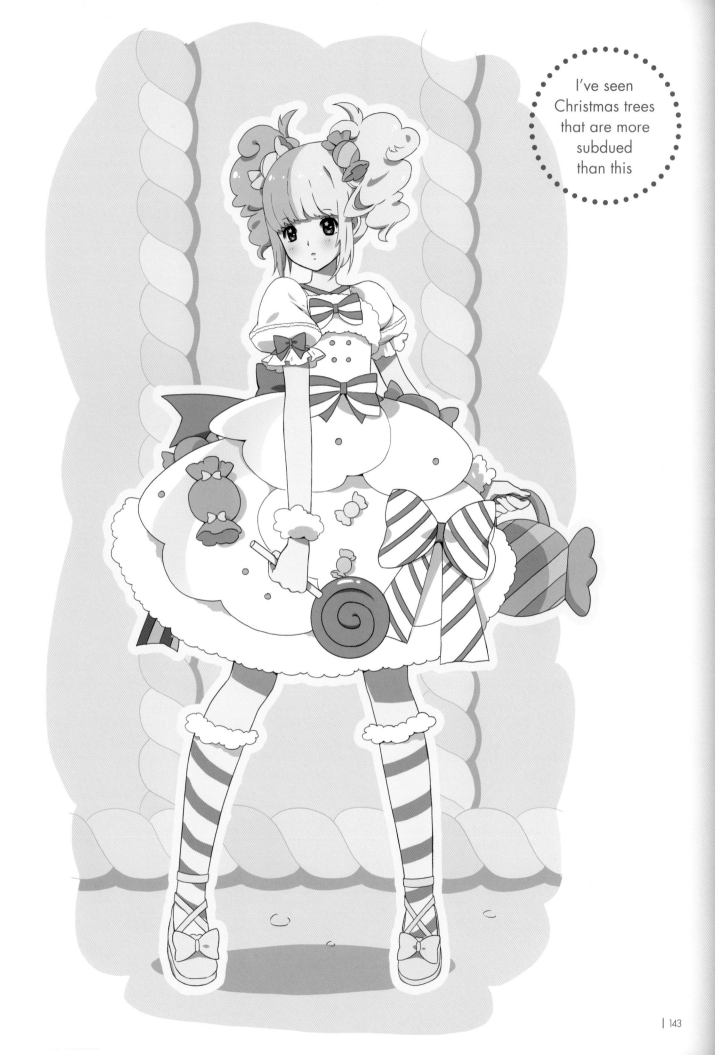

I've seen Christmas trees that are more subdued than this

INDEX